IDENTIFICATION PAPERS

IDENTIFICATION PAPERS

Diana Fuss

Routledge • New York London

Published in 1995 by
Routledge
29 West 35th Street
New York, NY 10001

Published in Great Britain by
Routledge
11 New Fetter Lane
London EC4P 4EE

Library of Congress Cataloging-in-Publication Data
Fuss, Diana
 Identification papers / Diana Fuss.
 p. cm.
 Includes bibliographical references and index.
 ISBN 0-415-90885-X.— ISBN 0-415-90886-8 (pbk.)
 1. Identification (Psychology) 2. Psychoanalysis and feminism.
 I. Title.
BF175.5.I43F87 1995
155.2—dc20 95-22215
 CIP

CONTENTS

ACKNOWLEDGMENTS

FOR SEVERAL YEARS NOW I have been thinking about the problem of identification, sustained by the interest and assistance of a group of people who have made my own intellectual and emotional life inestimably richer. A number of friends and colleagues have read all or most of this manuscript in its messiest stages, and to them I extend my deepest gratitude. Marcia Ian and Carolyn Williams have been a constant source of support; our weekly brunches kept me more alert than one has a right to be on a Sunday morning. Lee Edelman provided endless encouragement and emergency assistance when I most needed it. Ed Cohen kept me honest with his wry humor and sly skepticism about all things psychoanalytic. And David Halperin effectively subsidized the book by opening up his home and offering me an ideal work space in which to finish writing. This book would also not have been possible without the very real emotional and intellectual support of my reading group buddies. Walter Hughes graciously put his own work on hold to provide patient commentary and cheerful reassurance. Eric Santner, through his searching questions, challenged me to think harder about the more intransigent theoretical problems this book raises. And Eduardo Cadava remains the very best kind of colleague, a meticulous reader, and a sustaining friend. Together they have provided one of the most supportive, challenging, and motivational forums for intellectual discussion that I have ever experienced. Their generosity and influence mark every page.

Numerous other friends have read and commented upon portions of this manuscript, immeasurably improving the whole. I particularly thank Thomas Keenan, Cathy Caruth, Cora Kaplan, Elin Diamond, Andrew Parker, Jann Matlock, Rebecca Walkowitz, Marjorie Garber, Michael Warner, Geeta Patel, Wayne Koestenbaum, Joseph Litvak, Andrew Ross, and Michael Goldman. Thanks to Mary Ann Doane for continuing to influence my thinking in ways she may not even know; to Carole-Anne Tyler for her challenging critiques and for the inspiration of her scholarship; to Judith Butler for reminding me how very difficult and important the problem of identification can be; to James Fuss for showing me by example what it is to be an intellectual in the world; and to Wahneema Lubiano, Daniel Boyarin, Mary Jacobus, Ellis Hanson, Jay Geller, Tom Foster, Bill Martin, Dianne Sadoff, Gwen Bergner, Gayle Wald, and Ann Pellegrini for graciously sharing with me their work in progress. William Germano remains my favorite (and only) editor; his loyalty, support, and friendship speak volumes. Eric Zinner shepherded this project through its final stages; I thank him for his patience, direction, and excellent taste in cover designers.

I have been particularly fortunate in the institutional support I have received while at work on this book. A fellowship from the Center for the Critical Analysis of Contemporary Culture at Rutgers University provided me with a congenial environment for beginning the project. My year at Rutgers is especially memorable and important to me for the enduring friendships I formed there and for the supportive guidance of the center's directors, Carolyn Williams, George Levine, and Beryle Chandler. Harvard University's Center for Literary and Cultural Studies provided another exciting intellectual community that supported me through the completion of the book. My thanks to Marjorie Garber for inviting me and to Anthony Appiah, Henry Finder, Alice Jardine, Doris Sommer, Barbara Johnson, Barbara Claire Freeman, Jeffrey Masten, Svetlana Boym, and Phillip Brian Harper for making my year in Boston such a stimulating one. Fellowship support from Princeton University has made it possible for me to travel to libraries and to spend my summers writing, for which I am also grateful.

This book is dedicated to my mother, Joanne Fuss, in love, respect, and friendship.

Several chapters of this book have been previously published in slightly altered form. Chapter 2 previously appeared under the title "Freud's Fallen Women: Identification, Desire, and 'A Case of Homosexuality in a Woman,'" in *The Yale Journal of Criticism* 6:1 (Spring 1993): 1–23. Chapter 3 was first published under the title "Monsters of Perversion: Jeffrey Dahmer and *The Silence of the Lambs,*" in *Media Spectacles,* eds. Marjorie Garber, Jann Matlock, and Rebecca L. Walkowitz (New York and London: Routledge, 1993), 181–205. And chapter 5, "Interior Colonies: Frantz Fanon and the Politics of Identification," previously appeared in *diacritics* 24:2–3 (Summer-Fall 1994): 20–42.

If one has lost a love-object, the most obvious reaction is to identify one-self with it, to replace it from within, as it were, by identification.

Sigmund Freud,
An Outline of Psycho-Analysis

What one cannot keep outside, one always keeps an image of inside. Identification with the object of love is as silly as that.

Jacques Lacan,
The Four Fundamental Concepts of Psycho-Analysis

INTRODUCTION:
FIGURING IDENTIFICATION

As THIS BOOK'S TWO EPIGRAPHS from Freud and Lacan suggest, something rather "obvious" and "silly" distinguishes the work of identification. Identification is an embarrassingly ordinary process, a routine, habitual compensation for the everyday loss of our love-objects. Compensating for loss may be one of our most familiar psychological experiences, coloring every aspect of our relation to the world outside us, but it is also a profoundly defamiliarizing affair, installing surrogate others to fill the void where we imagine the love-object to have been. "If one has lost a love-object," Freud writes, "the most obvious reaction is to identify oneself with it, to replace it from within, as it were, by identification."[1] What is the status of this object that has already been lost to the subject, yet nonetheless remains present as the grammatical object of the sentence—the "it" that must be replaced from within by identification? Lacan explains that it is not the object itself that the subject takes inside but a likeness or facsimile: "What one cannot keep outside, one always keeps an image of inside. Identification with the object of love is as silly as that."[2] Identification, in other words, invokes phantoms. By incorporating the spectral remains of the dearly departed love-object, the subject vampiristically comes to life. To be open to an identification is to be open to a death encounter, open to the very possibility of communing with the dead.[3]

These revenants of the unconscious frequently take us by surprise. Identifications startle us by the apparent suddenness of their emergence,

I

the violence of their impact, the incalculability of their effects. Identifications are the origin of some of our most powerful, enduring, and deeply felt pleasures. They are also the source of considerable emotional turmoil, capable of unsettling or unmooring the precarious groundings of our everyday identities. These ghosts from the past can be neither casually summoned up nor willfully conjured away. They are shadow others, the phantasmal relics of our complicated psychical histories.

Identifications are erotic, intellectual, and emotional. They delight, fascinate, puzzle, confuse, unnerve, and sometimes terrify. They form the most intimate and yet the most elusive part of our unconscious lives. While we tend to experience our identities as part of our public personas—the most exposed part of our self's surface collisions with a world of other selves—we experience our identifications as more private, guarded, evasive. I would not wish to remain long, however, with a too simplistic differentiation between public identity and private identification; such a specious distinction disguises how every identity is actually an identification come to light. For the brevity and clarity of its form, I borrow my working definition of identity from Jean-Luc Nancy: identity is "the Self that identifies itself."[4] Identification is the psychical mechanism that produces self-recognition. Identification inhabits, organizes, instantiates identity. It operates as a mark of self-difference, opening up a space for the self to relate to itself as a self, a self that is perpetually other. Identification, understood throughout this book as the play of difference and similitude in self-other relations, does not, strictly speaking, stand against identity but structurally aids and abets it.

Yet, at the very same time that identification sets into motion the complicated dynamic of recognition and misrecognition that brings a sense of identity into being, it also immediately calls that identity into question. The astonishing capacity of identifications to reverse and disguise themselves, to multiply and contravene one another, to disappear and reappear years later renders identity profoundly unstable and perpetually open to radical change. Identification is a process that keeps identity at a distance, that prevents identity from ever approximating the status of an ontological given, even as it makes possible the formation of an *illusion* of identity as immediate, secure, and totalizable. It is one of the central claims of this book that it is precisely identity that becomes problematic in and through the work of identification.

In perhaps its simplest formulation, identification is the detour through the other that defines a self. This detour through the other fol-

lows no predetermined developmental path, nor does it travel outside history and culture. Identification names the entry of history and culture into the subject, a subject that must bear the traces of each and every encounter with the external world. Identification is, from the beginning, a question of *relation*, of self to other, subject to object, inside to outside. In *The Freudian Subject*, Mikkel Borch-Jacobsen posits an equivalency of subjectivity and identification: the subject *is* identification; the I *is* another.[5] Subjectivity is the name we might give to the place of the other, to the place where I desire as another, to the place where I become other.

Every relation, most especially the self-relation, is a response to the call of the other—the other who always exceeds me, the other who withdraws me from myself. Maurice Blanchot describes the process this way:

> It is the other who exposes me to "unity," causing me to believe in an irreplaceable singularity, for I feel I must not fail him; and at the same time he withdraws me from what would make me unique: I am not indispensable; in me anyone at all is called by the other—anyone at all as the one who owes him aid. The un-unique, always the substitute. The other is, for his part too, always the other, lending himself, however, to unity; he is neither this one nor that one, and nonetheless it is to him alone that, each time, I owe everything, including the loss of myself.[6]

This paradox of approximating identity through the retreat of identity is a recurrent theme in the philosophical discourse on the problem of alterity. In the wake of Hegel, philosophers of modernity repeatedly return to the question of whether the other as other can be grasped at all and whether the self is always only a substitute for the other that cannot finally be known. Some of the most radical work on the problem of the other can be found in twentieth-century French intellectual thought, where the topic of alterity enters the philosophical conversation most directly through the influence of Alexandre Kojève's lectures on Hegel's *Phenomenology of Spirit*.[7] This tradition of French Hegelianism—which includes contemporary thinkers as diverse as Philippe Lacoue-Labarthe, Jean-Luc Nancy, Emmanuel Levinas, Luce Irigaray, René Girard, Mikkel Borch-Jacobsen, Maurice Blanchot, Hélène Cixous, and Jacques Derrida —provides a larger philosophical framework in which to understand psychoanalysis's continued interest in the problem of identification.[8] While the concept of identification holds a status specific to the intellectual tradition of psychoanalysis,[9] the longer history of philosophical work on

3

the question of otherness clarifies the central problematic involved: how is it that only through the other I can be myself, only in the place of the other I can arrive at a sense of self?

Part of the problem for psychoanalysis in addressing this question is that identification, a process defined as the internalization of the other, itself eludes the analytic desire for possession and appropriation. The psychoanalytic literature on identification is littered with taxonomic qualifiers that seek to identify, with greater and greater precision, modes and types of identifications: primary and secondary, feminine and masculine, imaginary and symbolic, maternal and paternal, idio-pathic and heteropathic, partial and total, centrifugal and centripetal, narcissistic and regressive, hysterical and melancholic, multiple and ter-minal, positive and negative. This often incongruous proliferation of kinds of identifications points to a theoretical difficulty psychoanalysis must routinely confront in laying hold of its object, a difficulty, that is, in identifying identification. How can the other be brought into the domain of the knowable without annihilating the other *as other*—as pre-cisely that which cannot be known? One might say that the work of psychoanalysis is compelled to mime its object: the psychoanalytic appetite for epistemological possession enacts the very process of incorporation it seeks to describe, exposing the play of identification in every act of interpretation.[10]

Freud begins from the assumption that the other can at least be approximated, if not fully incorporated; he attributes the failure of earlier attempts to think the otherness of the other to a historical privi-leging of imagination over reason. Previous models that seek to concep-tualize the influence of other on self—demonic or ecstatic possession, contagious passion, animal magnetism, mesmerism, hypnosis—all repre-sent otherness in mystical rather than rational terms, subsuming science into religion. Freud presents his theory of psychical identification specif-ically as a corrective to the figurative excesses of nineteenth-century psychology. Identification replaces "sympathy," "imagination," and "sug-gestion" to describe, in more "scientific" fashion, the phenomenon of how subjects act upon one another. It is beyond the scope of this project to examine the historical conditions that produced this change in para-digms from religion to science, from hypnosis to psychoanalysis, from suggestion to identification, a series of progressive shifts and reversals that has already been carefully documented elsewhere.[11] What interests me here is Freud's ambivalent disavowal of the literary in his abandon-

4

ment of previous philosophies of the other, his substitution of a factual for a figural logic.

On the one hand, Freud is unusually attentive to the power of language and to the priority of the textual in his highly analogical descriptions of psychoanalysis. For Freud it is not only the case that creative writers discovered psychoanalysis first, but also that psychoanalysis operates as a form of creative writing or literary mythology.[12] In his use of literary tropes to describe the key concepts of psychoanalysis, Freud frequently summons the idea of textuality itself as a rich source of metaphor. The psychoanalytic theory of transference may provide the best example; drawing heavily on the language of book production to describe the psychical process of identification, Freud defines transferences as "new editions or facsimiles," "new impressions or reprints."[13] Freud's most direct acknowledgment of the figurative nature of scientific discourse comes in *Beyond the Pleasure Principle* (1920), where he notes that he is "obliged to operate with the scientific terms, that is to say with the figurative language, peculiar to psychology." Replacing "psychological terms by physiological or chemical ones" would fail to extract from scientific language its rhetorical sediment for "they too are only part of a figurative language."[14] Moreover, psychoanalysis, often understood as a form of narratology, closely identifies with the literary insofar as it has already been anticipated by it, compromised from the start by the necessity of travelling though language and texts.[15] On the other hand, Freud also insists that psychoanalytic case histories are scientific documents, not literary exercises. Any reader expecting to find a *"roman à clef"* in the documentation of his analytic treatments, Freud warns, can be assured that every precaution has been taken to guard against the encroachments of the rhetorical into the "purely scientific and technical."[16] The psychoanalyst is a "medical man" not a "man of letters," and psychoanalytic writing is science not fiction.[17] Psychoanalysis erects itself, as a science, *against* the literary. It seeks to establish its own truth claims on the basis of the repudiation of the power of figuration.

It appears that psychoanalysis can turn against tropes only by invoking them. Freud's scientific theory of identification is entirely predicated on a logic of metaphoric exchange and displacement. Metaphor, *the substitution of the one for the other*, is internal to the work of identification. Freud's concept of self-other relations fundamentally presupposes the possibility of metaphoricity—of iterability, redoubling, translation, and transposition. The Greek *metaphora*, meaning transport, immedi-

ately implicates the transferential act of identification in the rhetorical process of figuration. Psychoanalysis, at least where its theory of identification is concerned, can actually be understood as a scientific discourse on the very problem of metaphorization. My aim then in this book is not to reintroduce metaphor into a psychoanalysis that calls itself a science but rather to read the traces of a figurative logic already at work within a psychoanalysis that repeatedly and symptomatically forgets its metaphorical history.

In adopting a critical methodology that involves reading Freud against Freud (a practice that necessarily entails, to some degree, reading with him), I find myself following in the tradition of an entire body of feminist scholarship that posits a coexistence in psychoanalysis of radical, reactionary, seditious, and novel elements.[18] While identification tends to remain a largely peripheral question in much of this work (its reformist potential for feminism generally overlooked), the concept has come more sharply and dramatically into focus with the increased interest in the topic of queer performativity. While it may not always present itself as such, Eve Sedgwick's work has, from the beginning, been deeply invested in the question of identification—its seductions, its terrors, its possibilities. More than any other writer, Sedgwick is attentive to how identifications actually work in the domain of everyday experience. The not inconsiderable achievement of Sedgwick's three influential books, *Between Men: English Literature and Male Homosocial Desire*, *Epistemology of the Closet*, and most recently *Tendencies*, is their collective challenge to the silent presumption that identities wholly correspond to identifications and that sexuality is a seamless, monolithic, unfractured whole. Sedgwick's sustained interest in the myriad and complex ways sexuality is experienced by different subjects goes a long way towards demonstrating the momentousness of the psychoanalytic insight, "to identify *as* must always include multiple processes of identification *with*."[19] This same premise provides the theoretical foundation of Judith Butler's *Gender Trouble: Feminism and the Subversion of Identity* and *Bodies That Matter*, where the field of psychical identifications becomes a suggestive critical vantage point from which to examine the practice and theory of identity politics. Butler makes a number of salient points on the process of identification worth summarizing briefly here for their potential usefulness later: identifications are never brought to full closure; identifications are inevitably failed identifications; and identifications are vehicles for one another. Butler's comments on *dis*identifica-

tion go even farther in encouraging a reconceptualization of the political, laying the theoretical groundwork for a politics of affiliation fully cognizant of the sacrifices, reversals, and reparations involved in every imaginary identity formation. What at first may appear to be a refused identification, Butler proposes, might in some cases more accurately be termed a disavowed one—an identification that has already been made and denied in the unconscious. A disidentification, in other words, may actually represent "an identification that one fears to make only because one has already made it."[20]

Feminist film theory has long been concerned with the dynamic of identification and disidentification, especially as it pertains to film theory's central interest in the problem of spectatorship.[21] Taking as a point of departure the ability of cinema to elicit pleasure and unpleasure through the manipulation of spectatorial identifications, Mary Ann Doane has argued in *The Desire to Desire: The Woman's Film of the 1940s* and in *Femmes Fatales: Feminism, Film Theory, Psychoanalysis* that the gap which separates identification and desire for the male spectator is collapsed for the female spectator. The female spectator overidentifies with her image on the screen, binding identification to desire to the point where identification operates for women as "the desire to desire"— the desire to take on and to inhabit the desire of the other.[22] Kaja Silverman has extended this argument to include male spectators as well, arguing that phallic identification is enabled through a similar interaction of projection and misrecognition, and that even the most orthodox masculinities are sites of porous identifications and ambivalent, anxious desires. Silverman's two books on film theory, *The Acoustic Mirror: The Female Voice in Psychoanalysis and Cinema* and *Male Subjectivity at the Margins,* both place identification squarely in the social order, insisting on the importance of a "libidinal politics" that recognizes the absolute interaction of subjectivity and ideology, while further exploring the potential of subjective identifications to disturb or even destroy the most violent or oppressive of those ideologies.[23]

While it is not my purpose here to underemphasize the significant differences between these writers, if we read them together a larger picture emerges, that of a feminist theory deeply engaged with the problem of identification as it operates across a range of discourses and a plurality of cultural differences. At the very least, one can say that the psychoanalytic question of identification has emerged for feminism as a pressing political problem, and its deconstruction has profitably opened up new

avenues of research and innovative rethinkings of the political. Among the more striking agreements between the writers I have named is the idea that the form, strength, or trajectory of a particular identification can never be foretold in advance. Identifications are mobile, elastic and volatile. As sites of erotic investiture continually open to the sway of fantasy, the meaning of a particular identification critically exceeds the limits of its social, historical, and political determinations. What, then, is political about identification? What role does identification play in the world of social interaction we call politics?

One clear area of critical contention concerns exactly this question of the ethical-political significance of identification. Should certain previously abjected identifications be recuperated, sanctioned, or promoted politically? Is a program of fostering identifications across culturally constructed lines of race, ethnicity, class, gender, sexuality, religion, or citizenship a viable political strategy? Barbara Harlow has suggested that "'identification with' is not a 'personal moral duty' but a political choice." For Harlow, the practice of cross-identification, specifically with the struggle of oppressed social groups, becomes an urgent political imperative whenever the dominant ideology invokes a discourse of natural boundaries to categorize, regulate, and patrol social identities. Douglas Crimp makes a similar argument in support of identifications across identities in his discussion of the difficulties and exigencies involved in building effective political coalitions. Crimp notes that emerging social movements like ACT UP and Queer Nation are already formed and shaped by prior and competing identifications with other political groups (Black Power, feminism, third world liberation, Gay Liberation Front). While acknowledging the erratic and eccentric nature of identifications ("there is no predicting what identifications will be made and which side of an argument anyone might take"), Crimp sees an immediate political return in beginning "to rethink identity politics as a politics of relational identities, of identities formed through political identifications that constantly remake those identities."[24]

Other cultural critics see considerable risks in constructing a social movement on the precarious ground of psychical fantasy, not the least among them the danger posed by the imperializing character of many cross-cultural identifications. In *Writing Diaspora: Tactics of Intervention in Contemporary Cultural Studies*, Rey Chow analyzes the violent fantasies of displacement that underlie our nostalgic identifications with cultural others—fantasy idealizations that enact imaginary usurpations.

"Our fascination with the native, the oppressed, the savage, and all such figures," Chow writes, masks "a desire to hold onto an unchanging certainty somewhere outside our own 'fake' experience. It is a desire for being 'non-duped,' which is a not-too-innocent desire to seize control." Doris Sommer refers to this problem as the "presumption of identification"—overly sentimental or self-indulgent identifications that reflect "the ultimate violence . . . appropriation in the guise of an embrace." For Sommer, the "risk of identification" may not always be worth the taking; in fact, identification, and the symbolic violence it can wield, poses the very trap to be avoided in the already perilous process of forging political alliances across identities.[25] Of course, read psychoanalytically, *every* identification involves a degree of symbolic violence, a measure of temporary mastery and possession. As we will see in chapter 1, identification operates on one level as an endless process of violent negation, a process of killing off the other in fantasy in order to usurp the other's place, the place where the subject desires to be.

If a certain element of colonization is structurally indispensable to every act of interiorization, then the question of how the power of identification might be utilized in the service of a nonviolent, progressive-thinking politics becomes an extremely complicated issue. Judith Butler's *Bodies That Matter* offers an intelligent way out of this dilemma, avoiding the uncritical promotion of a politics that would encourage the assumption of new and different identifications without examining the exclusionary procedures that institute those identifications in the first place. Butler's work provides not a simple endorsement of the proliferation of identificatory possibilities but a considered evaluation of the ways in which any identification is purchased through a set of constitutive and formative exclusions.[26] But problems remain for the theorization and practice of a "politics of identification." Perhaps the most serious difficulty with designing a politics around identification is the fact that the unconscious plays a formative role in the production of identifications, and it is a formidable (not to say impossible) task for the political subject to exert any steady or lasting control over them. Given the capacity of identifications continually to evolve and change, to slip and shift under the weight of fantasy and ideology, the task of harnessing a complex and protean set of emotional ties for specific social ends cannot help but to pose intractable problems for politics. This is not to say, however, that identification has nothing to do with politics. For psychoanalysis, identification defines the very nature of the political

bond. Freud's *Group Psychology and the Analysis of the Ego* (1921) understands politics as a question of the individual subject's relation to the social group. To the extent that every social group is constituted for Freud through identification between its members, through social ties based upon a perception of similarity and shared interests, there can be no politics without identification.[27]

But Freud's description of the political bond as the product of a conscious identification appears to contradict his previous insistence that identifications are involuntary productions rooted in the domain of the unconscious. Are identifications conscious or unconscious? active or passive? immediate or belated? creative or lethal? These largely unresolved tensions in the psychoanalytic literature on identification continue to structure the various contemporary usages of the term, usages that cover the widest possible spectrum of critical interpretations. Some theorists view every identification as a cross-identification, while others read cross-identification as less a psychological given than a social mandate; some see identification as already in play and therefore relatively effortless, while others see identification as dangerous and difficult; some understand identification as a form of regressive nostalgia, while others view identification as a means of achieving real psychological change; and some highlight identification's tendency to align and to shore up identity, while still others emphasize identification's capability for dislocation and destabilization. Such pervasive contradictions are telling, for the very notion of identification (a process of substitution and displacement) puts these divisions into question. Identification is both voluntary and involuntary, necessary and difficult, dangerous and effectual, naturalizing and denaturalizing. Identification is the point where the psychical/social distinction becomes impossibly confused and finally untenable.

Accordingly, any politics of identity needs to come to terms with the complicated and meaningful ways that identity is continually compromised, imperiled, one might even say *embarrassed* by identification. For example, how might it change our understanding of the political, of the very nature and significance of the social tie, to know that every identity claim ("I am not another") is based upon an identification ("I desire to be another")? How might it change our understanding of identity if we were finally to take seriously the poststructuralist notion that our most impassioned identifications may incorporate nonidentity within them and that our most fervent disidentifications may already harbor the very identity they seek to deny? How, finally, might it change our under-

standing and practice of identity politics if the "identity" in question is always already an "improbable" one, always already an "eccentric ... distorted (displaced, dissimulated) subject in all sorts of identificatory roles and figures"?[28]

This book is largely an attempt to think through these questions by taking a closer look at the concept of identification, returning directly to the modernist discourse that has given identification its peculiar explanatory power—psychoanalysis. In the following pages I am primarily interested in Freud's work, where identification as an analytic concept is first systematically formulated, but the voices of some of Freud's most spirited revisionists can also be heard in these pages as they engage with the problem of identification across a range of disciplines, most prominently literature, philosophy, film theory, cultural studies, queer theory, and feminism. In a sense, this project takes a step backwards to situate the contemporary interest in identification in the intellectual and cultural context that first gave the idea its theoretical import and relevance. I proceed from the premise that the notion of identification has a history—a philosophically consequential history—and that the term inevitably carries with it a host of theoretical problems, ideological incoherencies, and conceptual difficulties.

One such conceptual difficulty is the long-standing confusion surrounding the question of identification's relation to its theoretical other, desire.[29] Freud distinguishes identification (the wish to be the other) from sexual object-choice (the wish to have the other). For Freud, desire for one sex is always secured through identification with the other sex; to desire and to identify with the same person at the same time is, in this model, a theoretical impossibility. These two psychical mechanisms, which together form the cornerstone of Freud's theory of sexual identity formation, work in tandem to produce a sexually marked subject. Yet as the following chapters will demonstrate in greater detail, psychoanalysis's basic distinction between wanting to be the other and wanting to have the other is a precarious one at best, its epistemological validity seriously open to question. Speaking of Freud's first full-length case history of hysterical identification, Parveen Adams challenges whether it is really possible to deduce so readily from Dora's identifications whom she might desire, or, conversely, whether Dora's sexual object-choices tell us much of anything at all about how she might identify. Why assume, in other words, that any subject's sexuality is structured in terms of pairs?[30]

Marcia Ian refers to the polarization of identification and desire as "one of Freud's great mistakes."[31] For Freud, the mistake is a convenient one. It allows him to theorize *homo*sexual desire as inherently contradictory, since desire can only be for the other and never for the same. Other markers of difference—race, ethnicity, class, nationality, language, age—are all uncritically subsumed to that of biological sex, itself a sufficiently diverse, inconstant, and mutable category to belie the very presumption of "sameness." Same-sex desire is explained away by recourse to the concept of identification: if two people of the same sex do desire one another, it is because one of the two has cross-identified with the opposite sex. For Freud, the story of homosexual desire is always a displaced form of heterosexuality. Interestingly, the identification/desire opposition does even more than rule out the possibility of homosexual desires. As Ian notes, it also denies the possibility of heterosexual identifications, "as if a man and a woman must automatically desire each other as other, and never respond to each other as in some way the 'same.'"[32]

Even Freud is unable to keep desire and identification completely straight. In "Mourning and Melancholia" (1917) Freud defines identification as a form of desire, "a preliminary stage of object-choice . . . the first way."[33] More recently, Borch-Jacobsen has described desire as a type of identification: "desire is precisely a *desire to be a subject*."[34] What is identification if not a way to assume the desires of the other? And what is desire if not a means of becoming the other whom one wishes to have? The critical displacement of the identification/desire opposition, evident even in Freud's own work, opens up a new way of thinking about the complexity of sexual identity formations outside the rigid thematics of cultural binaries.

Given the fundamental indissociability of identification and desire, the question that insistently poses itself is why Freud works so hard to keep them apart in the first place. Chapter One addresses this question both by looking at those specific textual instances where Freud calls up the notion of identification, as well as by closely examining the changes this notion undergoes from its earliest appearance in Freud's correspondence with Wilhelm Fliess, to its last invocation in a posthumously published journal note. I will argue that Freud summons and reworks the concept of identification to keep firmly in place a normative theory of sexuality based upon oedipal relations. Identification is also the theoretical lynchpin Freud's theory of oedipality requires to keep the homosocial and the homosexual from collapsing back onto one another, even as this same

critical lever repeatedly threatens to undermine the very dialogics upon which such tactical distinctions are based in Freud's work. I am further interested in this opening chapter in tracking the precise metaphorizations Freud invokes to fashion identification into a rigorous scientific concept. The changes in figuration that mark the evolution of the theory of identification over a forty year period tell us much about the institutional process of constructing an epistemological object of inquiry (in this case, "sexuality") and about the challenges psychoanalysis inevitably faced in attempting to account, scientifically, for the complexities of human relations by adopting a thoroughly tropological model.

I begin then with the claim that whatever else psychoanalysis may be, it is also something of a mixed metaphor system. Subsequent chapters of *Identification Papers* are organized around a group of metaphors and a series of theoretical questions about them. Freud elaborates his theory of identification through three principal figures: gravity, ingestion, and infection. The three sections that follow the opening chapter address these figures in turn, pairing each metaphor with a reading of a selected cultural text. I have chosen for discussion those texts that seemed to me particularly interesting from the point of view of contemporary theoretical work on sexuality and difference: the psychoanalytic case history (gravity), the serial killing film (ingestion), and the girls' boarding school novel (infection). Chapter 2 analyzes the curious Newtonian rhetoric of falling that underwrites the psychoanalytic theory of female sexual inversion presented in Freud's final case history, "The Psychogenesis of a Case of Homosexuality in a Woman" (1920). Chapter 3 turns to a film text, Jonathan Demme's *The Silence of the Lambs* (1991), to explore the power that Freud's identificatory model of oral-cannibal incorporation continues to wield over contemporary cultural representations of gay male sexuality. And chapter 4 revives a forgotten novel of adolescent lesbian desire, Dorothy Strachey's *Olivia* (1949), to critique the infection model of identification that Freud elaborates through a reading of group hysteria in a hypothetical girls' boarding school. By staging a critical confrontation between psychoanalytic theory and these different types of cultural production, I hope to demonstrate how psychoanalysis itself constitutes a powerful cultural narrative that continues to shape, in both regulative and disruptive ways, representations of sexual identity.

The book's concluding chapter on Frantz Fanon poses questions about identification that Freud fails to ask, unveiling some of the cultural and political investments governing the psychoanalytic theory of

self-other relations. In Fanon's work the considerations that I have been posing throughout this study are raised in particularly powerful ways; his politically-informed psychoanalytic work clarifies how the matter of politics has haunted identification from the very beginning. Fanon asks us to remember the violence of identification, the material practices of exclusion, alienation, appropriation, and domination that transform other subjects into subjected others. Identification is not only how we accede to power, it is also how we learn submission. In colonial relations, identification can operate, at once, as the ontological privilege of the colonizer and the subjugated condition of the colonized. Racial identity and racist practice alike are forged through the bonds of identification. This final chapter not only places the psychoanalytic concept of identification within colonial history, it suggests that colonial history shapes the very terms in which psychoanalysis comes to understand the process of identification.

NOTES

1. Sigmund Freud, *An Outline of Psycho-analysis* (1940), *The Standard Edition of the Complete Psychological Works of Sigmund Freud*, trans. and ed. James Strachey, 24 vols. (London: The Hogarth Press, 1953–74), 23:193.

2. Jacques Lacan, *The Four Fundamental Concepts of Psycho-analysis*, ed. Jacques-Alain Miller, trans. Alan Sheridan (New York and London: W. W. Norton and Co., 1981), 243.

3. As early as 1909, in an essay called "Introjection and Transference," Sandor Ferenczi speaks of identification as an encounter with the ghosts of one's past. Ferenczi notes that as an object of the patient's transferences, the physician is simply one of many "revenants" in whom the patient finds once again "the vanished figures of childhood." See Ferenczi's *Sex in Psychoanalysis* (New York: Basic Books, 1950), 41. More recently, in a fascinating set of cultural readings on the failure of introjection, Laurence Rickels represents the identificatory subject as a haunted transmitter of the dead. See Rickels' *The Case of California* (Baltimore and London: The Johns Hopkins University Press, 1991).

4. Jean-Luc Nancy, *The Birth to Presence*, trans. Brian Holmes (Stanford: Stanford University Press, 1993), 10.

5. Mikkel Borch-Jacobsen, *The Freudian Subject*, trans. Catherine Porter (Stanford: Stanford University Press, 1988). Borch-Jacobsen notes that the subject's place, in fantasy, is always that of the other (18). See also Borch-Jacobsen's *Lacan: The Absolute Master*, trans. Douglas Brick (Stanford: Stanford University Press, 1991) and *The Emotional Tie: Psychoanalysis, Mimesis, and Affect*, trans. Douglas Brick (Stanford: Stanford University Press, 1992).

6. Maurice Blanchot, *The Writing of the Disaster*, trans. Ann Smock (Lincoln and London: University of Nebraska Press, 1986), 13. For more of Blanchot's theory of alterity, see *The Infinite Conversation*, trans. Susan Hanson (Minneapolis and London: Minnesota University Press, 1993).

7. Alexandre Kojève, *Introduction to the Reading of Hegel* (New York and London: Basic Books, 1969). Mikkel Borch-Jacobsen analyzes at length the importance of Kojève and his teaching for postwar French thought in *Lacan: The Absolute Master*. For more on the influence of Hegel on contemporary French philosophy, see Judith Butler's *Subjects of Desire:*

Hegelian Reflection in Twentieth-Century France (New York: Columbia University Press, 1987), and Michael Roth, *Knowing and History: Appropriations of Hegel in Twentieth-Century France* (Ithaca: Cornell University Press, 1988).

8. One might consult, for example, Philippe Lacoue-Labarthe, *Typography: Mimesis, Philosophy, Politics*, ed. Christopher Fynsk (Cambridge, MA: Harvard University Press, 1989) and *The Subject of Philosophy*, ed. Thomas Trezise, trans. Trezise et. al. (Minneapolis and London: Minnesota University Press, 1993); Jean-Luc Nancy, *The Inoperative Community*, ed. Peter Connor (Minneapolis and London: Minnesota University Press, 1991); Emmanuel Levinas, *Time and the Other and Additional Essays*, trans. Richard A. Cohn (Pittsburgh, PA: Duquesne University Press, 1987), and *Otherwise than Being or Beyond Essence*, trans. Alphonso Lingis (Boston: M. Nijhoff, 1981); Luce Irigaray, *An Ethics of Sexual Difference*, trans. Carolyn Burke and Gillian C. Gill (Ithaca: Cornell University Press, 1993); René Girard, *Deceit, Desire, and the Novel: Self and Other in Literary Structure*, trans. Yvonne Freccero (Baltimore and London: Johns Hopkins University Press, 1965); Hélène Cixous, *"Coming to Writing" and Other Essays*, ed. Deborah Jenson, trans. Sarah Cornell et. al. (Cambridge, MA: Harvard University Press, 1991); and Jacques Derrida, *Psyché: Inventions de l'autre* (Paris: Galilée, 1987).

9. Identification is only one philosophical approach among many to the problem of alterity. It is beyond the ambitions of this book to track the many different treatments of otherness outside the tradition of psychoanalytic thought, a project that belongs more properly to a sociology of knowledge. Such a study might begin by looking to the work of Pierre Bourdieu.

10. It enacts what Jane Gallop has called in another context a "massive reading transference." See *Reading Lacan* (Ithaca and London: Cornell University Press, 1985), 30.

11. For a more detailed historical account, see Adam Crabtree, *From Mesmer to Freud: Magnetic Sleep and the Roots of Psychological Healing* (New Haven: Yale University Press, 1993), and Léon Chertok and Isabelle Stengers, *A Critique of Scientific Reason: Hypnosis as a Scientific Problem from Lavoisier to Lacan*, trans. Martha Noel Evans (Stanford: Stanford University Press, 1992). Chertok and Stengers cast this paradigm shift as a tension between the histories of "heart" and "reason." Ruth Leys studies the evolution of a new concept of mimesis in a reading of the imitation-suggestion school of American sociology. Following Borch-Jacobsen, Leys highlights the "antimimetic turn" in the modern theory of mimesis—the assumption that "there must be a subject who precedes mimesis and out of whom identification or imitation is produced." The ontological self is smuggled back into the mimetic paradigm under cover of this antimimetic requirement. See "Mead's Voices: Imitation as Foundation, or, The Struggle Against Mimesis," *Critical Inquiry* 19:2 (Winter 1993): 285. See also Leys' "The Real Miss Beauchamp: Gender and the Subject of Imitation," in *Feminists Theorize the Political*, eds. Judith Butler and Joan W. Scott (New York and London: Routledge, 1992): 167–214.

12. In "Why War?" (1933), Freud writes to Albert Einstein: "It may perhaps seem to you as though our theories are a kind of mythology and, in the present case, not even an agreeable one. But does not every science come in the end to a kind of mythology like this?" *Standard Edition* 22:211.

13. The full passage reads as follows: "What are transferences? They are new editions or facsimiles of the impulses and phantasies which are aroused and made conscious during the progress of the analysis; but they have this peculiarity, which is characteristic for their species, that they replace some earlier person by the person of the physician. . . . Some of these transferences have a content which differs from that of their model in no respect

whatever except for the substitution. These then—to keep to the same metaphor—are merely new impressions or reprints." See Freud's *Fragment of an Analysis of a Case of Hysteria* (1905), *Standard Edition,* 7:116.

14. Freud, *Beyond the Pleasure Principle* (1918), *Standard Edition* 18:60. Peter Brooks, in glossing this same passage, reads the type of figuration in question as "catachresis"—the trope that displaces the literal and the figurative, the factual and the rhetorical. See *Psychoanalysis and Storytelling* (Oxford: Blackwell, 1994), 41–42.

15. Lacoue-Labarthe makes this point eloquently in his investigation of philosophy's indebtedness to literature. See Lacoue-Labarthe's reading of fables in *The Subject of Philosophy*, 1–13. The interpretation of psychoanalysis as narratology is a position generally associated with the work of Peter Brooks. See Brooks's *Reading for the Plot: Design and Intention in Narrative* (Cambridge, MA: Harvard University Press, 1984), and *Body Work: Objects of Desire in Modern Narrative* (Cambridge, MA: Harvard University Press, 1993).

16. Freud, *Fragment of an Analysis,* 8–9.

17. Freud, presenting himself as "a medical man," is eager to distinguish himself in his first case history from "a man of letters": "I must now turn to consider a further complication to which I should certainly give no space if I were a man of letters engaged upon the creation of a mental state like this for a short story, instead of being a medical man engaged upon its dissection. The element to which I must now allude can only serve to obscure and efface the outlines of the fine poetic conflict which we have been able to ascribe to Dora. This element would rightly fall a sacrifice to the censorship of a writer, for he, after all, simplifies and abstracts when he appears in the character of a psychologist. But in the world of reality, which I am trying to depict here, a complication of motives, an accumulation and conjunction of mental activities—in a word, overdetermination—is the rule" (*Fragment of an Analysis,* 59). Analyzing at greater length Freud's "sly unliterariness," Steven Marcus has noted that "nothing is more literary—and more modern—than the disavowal of all literary intentions." See "Freud and Dora: Story, History, Case History," in *In Dora's Case: Freud–Hysteria–Feminism,* eds. Charles Bernheimer and Claire Kahane (New York: Columbia University Press, 1985), 68. We might remember, in this regard, that many years later Freud begins his study *Moses and Monotheism* (1939) under the working title, *Moses the Man, A Historical Novel.* For more on the complicated relation of psychoanalysis and literature, see *Literature and Psychoanalysis: The Question of Reading: Otherwise,* ed. Shoshana Felman (Baltimore and London: The Johns Hopkins University Press, 1982).

18. The following group of texts represents only a small selection of an extensive body of work that stages a productive encounter between feminism and psychoanalysis: Teresa Brennan, ed., *Between Feminism and Psychoanalysis* (New York and London: Routledge, 1989); Richard Feldstein and Judith Roof, eds. *Feminism and Psychoanalysis* (Ithaca and London: Cornell University Press, 1989); Jane Gallop, *The Daughter's Seduction: Feminism and Psychoanalysis* (Ithaca: Cornell University Press, 1982); Marcia Ian, *Remembering the Phallic Mother: Psychoanalysis, Modernism, and the Fetish* (Ithaca and London: Cornell University Press, 1993); Luce Irigaray, *Speculum of the Other Woman,* trans. Gillian C. Gill (Ithaca: Cornell University Press, 1985); Jacqueline Rose, *Sexuality in the Field of Vision* (London: Verso, 1986); Hortense Spillers, "Mama's Baby, Papa's Maybe: An American Grammar Book," *Diacritics* (Summer 1987): 65–81; Gayatri Chakravorty Spivak, "Echo," *New Literary History* 24:1 (Winter 1993): 17–43, and "Psychoanalysis in Left Field and Fieldworking: Examples to Fit the Title," in Sonu Shamdasani and Michael Münchow, eds., *Speculations after Freud: Psychoanalysis, Philosophy, Culture* (New York and London: Routledge, 1994), 41–76; Madelon Sprengnether, *The Spectral Mother: Freud, Feminism,*

and Psychoanalysis (Ithaca and London: Cornell University Press, 1990); and Elizabeth Wright, ed., *Feminism and Psychoanalysis: A Critical Dictionary* (Oxford: Blackwell, 1992).

19. Eve Kosofsky Sedgwick, *Epistemology of the Closet* (Berkeley and Los Angeles: University of California Press, 1990), 61. See also *Between Men: English Literature and Male Homosocial Desire* (New York: Columbia University Press, 1985), and *Tendencies* (Durham: Duke University Press, 1993).

20. Judith Butler, *Bodies That Matter* (New York and London: Routledge, 1993), 112. See also *Gender Trouble: Feminism and the Subversion of Identity* (New York and London: Routledge, 1990).

21. Indeed, identification has been so much at the center of contemporary film theory that a recent book devotes itself entirely to the goal of displacing its hold in favor of a less speculative theory of reading. See David Rodowick, *The Difficulty of Difference: Psychoanalysis, Sexual Difference, and Film Theory* (New York and London: Routledge, 1991). Jackie Stacey also argues that theories of cinematic identification focus too narrowly on the psychical connections between stars and their audiences, ignoring the social context of the cinema. See Stacey's *Star Gazing: Hollywood Cinema and Female Spectatorship* (New York and London: Routledge, 1994), especially 126–75. These critiques, while generally compelling, tend to overlook the ways in which identifications operate precisely *as* social relations; the psychoanalytic theory of identification is, from the outset, a theory of sociality, an analysis of the role of culture in the shaping of identity.

22. Mary Ann Doane, *The Desire to Desire: The Woman's Film of the 1940s* (Bloomington and Indianapolis: Indiana University Press, 1987), and *Femmes Fatales: Feminism, Film Theory, Psychoanalysis* (New York and London: Routledge, 1991). See also Doane's "Misrecognition and Identity," in *Explorations in Film Theory: Selected Essays from Ciné-Tracts*, ed. Ron Burnett (Bloomington and Indianapolis: Indiana University Press, 1991), 15–25.

23. Kaja Silverman, *Male Subjectivity at the Margins* (New York and London: Routledge, 1992), and *The Acoustic Mirror: The Female Voice in Psychoanalysis and Cinema* (Bloomington and Indianapolis: Indiana University Press, 1988).

24. Barbara Harlow, "Sites of Struggle: Immigration, Deportation, Prison, and Exile," in *Criticism in the Borderlands: Studies in Chicano Literature, Culture, and Ideology*, eds. Héctor Calderón and José David Saldívar (Durham: Duke University Press, 1991), 163. Douglas Crimp, "Right On, Girlfriend!" in *Fear of a Queer Planet: Queer Politics and Social Theory*, ed. Michael Warner (Minneapolis: University of Minnesota Press, 1993), 316 and 313. Elin Diamond, in a reading of playwright Adrienne Kennedy's work, also provides a compelling argument in favor of deploying identification for political ends. Diamond sees the theatricalization and politicization of one's own identifications as a radically transformative process; for Diamond, the capability of identification to override the constraints of identity gives this psychical process enormous political efficacy. See Diamond's "Rethinking Identification: Kennedy, Freud, Brecht," *Kenyon Review* 15:2 (1993): 86–99.

25. Rey Chow, *Writing Diaspora: Tactics of Intervention in Contemporary Cultural Studies* (Bloomington and Indianapolis: Indiana University Press, 1993), 53; see also Chow's *Woman and Chinese Modernity: The Politics of Reading Between West and East* (Minneapolis: University of Minnesota Press, 1991). Doris Sommer, "Resistant Texts and Incompetent Readers," *Poetics Today* 15:4 (Winter 1994), 543. A further danger posed by thinking the political in strictly psychical terms is what Gayatri Spivak identifies, in *Outside in the Teaching Machine,* as the problem of making a fetish of identity (New York and London: Routledge, 1993), 65.

26. See especially Butler's "Phantasmatic Identification and the Assumption of Sex," 93–119.

27. Sigmund Freud, *Group Psychology* (1921) 18: 67–143. An excellent discussion of these issues—what the political does to psychoanalysis, and what psychoanalysis does to the political—can be found in Philippe Lacoue-Labarthe's and Jean-Luc Nancy's "The Unconscious Is Structured like an Affect" (Part I of "The Jewish People Do Not Dream"), *Stanford Literature Review* 6:2 (Fall 1989): 191–209, and "From Where Is Psychoanalysis Possible?" (Part II of "The Jewish People Do Not Dream"), *Stanford Literature Review* 8:1–2 (Spring–Fall 1991): 39–55. I would suggest, as a corrective to Freud, that it may be more useful, and more accurate, to think of politics as originating not in proximity but in distance, not in similitude but in difference, or in the difference that makes a fantasy of similitude possible. To be "like" the other is to be different from the other, to be precisely *not* the same. Identification is predicated upon the *unlikeness* of the self and the other it emulates; it works simultaneously to construct and to displace identity by incorporating nonidentity within it. Politics thus emerges not out of sameness but out of the noncoincidence between self and other that gives rise to a desire for an illusory sameness.

28. Borch-Jacobsen, *The Freudian Subject*, 54.

29. Freud only infrequently uses the word "desire" in his work; desire is more Lacan's term than Freud's. As Samuel Weber has pointed out in *Return to Freud: Jacques Lacan's Dislocation of Psychoanalysis*, trans. Michael Levine (Cambridge, UK: Cambridge University Press, 1991), the German word for desire, *Begehren*, is not even included in the index to the German edition of Freud's collected works. Instead Freud uses words like wish, libido, eros, drive, and excitation to connote what Lacan will later gather together under the single category of *désir* (120–21). I will be using desire in this broader Lacanian sense whenever referring to the entire complex of concepts that Freud opposes to identification.

30. Parveen Adams, "Per Os(cillation)," *Camera Obscura* 17 (May 1988): 7–29. Wayne Koestenbaum addresses, in a more personal vein, this same problem of organizing all sexuality around the polarities of identification and desire. Speaking of his own early fascination with movie musical divas, Koestenbaum writes: "I spent much of my childhood trying to distinguish identification from desire, asking myself, 'Am I in love with Julie Andrews, or do I think I *am* Julie Andrews?' I knew that to love Julie Andrews placed me, however vaguely, in heterosexuality's domain; but to identify with Julie Andrews, to want to be the star of *Star!*, placed me under suspicion." *The Queen's Throat: Opera, Homosexuality, and the Mystery of Desire* (New York: Poseidon Press, 1993), 18. For a useful discussion of autobiography and identification, see also Biddy Martin's "Lesbian Identity and Autobiographical Differences," in *Life/Lines: Theorizing Women's Autobiography,* eds. Bella Brodzki and Celeste Schenck (Ithaca and London: Cornell University Press, 1988), 77–103.

31. Marcia Ian, *Remembering the Phallic Mother*, 4.

32. Ibid.

33. Freud, "Mourning and Melancholia" (1917) 14:249.

34. Borch-Jacobsen, *The Emotional Tie*, 24. In *The Freudian Subject*, Borch-Jacobsen explains: desire "does not aim essentially at acquiring, possessing, or enjoying an object; it aims ... at a subjective identity. Its basic verb is 'to be' (to be like), not 'to have' (to enjoy)" (28).

I

IDENTIFICATION PAPERS

FREUD'S PAPERS ON IDENTIFICATION begin as early as the correspondence to Wilhelm Fliess in the late 1890s and conclude forty years later with a posthumously published journal note. In a professional career comprised of several hundred published pieces, ranging from letters, reviews, and prefaces to scientific abstracts, case histories, and analytical papers, Freud never allocated to identification a book or monograph of its own (Lacan was later to devote a whole seminar to the problem). Its most sustained treatment comes in Chapter Seven of *Group Psychology and the Analysis of the Ego*, but, even in this focussed investigation of group ties, what may be psychoanalysis's most original idea commands far less rigorous attention than a host of other familiar Freudian concepts fundamentally dependent upon it, concepts including oedipality, fantasy, repression, castration, and ambivalence. The theory of identification, one of Freud's most important contributions to twentieth-century thought, is also one of the most imperfectly understood—not least of all by Freud himself.

Of Sponges and Condoms

Two of Freud's earliest references to identification [*Identifizierung*] appear in some fragmentary case notes on hysterical neurosis, contained in a letter, dated May 2, 1897, to the ear, nose, and throat doctor, Wilhelm Fliess. Freud entitles the first fragment "The Part Played by Servant-Girls":

An immense load of guilt, with self-reproaches (for theft, abortion, etc.), is made possible [for a woman] by identification with these people of low morals, who are so often remembered by her as worthless women connected sexually with her father or brother. And, as a result of the sublimation of these girls in phantasies, most improbable charges against other people are made in these phantasies. Fear of prostitution [i.e. of becoming a prostitute] (fear of being in the street alone), fear of a man hidden under the bed, etc., also point in the direction of servant-girls. There is tragic justice in the fact that the action of the head of the family in stooping to a servant-girl is atoned for by his daughter's self-abasement.

The second note, which immediately follows this class narrative of guilt, shame, and atonement, is called, simply, "Mushrooms":

There was a girl last summer who was afraid to pick a flower or even to pull up a mushroom, because it was against the command of God, who did not wish living seeds to be destroyed.—This arose from a memory of religious maxims of her mother's directed against precautions during coitus, because they mean that living seeds are destroyed. "Sponges" (Paris sponges) were explicitly mentioned among these precautions. The main content of her neurosis was identification with her mother.[1]

Both are stories of feminine identification; both focus upon women's sexual fears; both allude to the possible consequences of heterosexual intercourse for women. But more importantly, both fragments revolve around the question of pregnancy—in one case its termination, in the other its prevention. But what does pregnancy have to do with identification? How do the material practices of abortion and contraception help Freud to pose the question of psychical incorporation? Why does a German story of identification begin with a Paris sponge?

The story of identification properly begins with Freud's trip to Paris in 1885 and his encounter with the Parisian neurologist, Jean Martin Charcot. The seed of Freud's earliest speculations on the sexual etiology of hysteria is planted by Charcot, whose use of hypnosis to treat hysteria among charity patients in a large teaching hospital first alerts Freud to the possibility of a repressed sexual trauma behind the hysterical symptom. This "seed" of intellectual discovery comes to Freud through the penetrating intellect of a man whom he considered a surrogate father. The figure of the living seed, alluded to in Freud's letter to Fliess, actually appears first in a letter to Freud's fiancée, Martha Bernays, on the subject of Charcot's professional seduction: "Whether the seed will

one day bring forth fruit, I do not know; but that no other human being has ever acted on me in this way I know for certain."[2] That Freud experienced his discipleship under the famous Parisian physician as a metaphorical impregnation is made clearer still by the birth of Freud's first son whom he named Jean Martin, after Charcot. Equally influential for Freud's early thinking on the problem of hysteria and its possible links to sexual reproduction was Josef Breuer, another successful physician and substitute father figure for Freud. The details of Breuer's treatment of Anna O. (the founding case of psychoanalysis) convinced Freud that hysteria was fundamentally a question of unconscious imitation. Declaring that she was pregnant with Dr. B's child, Bertha Pappenheim's hysterical spasms and convulsions reproduced in fantasy the act of reproduction itself. Historically and theoretically, psychoanalysis begins with a performance of an imaginary birth.

But there is a third sense in which psychoanalysis might be said to be the progeny of a hysterical pregnancy. At the time Freud writes his letter to Fliess on the subject of Paris sponges, he was beginning a three-year analysis of his own hysteria triggered by the death of his father. Freud was later to speculate that his hysterical symptoms, which included a nose infection, headache, and fits of melancholia, may have also issued from a repressed homosexual desire for his friend Fliess, the nose doctor.[3] But initially Freud is content to attribute his professional anxieties to a feminine identification, the very precondition, in his later writings, for a male homosexual object-choice. A letter to Fliess dated November 14, 1897, opens with a "birth announcement": "It was on November 12, a day dominated by a left-sided migraine, ... that, after the frightful labour-pains of the last few weeks, I gave birth to a new piece of knowledge."[4] For Freud, pregnancy is apparently only a state of mind, and femininity a position any sexed subject can inhabit.

The pregnant woman is in many ways the perfect figure for a psychoanalytic model of identification based upon incorporation. As Otto Fenichel comments, pregnancy represents the "full realization of identificatory strivings to incorporate an external object bodily into the ego and to enable that object to carry on an independent existence there."[5] But it is another follower of Freud's, Helene Deutsch, who brings this idea to term. Deutsch elaborates an entire psychology of women on the theoretical ground of what we might call *in utero identification*, the idea that the fetus occupies the interiorized position of a "second ego" or "ego in miniature" in relation to the pregnant woman who is "both

mother and child at the same time." The biological processes of pregnancy and parturition offer ready-made models for the psychical work of identification, defined by Deutsch, Fenichel, and Freud as the ego's introjection and eventual expulsion of the object.[6]

And yet the two working papers in the May 1897 Fliess correspondence are less about pregnancy *per se* than its termination or prevention. Abortion and contraception are the occasional subtexts for the two feminine identifications Freud describes: a bourgeois daughter's identification with a servant-girl, and a young girl's identification with her god-fearing mother. In this second case, the girl's neurotic fear of picking flowers or mushrooms is related to a specific maternal instruction prohibiting the use of contraceptives. The linguistic clue that unlocks the case for Freud is the German word for mushroom, *Schwämme*, which also means sponge—a popular form of birth control for European women. Identifying herself with her mother, the girl's irrational fear of *Schwämme* is based upon an anxious concern for her own conception and survival. But the story does not terminate here. In Freud's reading of the neurosis, the girl's phobic reaction to the mushroom/sponge operates as a diplaced terror and fascination with what it implicitly assumes: sexual intercourse and pregnancy. In a later fragment on the same case entitled "Wrapping-Up," Freud notes that "the girl insisted that any objects handed to her must be wrapped up. (Condom)." Discontented with his initial reading which discovers the source of the girl's neurotic behavior in the repudiation of birth control, Freud locates it instead in her unconscious *obsession* with contraception. It will come as no surprise that Freud's personal and professional views on birth control were staunchly conservative. Throughout his life Freud considered the practice of birth control as one of the prime etiological factors in the production of anxiety neurosis. To the degree that contraceptives interfered with the full gratification of sexual pleasure, Freud believed that the use of a sponge or a condom during heterosexual intercourse predisposed the subject to hysteria.[7]

Through a similar logic, termination of a pregnancy was also identified by Freud as one of the causes of hysterical identification and neurotic symptom formations, this time through the "intense load of guilt" he assumed the woman must carry in place of the aborted child. Heavy with remorse, the woman identifies with the servant-girls of her childhood whom she remembers as "worthless women connected sexually with her father or brother." In unconsciously identifying herself with the

household servants who have been sexually exploited by the male members of her family, the woman enacts in fantasy her own incestuous, oedipal desires, while at the same time atoning for her father's sins through her "self-reproaches" and "self-abasement." Both in "The Part Played by Servant-Girls" and in "Mushrooms," identification is fundamentally a question of *lowness*: "people of low morals," "fear of a man hidden under the bed," a father "stooping to a servant-girl," a "daughter's self-abasement," a "flower," a "mushroom," a "seed." From the very beginning, identification is understood as a problem of the ground, rather vaguely associated, in "The Part Played By Servant-Girls," with the gravitational pull of sublimation. Although a fairly pervasive figure in the papers on identification, the trope of gravity is nonetheless almost entirely buried. Unlike Freud's other two central metaphors for identification (ingestion and infection), which each receives extended analysis, the metaphor of gravity remains submerged in Freud's work, undertheorized and largely unnoticed. It is as if the conceptualization of identification as what is below consciousness obeys its own figurative logic and stays just beneath the surface of Freud's prose, readable only through its symptomatic materializations.

Identification also operates along a certain class register in "The Part Played by Servant-Girls." Unlike Freud's later discussions of cross-class identifications between women, cases that tend to focus mainly on a servant's erotic ambitions to kill off the mistress and to take her place with the master,[8] this early narrative stages a different scenario: a middle-class daughter's identification with rival servant-girls who in the past have assumed the mother's place with the father, the very place that the daughter herself now unconsciously wishes to occupy. The bourgeois woman who identifies with "people of low morals" is one of the first in a long line of Freudian hysterics. The earliest reference to *Identifizierung* in Freud's writings, preceding even the present fragmentary notes, helps to clarify the tenuous connections between class, identification, height, and falling that structure so many of Freud's texts on femininity. In an earlier letter dated December 17, 1896, Freud attempts to explain to Fliess the root mechanism of agoraphobia in women: "No doubt you will guess it if you think of 'public' women. It is the repression of the intention to take the first man one meets in the street: envy of prostitution and identification."[9] Freud also cites envy of street-walkers as the basis of another common phobia, fear of "falling out of the window," where the window is all that consciously remains of a sublimated identi-

fication with prostitutes. The phobia is based upon the repression of a particular image: "Going to the window to beckon a man to come up, as prostitutes do" (217). The two phobias in "The Part Played by Servant-Girls" become readable within the context of this earlier passage on cross-class identification. For Freud, the bourgeois woman's "fear of prostitution" and "fear of being in the street alone" are symptoms of a powerful unconscious identification with "fallen women."

When speaking of class identifications, we might recall that Freud personified psychoanalysis itself as a female domestic, objecting spiritedly when other analysts sought to elevate her to the status of a respectable lady. Writing to the American psychoanalyst James Jackson Putnam, Freud protests, "you make psychoanalysis seem so much nobler and more beautiful: in her Sunday clothes I scarcely recognize the servant who performs my household tasks." [10] For Freud, psychoanalysis is less a noble enterprise than a service profession based upon a crass money transaction. While it is tempting to suggest that Freud chose to open his medical practice on an Easter Sunday in 1886 to commemorate his boyhood affection for the Czech nanny who used to bring Freud to Catholic Church with her on Sundays, such an inference is immediately complicated by Freud's adult dislike for the Church of Rome and its official sanctioning of racial anti-Semitism. It seems truer to say that the economics of psychoanalytic practice provide the material ground of Freud's own anxious identification with his old Catholic nurse who routinely extorted money from Freud as a child. Several months after the servant-girl tale, Freud confesses in another letter to Fliess that "just as the old woman got money from me for her bad treatment of me, so to-day I get money for my bad treatment of my patients." [11] Freud's lifelong repudiation of the anti-Semitic caricature of Jewish professional men as unscrupulous, money-grubbing swindlers finds displaced inversion in the parallel Freud draws here between the practicing psychoanalyst and the larcenous Catholic servant woman of his childhood.

There is surely a whole book to be written on the matter of Freud's feminine identifications, unconscious identifications that cover an astonishing range of subjects, from pregnant women to pubescent girls, from maids to mistresses, from prostitutes to colleagues. [12] Freud's representation of the psychoanalyst as a working-class servant-woman signals an insecurity that appears to have plagued Freud throughout his career. In the demand for pecuniary reimbursement from the patient for a treatment that never promises a cure, how, Freud wonders, is the psychoana-

lyst any different from the dishonest Catholic nurse who demands recompense for her bad care of her charge or from the anti-Semite's Jew who swindles for financial profit? Worse still, in its extraction of money for specifically *sexual* services rendered, how is the practice of psychoanalysis any different than the profession of prostitution? Might not the bourgeois woman's "fear of prostitution" in "The Part Played By Servant-Girls" in some profound sense mirror Freud's own? By following the path of Freud's complicated cross-class, cross-gender, cross-ethnic identifications, we can perhaps begin to unravel the anxieties that imperfectly structure the "science" of psychoanalysis, both as a theory and as a practice.

A Supper Party

Freud's next major foray into the problem of identification comes wrapped up in a story of desire, or more accurately, a story of *aborted* desire. This story, included in *The Interpretation of Dreams* (1900), begins with a dream of an unfulfilled wish and concludes with Freud's virtuoso demonstration that even a forsaken wish can fulfill an unconscious desire. I speak, of course, of the dream of the abandoned supper party, a dream recounted to Freud by one of his cleverest patients, the witty butcher's wife:

> "I wanted to give a supper-party, but I had nothing in the house but a little smoked salmon. I thought I would go out and buy something, but remembered then that it was Sunday afternoon and all the shops would be shut. Next I tried to ring up some caterers, but the telephone was out of order. So I had to abandon my wish to give a supper-party."[13]

Behind the dream of the abandoned supper party is a trio of characters composed of a stout butcher, his plump wife, and the wife's skinny friend. It is a rather ordinary story of weight reduction and food consumption, of gastronomic craving and fastidious self-denial, of sexual jealousy and unconscious desire. Each member of this hysterical triangle has a wish: the butcher wishes to lose weight and so begins a program of dieting and exercise, vowing to refuse all dinner invitations; the butcher's wife has a love for caviar but curiously begs her husband not to give her any; and the skinny friend, who begrudges herself salmon no less than the butcher's wife foreswears caviar, wishes to grow stouter, inquiring of Freud's patient when she will host another dinner party.

Jealous of her husband's admiration for her friend, the butcher's wife is consoled by the knowledge that her friend is thin and her husband prefers plump. With this last morsel of information, Freud is able to reconstruct the logic of the dream work. The dream of the abandoned supper party can now be understood as the fulfillment of the wife's unconscious wish *not* to help her friend grow fatter and thus attract her husband even more. The wife's wish is that her husband's wish should not be fulfilled.

But there is more: the "I" of the supper party dream is really "she"— the friend and not the wife.[14] After all, Freud explains, it is smoked salmon, the friend's favorite dish, that figures in the dream, not the caviar favored by the butcher's wife. In her dream the butcher's wife has "put herself in her friend's place, ... identified herself with her friend" (149). The dream follows a hysterical thought process in which the dreamer establishes an identification with her rival by "creating a symptom—the renounced wish" (150). Freud summarizes the hysterical identification in exact terms: "my patient put herself in her friend's place in the dream because her friend was taking my patient's place with her husband and because she (my patient) wanted to take her friend's place in her husband's high opinion" (150–51). Once again, an analysis of hysteria leads Freud back to the idea of feminine identification, an idea that has already achieved for Freud a certain definitional centrality. For Freud, hysteria *is* feminine identification, even (as the example of his own hysteria attests) where only men are concerned.

The dream of the butcher's wife is one of the primal scenes of psychoanalytic interpretation; Freud's commentators return to it again and again to learn the lesson Freud himself learns from the dream analysis, the lesson of interpretation. For Jacques Lacan, the dream of the supper party is preeminently an allegory of desire and its difficult structuration. In "The Direction of the Treatment and the Principles of Its Power," Lacan takes another look at the fish symbolism of the butcher's wife's dream and reads in the exchange of salmon for caviar (friend for wife) a formula for desire *as such*: "desire is the desire of the Other."[15] The witty hysteric both wants and does not want caviar; her desire for caviar is "the desire of a woman who has everything, and who rejects precisely that" (261). The desire with which the butcher's wife identifies is her friend's desire, signified by the metaphoric dream substitution of a slice of smoked salmon for caviar. But why fish? In Lacan's interpretation, the hysteric's desire is always for the butcher's "pound of flesh" (265), his

fleshy member, his sliding signifier. "To be the phallus, if only a some-
what thin one. Was not that the ultimate identification with the signifier
of desire?" (262) For Lacan, the butcher with his wholesale meat is the
most important figure in the hysterical triangle. Lacan is the first to
ask: What does the butcher want? "Has he too, perhaps, not got a desire
that is somewhat thwarted, when everything in him is satisfied?" The
butcher, "the man of the slice of backside," has everything he ostensibly
desires in his plump wife, and yet he is drawn to the thin woman like a
fish to water. It is thus the husband's desire for the friend that becomes
the point of identification for the wife: "the woman identifies herself
with the man, and the slice of smoked salmon takes the place of the
desire of the Other" (262). In contrast to Freud's analysis, the Lacanian
reading situates the butcher at the end of the transferential circuit of
desire and unveils a masculine identification structuring the unfulfilled
wish fantasy.

Catherine Clément, in a clever piece called "No Caviar for the
Butcher," takes Lacan's theory of a masculine identification to its logical
Freudian conclusion. If the butcher's wife places herself in her husband's
position, then she must desire the other woman as her husband does.
Desire *of* the Other metonymically slides into desire *for* her: "in the
dream the slice of smoked salmon stands in the place of the friend and
hence it also stands for the desire for the friend, which goes unsatisfied."
This drama of triangulated desire involves more than a case of hetero-
sexual jealousy; the wife's identification with her husband's desire opens
up a space for a forbidden homoerotic object-choice. For Clément,
the hysteric's dilemma is specifically "'How can another woman be
loved?'",[16] a question weighted ultimately more in the direction of desire
than identification. The hysteric, in other words, asks not "How can I be
a woman?" but "How can I have one?" In Clément's reading, the ques-
tion of same-sex desire between women is irreducible to the question of
hysterical identification.

Cynthia Chase, in the most recent and most comprehensive rereading
of the dream of the abandoned supper party, interprets the dream as a
replay of primary narcissism and preoedipal desire. The shift in focus
from Freud to Lacan/Clément, "from *la belle bouchère*'s [the beautiful
butcheress's] heterosexual desire and Oedipal identification with her
friend, to her homosexual desire and 'pre-Oedipal' identification with
her husband,"[17] leads Chase to the conclusion that what we actually
have in the story of the beautiful butcheress is an allegory of the infant's

primary identification with the phallic mother: "*la belle bouchère* identifies with the *signifier* of her husband's desire, the phallus, and this is like the baby's identifying with the signifier of the mother's desire. As a story of the baby merges in with Lacan's story of *la belle bouchère*, it becomes a story of *la b.b.*" (WB, 1001). *La b.b.*'s identification with her husband's desire is thus a "recapitulation" (DI, 80) of her identification with the mother's phallic desire. Chase offers maternal sexuality as the governing topos of Freud's story of identification and desire, locating identification *in* desire—desire not strictly *for* but *of* the mother. The Kristevan image of the desiring woman as phallic mother provides Chase with an alternative psychical model for lesbian desire, one that locates the wife's desire for her friend in a masculine identification with her husband that replays an earlier "primordial" relation to the preoedipal phallic mother.

Chase is herself disturbed by the consequences of such a reading, a reading that posits identification with the phallus as the inevitable precondition of female subjectivity. As Chase usefully formulates the problem: "How could the notion of a necessary identification with the phallus or even the mere identification of the phallus as the signifier of desire form part of a feminist understanding of desire and meaning?" (DI, 66–67) How, indeed, can such a question even be posed without capitulating in advance to the presumption of a "*necessary* identification with the phallus"? Chase fully understands the risk involved in reclaiming the phallus for and as the mother's desire, but she takes it anyways, "for love of *la b.b.*" (DI, 67).[18] In many ways it is a risk worth taking: Chase's retelling of the story of *la b.b.* is by far the wittiest of them all, the most adventurous and even audacious in its reappropriation of the phallus for women. And yet, where lesbian desire is concerned, it is the same old story—a narrative of maternal care and female narcissism, of masculinization and preoedipalization. How does the project to uncover the "preoedipal dimension" of both the story of the beautiful butcheress and the case of Dora (DI, 80) differ in any significant way from Freud's definition of lesbian desire as a woman's unresolved preoedipal attachment to the phallic mother? How does the interpretation of *la belle bouchère* as "*la b.b.*," and the coordinated reading of the wife's desire for her female friend as the replaying of a narcissistic relation to the maternal, advance us beyond Freud's understanding of lesbianism, articulated in "Femininity," as two women "who play the parts of mother and baby with each other as often and as clearly as those of husband and wife"?[19] Is it possible to pose the question of desire between women outside the

identity positions that in fact each of these readings offers—the twin poles of masculine identification and infantile preodipalization? In short, does the dream of the butcher's wife have any other stories to tell?

We might begin by returning to Freud and addressing one component of the story that all the commentaries overlook, the question of the butcher's identifications. Lacan asks what the butcher wants to *have*, not what he wants to *be*, and yet the two questions are fundamentally related. If it is true that the butcher's wife identifies with her husband's desire for the other woman, to what degree is the husband's desire for the friend itself motivated and structured by a prior feminine identification? The husband, after all, has just one wish, the wish to lose weight, the wish to become as svelte and thin as his wife's skinny friend. Posing the matter slightly differently, why should we believe the claim of the jealous wife that her husband's close relation to her friend is based upon desire and not identification? Moreover, might the wife's own desire for her friend travel a slightly less circuitous route, one that does not necessarily bypass the husband but calls into question his strategic placement as both etiological starting point and teleological endpoint of female sexual desire? Perhaps we need go no farther than Freud's own reading of the problem of sexual jealousy. Though none of the butcher's wife's interpreters reference Freud's later investigation of jealousy as a sign of both a repressed homosexual impulse and a simultaneous defense against it, the story of *la belle bouchère* provides a fitting illustration of Freud's interpretation of sexual rivalry as a manifestation of an insufficiently repressed homosexual desire.[20] In this instance, the wife's anxiety that "my husband is attracted to my woman friend" functions as a disguised declaration of the very opposite suspicion, "I am attracted to my woman friend." This narrative of identification and desire might easily be read as a story of "between women," with the butcher, at most, a convenient identificatory relay for a socially prohibited lesbian desire.

But even this retelling of the dream of the butcher's wife offers simply another narrative, another recasting of a tale that demonstrates a powerful resistance to interpretive mastery. Freud's compressed story of hysterical desire has produced a plethora of contradictory narratives on identification. The butcher's wife has been read, alternately, as a feminine-identified heterosexual (Freud), a masculine-identified heterosexual (Lacan), a masculine-identified lesbian (Clément), a maternal-identified infant (Chase), and a feminine-identified lesbian (Fuss). If there is a story to be told in the dream of the abandoned supper party, it may well be

the capacity of narrative to reproduce more narrative. What is finally at stake in these multiple condensations and displacements of a single abridged story of unfullfilled desire is a notion of interpretation *as* condensation and displacement. The critical desire for a readable and concise ending to the story of the butcher's wife—not only to the dream but to Freud's interpretation of the dream—paradoxically defers closure and keeps the story open to further rereading. By conflating and dislocating the meaning the butcher's wife has given to her own dream, psychoanalytic interpretation employs the very same techniques that organize the dream work.[21] In this regard, Freud's *Interpretation of Dreams* might be read as a dream of what interpretation can or might be—a prolongation of reading through the acts of condensation and displacement, metaphor and metonymy, identification and desire.

Totem Meals

The dinner that never happened leads us eventually to the one that did (at least in Freud's scientific mythology): the totem meal. It may be Freud's most familiar tale—the story of the expelled sons uniting to overpower and to cannibalize the despotic father who has claimed all the women of the tribe for himself. Freud's narrative completes the myth of origins Charles Darwin had already begun some forty years earlier in his account of the patriarchal primal horde. We first pick up the story of the totem meal in Freud's *Totem and Taboo* (1913):

> One day the brothers who had been driven out came together, killed and devoured their father and so made an end of the patriarchal horde. United, they had the courage to do and succeeded in doing what would have been impossible for them individually. . . . Cannibal savages as they were, it goes without saying that they devoured their victim as well as killing him. The violent primal father had doubtless been the feared and envied model of each one of the company of brothers: and in the act of devouring him they accomplished their identification with him, and each one of them acquired a portion of his strength. The totem meal, which is perhaps mankind's earliest festival, would thus be a repetition and a commemoration of this memorable and criminal deed, which was the beginning of so many things—of social organization, of moral restrictions and of religion.[22]

This story of jealousy and love, hatred and admiration, violence and commemoration once again revives the question of a parental identification, only this time with the father and not the mother. With *Totem and*

Taboo, the entire psychoanalytic narrative on identification decisively shifts from an investigation of feminine influence to a demonstration of masculine authority. *Totem and Taboo*'s story of a primordial struggle between men clarifies a change in focus for Freud that may have already been prefigured by the metaphorical substitutions structuring the earlier texts on identification—the replacements of sponge by condom, or fish eggs by salmon. Virtually every metaphorization of identification subsequent to *Totem and Taboo* attempts to locate the origins of self-other relations in a model of the son's affective ties to the father. From this point on, Freud's theoretical aim is to establish, beyond any possible doubt, the paternity of identification.

But why this apparently sudden deviation from maternity to paternity, from femininity to masculinity, from mother to father, and from daughter to son? What has happened between *The Interpretation of Dreams* and *Totem and Taboo* to change Freud's orientation on identification? In the interim period Freud "discovers" the Oedipus complex, the feelings of rivalrous hatred and incestuous love children experience toward their parental ideals. The term "Oedipus complex" first appears in Freud's writings in 1910 in "A Special Type of Choice of Object Made by Men,"[23] although Freud had already touched briefly on the subject as early as the October 15, 1897 letter to Fliess where he writes that "in germ and in phantasy," every child is an "Oedipus" in love with his mother and jealous of his father.[24] It is no coincidence for Freud that Sophocles' *Oedipus Rex* stages another drama of parricidal murder and filial guilt. In Freud's mind the story of Oedipus replays the first killing of the primal father, a primordial male crime that institutes the very moral laws against murder and incest that Oedipus later transgresses. And yet it is clearly the second story of oedipal prohibition and punishment that provides the frame of reference for the first, retroactively providing an interpretive lens through which to understand the transgressions of the lawless sons. Freud constructs his story of the patriarchal prelaw from a perspective firmly ensconced within the law, instituting a myth of a "before" to create an aura of inevitability to the events of an "after." The story of the origin of the law, in other words, is no more and no less than a self-authorizing production of the law that seeks to reorient all social relations around the primacy of the phallus.

Freud's story of the origins of culture follows a conventional crisis-resolution plot. Driven by both fear and envy of the father, the rebellious sons attempt to become like him by literally incorporating a part of him.

But the criminal deed is accomplished in vain, for as soon as the sons' hatred for the father is satisfied, an unconscious pull of affection takes over and produces in the brothers an overpowering remorse. The dead father becomes much stronger than the living father had ever been, for now the sons, under the pressure of internalized guilt, attempt to revoke the crime by subjecting themselves to their own social and sexual prohibitions. Culture, sociality, law, morality, and religion are all founded at the "scene of the father's vanquishment" which is also, simultaneously, the site of his "supreme triumph": "the revenge taken by the deposed and restored father was a harsh one: the dominance of authority was at its climax" (150). Totemism arises from the filial experience of guilt and the need to allay it; a memorial festival, the totem meal allows the brothers to pay homage to the father in death as they had failed to do when he was living.

This narrative of cannibal-parricide provides Freud with a fuller understanding of three defining features of the mechanism of identification. First, it uncovers the central role of *ambivalence* in identification. The sons hate their father but they also simultaneously love and admire him. Identification travels a double current, allowing for the possibility of multiple and contradictory identifications coexisting in the subject at the same time. What Freudian psychoanalysis understands by "subjectivity" is precisely this struggle to negotiate a constantly changing field of ambivalent identifications; indeed, subjectivity can be most concisely understood as *the history of one's identifications*.[25] Second, the story of the cannibal sons uncovers the *violence* at the heart of identification. All active identifications, including positive ones, are monstrous assassinations: the Other is murdered and orally incorporated before being entombed inside the subject. And finally, identification is an act of *repetition and remembrance*. While the totem meal allows the brothers to expiate the guilty primordial deed, it also repeats the crime once again, permitting them to celebrate their victory over the father and to reappropriate his powers. Identification is only ever partially secure and never complete. The whole unconscious process functions as a form of psychical memorialization in which the subject must repeatedly kill and ingest what it wishes to preserve a remainder of inside.

The myth of the totem meal, the dream of the abandoned supper party, and the story of the mushroom all suggest that identification pertains to food intake, to what can and cannot be digested, to what goes into (and eventually comes out of) the corporeal subject. Freud's story

of identification is a tale of interiors and exteriors, boundaries and permutations, transgressions and resistances. It is, above all, a story of orality. Identification, Freud tells us, represents a holdover from the earliest recognizable phase of sexual organization, the "'cannibalistic' or 'oral' phase, during which the original attachment of sexual excitation to the nutritional instinct still dominates the scene."[26] The cannibalistic pregenital phase, in which sexual activity is still indistinguishable from food ingestion, provides the prototype for identification as a form of oral sadism: "during the oral stage of organization of the libido, the act of obtaining erotic mastery over an object coincides with that object's destruction."[27] Identification operates for the subject as the primary means of gaining control over the objects outside itself; identification is a form of mastery modelled directly on the nutritional instinct.

Freud's specific choice of cannibalism to figure psychical identification reminds us that Freud's theory of self-other relations takes shape historically within a colonialist context. Nowhere are the signs of this colonial heritage more pervasive than in Freud's *Totem and Taboo*, which bears the frequently overlooked subtitle, *Some Points of Agreement Between the Mental Lives of Savages and Neurotics*. In the mental life of "savages," Freud argues, we see a "well-preserved picture" (1) of the earliest stages of human psychological development. Freud relies upon the signifier of temporality to construct the racial Other in culturally ethnocentric terms, reading in the unconscious life of "primitives" the preservation of "the primaeval past in a petrified form" (103). Echoing Hegel's infamous pronouncement in *The Philosophy of History* that the Other has no history, Freud comments in *Totem and Taboo* that "primitive races" possess "no tradition and no historical memory" (56). Freud's theoretical reductionism in *Totem and Taboo* actually converges from two directions. From the one side, he employs an evolutionary schema to describe psychosexual development, analogizing the changes in sexual maturity to the "progress" of civilizations, while from the other side he relies upon a psychosexual paradigm to describe evolutionary change, ranking cultures according to a developmental scale.[28] By working both ends to the middle, Freud's anthropological system keeps (re)producing the same unchanging objects—imaginary others onto which it projects the stationary features that more accurately characterize its own epistemological traits.

The construction of "the primitive" as a timeless, changeless, history-less Other in many ways resembles that other familiar figure of arrested

development in the annals of psychoanalysis, "the homosexual." As early as the first and second drafts of the *Three Essays on the Theory of Sexuality*, we find Freud representing primitivity and homosexuality explicitly in terms of one another, arguing that inversion is "remarkably widespread among many savage and primitive races," and that "in inverted types, a predominance of archaic constitutions and primitive psychical mechanisms is regularly to be found."[29] Both "invert" and "savage" are represented in temporal terms, placed within a static ontology that constructs each figure as representative of a primordial phase of human development. Identification, the first and most "primitive" of the psychical mechanisms, provides Freud with a ready conceptual relay linking "invert" and "savage"—modernity's two great figures of mimetic prowess.[30] In the psychoanalytic literature on "inverts" and "savages," repeated references to orality, the most archaic of the erotic zones, strengthens this connection by invoking cultural mythologizations of sexual and racial others as cannibal-sodomites.[31] It is against this violent historical backdrop of colonialism that we need to place Freud's tentative speculations in *Totem and Taboo* that a homosexual bond most likely united the cannibal sons of the primal horde. "The organization that made them strong," Freud hypothesizes, "may have been based on homosexual feelings and acts" (144).[32] Locating the origin of culture in the *repression* of homosexuality and in the *taboo* against cannibalism, Freud plays out an all too familiar colonialist narrative, for in the end Freud's stories of oral incorporation are never just about eating. They offer up complex narrativizations of the colonialist construction of the Other as primitive, bestial, and predatory. And they demonstrate how psychoanalysis, putatatively a universal science of sexuality, actually operates "as a quite elaborate form of ethnography—as a writing of the ethnicity of the white Western psyche."[33]

Mourning and Melancholia

The selection of eating as a figure for the interiorization of the Other leaves several important questions on identification unaddressed. What happens when the subject *refuses* to incorporate and *resists* identifying with the Other? Is it possible to repudiate an identification or to remove oneself altogether from a relation of alterity? What exactly determines what can or cannot be psychically incorporated? What distinguishes, for the subject, an edible object from an inedible one? And how can we ulti-

mately tell the difference between an identification and a desire, between an emotional tie and an emotional object, or, for that matter, between a self and an other? Though "Mourning and Melancholia" (1917) fails to answer fully any of these questions, it nonetheless begins the difficult task of building an analytic vocabulary to talk more complexly about them. "Mourning and Melancholia" reorients the discussion of identification around a new analytical concept, the ego, which Freud introduces into his theory of subjectivity as the unconscious agent that does the identifying. Eventually, in *The Ego and the Id* (1923), Freud will reach one of his most critical insights into subject-object relations simply by turning this formulation around and showing how it is actually the ego that is constituted through and by the mechanism of identification.[34]

Freud begins with the theme of mourning, defined as "the reaction to the loss of a loved person, or to the loss of some abstraction that has taken the place of one, such as one's country, liberty, an ideal."[35] Mourning is the subject's response to the removal of a love object and to the sudden withdrawal of libidinal investment that the absence of the object demands from the ego. Working from the assumption that "people never willingly abandon a libidinal position" (244), Freud suggests that the subject in mourning simply converts the lost love object into an identification, in effect becoming the object that it can no longer have. This becoming is itself a form of having: mourning prolongs the hallucinatory belief in the existence of the object by giving it a certain shelf life inside the ego. A successful resolution to the process of mourning is finally brought about when this identification takes hold and the subject is free to displace its libidinal energies onto a new object.

Melancholia is the risk every subject runs in failing to bring about an adequate compensation for the loss that inaugurates mourning. Where the mourner succeeds in converting object loss into identification, the melancholic spectacularly fails, unable or unwilling to incorporate the once beloved object. Yet this *failure* of introjection does not necessarily imply a *refusal* of identification; on the contrary, identification is simply doing its work more vigorously elsewhere, taking the ego itself as its object of incorporation.[36] Melancholia operates as a self-destructive, self-consuming pathology. By mistaking its own ego for the object that must be foresaken, the melancholic subject, in effect, commits suicide, suffering much the same fate as the lost object. Turning identification's violent impulses completely inward, the ego consumes itself in an act of auto-cannibalism. An especially vengeful mode of identification, melancholia

represents not the opposing of mourning but its most violent continuation. When Freud defines melancholia as "abnormal" or "pathological mourning" (243, 250), he means to imply that the difference between these two forms of identification may be only a matter of degree.

Freud's "Mourning and Melancholia" does more than show us the central function identification serves in the work of mourning; it also gives us a much clearer picture of the vital role mourning plays in the act of identification. All identification begins in an experience of traumatic loss and in the subject's tentative attempts to manage this loss. At this stage in Freud's thinking, identification is fundamentally a *reactive* mechanism that strives to preserve a lost object relation while simultaneously searching for a substitute gratification. As we have already seen in *Totem and Taboo*, identification works as a form of elegy, remembering and commemorating the lost object by ritualistically incorporating its serial replacements. In identification the subject paradoxically destroys the love object only in order better to preserve it: "better fragmented, torn, cut up, swallowed, digested . . . than lost."[37]

Ultimately, all that remains of the Other is the Other's remains; the subject becomes a veritable cemetery of lost, abandoned, and discarded objects. But where, in this newest theorization of identification, does the interminable process of mourning begin? What first sets the metonymic chain of substitutive objects in motion? Eating the Other has a most particular referent for Freud: identification attempts to conjure up an original object by restaging in fantasy the child's infantile relation to the mother, a relation of need and demand based upon oral gratification. Like the return of the living dead, the repressed maternal resurfaces to remind us that, when we mourn, it is the impossible return of the lost maternal object that we lament. For Freud, mourning is always a maternal bequest, an inheritance from the mother. Perhaps this is what Avital Ronell means when she refers to identification as a form of "mourning sickness," or what Laurence Rickels has in mind when he reads identification as "mummification."[38] Rickels' work, in particular, is haunted by the question of mournful identifications, of self-relations that must always take a detour via the dead (m)other—"the other, who is always the first to go."[39]

In Freud's work the detour through the dead other also has an immediate historical referent: the trauma of the First World War. Freud turns his attention to the problem of mourning and melancholia in January of 1914 on the eve of the "Great War," in nervous anticipation of the

profound psychical and personal loss such a massive human conflict will inevitably inflict. In his own work on historical trauma, Robert Jay Lifton has recently suggested that psychoanalysis is able to come to terms with World War I only by integrating, into its scientific model of the sexual instincts, a theory of the death drive.[40] I would suggest that something very similar appears to be happening with the concept of identification, which Freud recasts during this period as a psychological mechanism for *surviving* loss, not just precipitating it. Freud recasts identification as a paradigm for retaining the human ties that the violent upheaval of a modern world war threatens to sever irreparably. Freud's entire elaboration of the theory of identification works ceaselessly to negotiate a traumatic perception installed at the very heart of modernity: the fear of a fundamental and irretrievable loss of connection to the Other.

After World War II and the Holocaust, this early Freudian view of identification as a death-defying feat on behalf of the subject becomes impossible to sustain. Theories of identification survive in modernism and postmodernism, but only as painful and poignant meditations on the possibility of identification's own impossibility. One thinks, for example, of Jacques Derrida's startling formulation on the impossibility of mourning: if we are true to the Other whom we mourn, then we must respect the Other *as Other* and stop mourning.[41] This is also immediately to say that if we are true to the Other with whom we identify, then we must respect the Other as Other and stop identifying. It is the psychoanalytic literature on the Holocaust that may have the most to tell us on the subject of unmournable death. Dori Laub's clinical work on surviving trauma dramatically demarcates what may well be the outermost limits of identification. Traumatic events of the magnitude of the Holocaust actually memorialize the work of identification, in effect by making the imagination of the Other impossible:

> There was no longer an other to which one could say "Thou" in the hope of being heard, of being recognized as a subject, of being answered. The historical reality of the Holocaust became, thus, a reality which extinguished philosophically the very possibility of address, the possibility of appealing, or of turning to, another.[42]

Not all losses, it seems, can be recuperated. Trauma, defined as the *withdrawal* of the Other, marks the limit case of a loss that cannot be assimilated. To the extent that identification is always also about what cannot be taken inside, what resists incorporation, identification

is only possible traumatically. Trauma is another name for identification, the name we might give to the irrecoverable loss of a sense of human relatedness.

Mental Infections

What, then, is human relatedness? Freud first begins to consider seriously this deceptively simple question, and the whole related issue of group identification, in the spring of 1919, provoked by the end of the bloody and traumatic war to address the problem of why individuals sacrifice personal desires in favor of the promotion of group interests. The result was Freud's study of the creation, organization, and disintegration of social groups entitled *Group Psychology and the Analysis of the Ego*, completed two years later in March of 1921. Freud's twin subjects in this text are the proper conditions of group formations and the possible factors in their dissolution. *Group Psychology* also provides us with Freud's lengthiest discussion of the problem of identification. That this most interior of psychoanalytic concepts—itself a theory of interiorization—should find itself embedded at the center of Freud's philosophy of sociality functions as a powerful reminder that every emotional tie is also a social one. Freud makes the point explicitly in the opening of *Group Psychology*:

> In the individual's mental life someone else is invariably involved, as a model, as an object, as a helper, as an opponent; and so from the very first individual psychology, in this extended but entirely justifiable sense of the words, is at the same time social psychology as well.[43]

This study of individual psychology assumes, from the outset, a theory of group relations, a theory of subjectivity in which every subject is constituted relationally. Freud's psychoanalysis, far from abjuring or ignoring the question of social collectivities, sees itself as playing an important role in the newly emerging discipline of sociology. Psychoanalysis has no need to incorporate or to identify with sociology since *it has always been* a science of social relations.[44]

The shift to the problem of group psychology introduces into psychoanalysis an entirely new set of metaphors for identification and, along with it, a new assortment of theoretical problems. Supplementing rather than replacing the trope of ingestion, the figure of *infection* conceptualizes an alternative relation to groups of objects outside ourselves. Unlike

the ingestion model of identification, which stresses the subject's annihilation of the Other through oral incorporation, this other kind of identification works more like a case of contagious infection in which it is the subject who is vulnerable to invasions from without. These two dominant metaphorics of identification in Freud, ingestion and infection, follow opposite trajectories. While the first (oral ingestion) involves an active subject's conservation of the object of its idealization, the second (contagious infection) entails a passive subject's infiltration by an object not of its choosing. Capturing both the transitive and intransitive registers of identification, the *OED* defines the process as "the act of identifying or fact of being identified." We can thus economically summarize the difference between identifications as the difference between an active and a passive relation to the Other: to seize the Other, or to be seized by the Other.

In Chapter Seven of *Group Psychology*, Freud offers the example of girls in a boarding school to illustrate the phenomenon of a contagious identification. "Supposing," Freud writes, "one of the girls in a boarding school has had a letter from someone with whom she is secretly in love which arouses her jealousy, and that she reacts to it with a fit of hysterics; then some of her friends who know about it will catch the fit, as we say, by mental infection" (107). This example, which I will be discussing in much greater detail in a later chapter on hysterical identification, points to a certain confusion in Freud's thinking on the question of identification and agency: does one possess an identification or is one possessed by it? Contrary to Freud's previous narratives of identification, the hypothetical story of the girls' boarding school suggests the possibility that one can be taken completely unawares by an identification. Otherness, which always comes from without, infiltrates and takes over the ego to the point that it, too, "catches the fit" and becomes a carrier— a carrier of difference. This disease model of alterity depicts the subject as peculiarly vulnerable, even *susceptible*, to sudden invasions from the Other. It represents alterity as an infectious agent that can spread through unseen currents of "mental infection," putting every subject at potential risk.

But what, exactly, is contagious in the example of a mental infection? Contagion, it turns out, issues from exemplarity itself. Identification brings the problem of exemplarity into play since examples, by definition, are encouragements or inducements to imitation. Freud learns the lesson of the example from Nietzsche who defines "the compulsion to

imitate" as "extreme irritability, by means of which a certain example becomes contagious."[45] Freud writes in *Totem and Taboo* that an identification "acts like a contagion because examples are contagious."[46] Contagion infects identification from the start, through the example of exemplarity. For Freud, the potency of the contagion metaphor lies in its exposure of identification as a danger and a threat; coming into contact with the Other always brings with it a risk of contamination. This "other" model of identification thus operates implicitly as an antidote to the first, implying that we may not, in fact, be in complete control of our unconscious identifications.

The idea of mental infection suggests to Freud how a collection of individuals, seemingly distinct from one another, might act as one, even against their own individual interests. Gustav Le Bon has already made the point in *Psychologie des foules* (1895), the text that exerts perhaps the greatest power of suggestibility over Freud's theory of group psychology. "In a group," Le Bon writes, "every sentiment and act is contagious, and contagious to such a degree that an individual readily sacrifices his personal interest to the collective interest."[47] Le Bon classifies contagion as a form of hypnosis, an effect of suggestibility in the hypnotic state. A group subject is a hypnotized subject, one who, under the influence of suggestion, performs acts he or she ordinarily would never commit. In a group, "conscious personality" vanishes, "will and discernment" disappear, and the individual becomes an "automaton" (76). While the leader performs the role of hypnotist, holding his followers in a state of "fascination" (75, 81), this original suggestion is ultimately strengthened and secured through "the contagious effect which the individuals exercise upon one another" (77). The infection that binds the group thus moves in two different directions at once, between the leader and his followers and between the group members themselves; in the topology of group psychology, what holds a collectivity together is thus a double axis comprised of both vertical and horizontal identifications.

Freud's purpose in *Group Psychology* is to relocate the source of this group infection from hypnotic suggestion to the libidinal drives. While the sociologists all insist that "groups are distinguished by their special suggestibility" (89),[48] Freud questions the reasoning whereby "suggestion, which explained everything, was itself to be exempt from explanation" (89). Challenging whether suggestibility can really be considered "an irreducible primitive phenomenon, a fundamental fact in the mental life of man" (89), Freud recalls Bernheim's early demonstrations in the

art of hypnosis and remembers feeling even then "a muffled hostility to this tyranny of suggestion": "when a patient who showed himself una-menable was met with the shout: "What are you doing? *Vous vous con-tre-suggestionnez!*", I said to myself that this was an evident injustice and an act of violence. For the man certainly had a right to counter-sugges-tions if people were trying to subdue him with suggestions" (89). Hypnosis poses a risk to the unsuspecting or unwilling subject by sub-duing the person's own will and subjugating it to the violent force of the will of another. It was for this reason that Freud rejected the hypnotic method in the first place in favor of the more radical talking cure, setting up psychoanalysis as a more scientific alternative to hypnosis. But hav-ing rejected suggestion as the key to group solidarity, Freud still needs to explain what bonds a group together: what is the precise link that constitutes a social tie?

Some thirty years after disclaiming hypnosis as a possible foundation for psychoanalysis, Freud returns to "the riddle of suggestion" (89) to replace it with a new concept, the libido. A simple collectivity, he argues, does not comprise a group; "the essence of a group lies in the libidinal ties existing in it" (95–96). Freud's description of the libidinal constitu-tion of groups emphasizes the critical role identification plays in trans-forming a "collectivity" into a "group": "a primary group of this kind is a number of individuals who have put one and the same object in the place of their ego ideal and have consequently identified themselves with one another in their ego" (116). To demonstrate this theory of libidinal group ties, Freud examines two "highly organized, lasting, and artificial groups" (93), the church and the army. That Freud should cite two male homosocial institutions as the main examples for his theory of libidinal group structures is, after *Totem and Taboo*, not very surprising. In *Group Psychology*'s oedipal morphology of groups, the leader is a substitute father or elder brother who loves all of his followers equally; the democ-ratic reach of the father's love permits the group members to equate themselves with one another, thereby minimizing any serious rivalry among them. Yet the argument pivots upon a curiously *un*Freudian con-ceptualization of libido—a libido denuded of any kind of sexual drive. This non-libidinous libido, this love without eros, is exactly Freud's defi-nition of the social group. Freud posits "desexualized, sublimated homo-sexual love for other men" (103) as the basis of *all* social group ties, the defining feature of not only the type of sociality represented by the spe-cific institutions of church and army but of the social impulse *in toto*.

Could there be such a thing then as a "homosexual group"? In Freud's reasoning, homosexuality is antithetical to sociality since inversion operates as a form of self-love that insists upon preserving the individual's desires at the expense of the group's needs. Defined elsewhere by Freud as narcissistic object-choice,[49] male homosexuality poses the most serious threat of all to the continuance of the male homosocial group based upon anaclitic relations. By defining homosexuality from the outset as anti-social, Freud efficiently writes out the possibility of a "group" of homosexuals. Following this logic, there could be no such thing as a homosexual group since the homosexual, as narcissist, would stand to undermine even his own group interests.

Later, Freud substantially revises this view to propose that all sexuality is "unfavorable" to the formation of groups (140). To the degree that any sexual desire on the part of the individual seeks to preserve self-interest, it risks destabilizing and perhaps disintegrating the group bond. Freud concludes *Group Psychology* with this astonishing statement:

> love for women breaks through the group ties of race, of national divisions, and of the social class system, and it thus produces important effects as a factor in civilization. It seems certain that homosexual love is far more compatible with group ties, even when it takes the shape of uninhibited sexual impulses—a remarkable fact, the explanation of which might carry us far. (141)

The male homosocial group can apparently tolerate homosexuality among the ranks better than it can socially manage or regulate heterosexuality; while civilizations fall under the jealous rivalry provoked by the love of men for women, male homosexuality can somehow (Freud does not explain how) be more seamlessly incorporated. This is a "remarkable" statement for reasons not the least of which is how seriously it contravenes nearly everything that has come before it—everything, that is, except a now telling earlier discussion of "love" and "eros." In Chapter Four of *Group Psychology* entitled "Suggestion and Libido," Freud entertains the idea that love (the basis of the group bond) and eros (the threat to group harmony) may not be so incompatible after all. In fact, love appears to issue from the same "energy" source as sexual desire and indeed, Freud concludes, they are wholly coincident: "the 'Eros' of the philosopher Plato coincides exactly with the love-force, the libido of psychoanalysis" (91). To clinch the point he notes that "the Greek word 'Eros' . . . is in the end nothing more than a trans-

lation of our German word *Liebe* [love]" (91). A collapse in distinction between love and eros opens up two possibilities: that the leader may *sexually* love his followers (is the example of Plato any accident?) and that the group members may also desire one another. In the historically inverted translation of *Eros* for *Liebe*, Plato penetrates Freud, and sexuality enters love.

This mutual contamination of love and eros poses certain problems for Freud's theorization of group ties. Specifically, how do we know when the amorous couple "love-eros" is serving to preserve the group and when it is working to undermine it? The possibility of recognizing love and eros as translations of one another—the possibility, in other words, of completely erasing the boundary between them—suggests that homosociality is never very far from the homosexuality it claims to "repress," and that the former may even make the latter possible. At this point in *Group Psychology* Freud is not wholly unaware of the implications of his own theorizing, for the love-eros equation becomes too dangerous to sustain for more than the briefest instance of its articulation. A theoretical concept, an internal psychical mechanism, is required to keep the social and the sexual from infecting one another, and for Freud that mechanism is identification. To foreclose the possibility that his own analysis has opened up—the possibility that members of a same-sex group may actually desire each other despite (or indeed because of) the prohibition against it—Freud takes a sudden detour in the middle of *Group Psychology* to ask whether object-cathexis is the only kind of emotional tie in psychical life. Freud's theory of identification emerges in this context as the "other mechanism" for an emotional tie (104); not incidentally, it also appears as a theoretical *defense* against any eventuality of a nonsublimated homosexual love as the basis of a homosocial group formation. By extracting identification from desire, insisting that a subject cannot identify with another person and desire that person at the same time, Freud is able to conceptualize homosexuality and homosociality as absolutely distinct categories.

Freud's entire theory of subjectivity rests on this rather precarious but pervasive distinction between object-choice and emotional tie. Freud puts forward the desire/identification opposition as a more reliable scientific means of distinguishing normative (hetero)sexualities on the one hand from perverse (homo)sexualities on the other. Identification is the mechanism Freud summons to keep desire from overflowing its socially sanctioned borders. But as hard as Freud labors to keep desire and iden-

tification from infecting one another, the signs of their fluid exchanges surface everywhere to challenge and to weaken the *cordon sanitaire* erected between them. This book proceeds from the premise that it is these very moments of contamination, in which the desire/identification binary becomes confused and undecidable, that can tell us the most about what, precisely, is at stake in their culturally enforced opposition.

Phallic Erections

After *Group Psychology and the Analysis of the Ego*, Freud adds little that is new to his previous pronouncements on the problem of identification. Subsequent works, in particular *The Ego and the Id* (1923) and *Moses and Monotheism* (1939), are notable mainly for the way each text briefly rehearses, sometimes in verbatim form, Freud's earlier positions on identification. Freud leaves the job of pulling together and organizing his disparate and often contradictory remarks on identification to a younger colleague, Otto Fenichel, who struggles to complete the job Freud leaves undone. It is not that Freud has lost interest in identification after the publication of *Group Psychology*; it is rather as if Freud has so thoroughly incorporated the subject into his thinking that it simply disappears as an *autonomous* object of inquiry.

Otto Fenichel's paper on "Identification," first published in the *International Journal of Psychoanalysis* in 1926, offers several useful clarifications of Freud's theory of subject-object relations. Fenichel explains that in identification—defined as "changes in the ego, in which characteristics which were previously perceived in an object are acquired by the perceiver of them"—the subject consumes not a real object but a mnemic idea of it.[50] From the very beginning identification is mediated by what Fenichel calls an "object representative" (98), not an actual object but a metaphorical stand-in, a concept that immediately helps to make sense of Freud's otherwise enigmatic statement that "when all is said and done, it is impossible to destroy anyone *in absentia* or *in effigie*."[51] Fenichel also expounds on the ambiguous role desexualization and sublimation play in Freud's theory of identification. Forced by "external and internal conditions to resign the object it is fixated on" (99), the libidinous subject finds a substitute object in its own ego: "the subject no longer has any interest in the real object (or not nearly so much as before); his ego changes and becomes like an object and the libido concerned is desexualized" (99). Once incorporated, the object is no longer

libidinally invested, which is what leads Freud to the conclusion that all sublimation occurs by way of identification. Finally, Fenichel's paper on identification illustrates how the formation of the subject actually proceeds through a series of *deformations*. The ego can persuade the id to relinquish the love relationship only on the condition that it significantly alter its own form in imitation of the love object. The ego's adaptability makes it capable of extraordinary change and activity, at the same time that the continual process of disfiguration, in Freud's words, "exposes it to the danger of maltreatment and death."[52]

But Fenichel's survey of Freud's theory of identification leaves any number of critical questions unanswered. How does the *perception* of an object eventually translate into its *acquisition*? Is visual perception the only possible ground of identification? What are the "external and internal conditions" under which an object must be relinquished? What determines which objects are to be accommodated by the ego, and which objects are not? And most importantly, if identification is the outcome of the ego's response to an object-cathexis, then how is it that Freud can claim elsewhere that identification precedes object-cathexis? If identification *is* an abandoned object-relation, then how can it simultaneously be the *precondition* for an object-relation?[53] Freud intends to put the problem to rest in his final remarks on identification, contained in a sheet of working notes published after his death in 1939. Returning to the question of "being" and "having" first introduced in *Group Psychology*, Freud reiterates his conviction that even though every identification is a failed object-relation, identification nonetheless precedes desire:

> "Having" and "being" in children. Children like expressing an object-relation by an identification: "I am the object." "Having" is the later of the two; after loss of the object it relapses into "being." Example: the breast. "the breast is a part of me, I am the breast." Only later: "I have it"—that is, "I am not it."[54]

Freud now claims that identification both precedes *and* follows object-love, and yet nowhere is it explained how an identification first produces a love-relation—that is, how "I am the breast" evolves into "I have it." This chicken-and-egg question on the temporal sequence of identification and desire proves to be a significant stumbling block for Freud. It may even account for Freud's failure to make any further headway on the problem of identification after once deciding (his favorite example of the breast notwithstanding) that "an individual's first and

most important identification" is "his identification with the father . . . a direct and immediate identification [that] takes place earlier than any object-cathexis."[55]

In what sense can identification with the father be said to be "direct and immediate"? Apparently because, as Freud explains in *Group Psychology*, identification is itself "typically masculine" (105). Identification operates as a phallicizing process, "mould[ing] a person's own ego after the fashion of the one that has been taken as a model" (106). In his essay on "the Mirror Stage," Lacan will make much of the ego's phallic erection, describing the first person "Je" (or in English, "I," that orthographic architectural column) as a "statue in which man projects himself."[56] Later still, Mikkel Borch-Jacobsen, in a riveting chapter on Lacan called "The Statue Man," will speak of the ego's "optical erection" in which "the subject learns to hold itself straight, upright, by spatially identifying with the specular image."[57] For these writers, identification works as a *hardening* or *stiffening* of the ego; the subject is *erected* through identification. Through its own moulding of a theory of identification, psychoanalysis builds a monument to what it perceives as its most vital part: the phallus. And yet the price of the phallus's institutionalization in psychoanalysis can only be the loss of its vitality. The statue, after all, is a lifeless form, and the identifying subject is no more than a desiring subject captured in a state of arousal: a frozen phallic erection. Ultimately unable to renovate or to breathe life into such a turgid model, Freud simply lets identification stand—as the cornerstone of his theory of sexuality.

Wrapping Up

How do changes in the unconscious happen? The psychoanalytic theory of identification is an attempt to answer this very particular question. In its simplest articulation, psychical change occurs whenever we are confronted with a new object in the external world. In its more complicated formulation, change happens whenever the ego, under pressure from an instinctual demand for an unattainable object, transforms itself into the object "for the sake of the id."[58] The ego defuses internal tension by making of itself a sacrificial offering to the id: "When the ego assumes the features of the object, it is forcing itself, so to speak, upon the id as a love-object and is trying to make good the id's loss by saying: 'Look, you can love me too—I am so like the object'" (30). At the same time that the ego is under pressure from the id, it must cater to the

superego, which comes into being as a "memorial" (48) to the punishing father who has been introjected and taken as a model. Threatened by both a punitive superego and an unforgiving id, the ego manages its double jeopardy by simultaneously destroying the object to satisfy the superego and imitating the object to gratify the id. Identification thus operates typically as a compromise formation or a type of crisis management.

Underwriting Freud's theory of identification is a spatial metaphorization of the unconscious as a field of divisions, hostilities, rivalries, clashes, and conflicts. Situated in the middle of this contested terrain, the ego performs the strategically vital role of preventing the outbreak of open strife between the warring factions of the subject. Mediating not only between the forces within the subject but also between the subject and the forces outside it, the ego occupies the space of a borderlander. Described by Freud as a "frontier-creature" (56), the ego patrols the borders of identity by means of a policing mechanism of its own: identification. Those objects that cannot be kept out are often introjected, and those objects that have been introjected are frequently expelled—all by means of the mechanism of identification. Identification thus makes identity possible, but also places it at constant risk: multiple identifications within the same subject can compete with each other, producing further conflicts to be managed; identifications that once appeared permanent or unassailable can be quickly dislodged by the newest object attachment; and identifications that have been "repudiated and even overcompensated"[59] can reestablish themselves once again much later. The history of the subject is therefore one of perpetual psychical conflict and of continual change under pressure. It is a profoundly turbulent history of contradictory impulses and structural incoherencies. To the unconscious, there are no "correct" or "incorrect" identifications, no "proper" or "improper" desires. There are only identifications and desires that mould and shape the ego—which is why attempts to legislate the unconscious have always had rather mixed success.

This, indeed, would seem to be the fate of psychoanalysis when it programmatically attempts to reorient patients' unruly desires by monitoring their wayward identifications. In his clinical approach to the treatment of neurotics, Freud concentrates on helping his patients raise to the level of consciousness a buried identification—for example, Dora's unconscious identification with her father, or the Wolf Man's unconscious identification with his mother. But what is striking about all of Freud's case histories is that in none of them does the mere "bringing to

light" of an unconscious identification resolve the patient's neurosis. Instead, the record of Freud's own case notes makes it clear that whatever changes do take place during the analysis are the byproduct of an identificatory transference between analyst and analysand that neither party fully controls, much as each might attempt to govern or to predetermine the outcome.

A rare acknowledgment from Freud of the danger of trying to control a patient's identifications appears, in displaced form, in a telling analogy he draws in *The Ego and the Id* between the ego and the physician. The passage is important enough to be quoted in its entirety:

> [The ego] behaves like the physician during an analytic treatment: it offers itself, with the attention it pays to the real world, as a libidinal object to the id, and aims at attaching the id's libido to itself. It is not only a helper to the id; it is also a submissive slave who courts his master's love. Whenever possible, it tries to remain on good terms with the id; it clothes the id's *Ucs.* [unconscious system] commands with its *Pcs.* [preconscious system] rationalizations; it pretends that the id is showing obedience to the admonitions of reality, even when in fact it is remaining obstinate and unyielding; it disguises the id's conflicts with reality and, if possible, its conflicts with the super-ego too. In its position midway between the id and reality, it only too often yields to the temptation to become sycophantic, opportunist and lying, like a politician who sees the truth but wants to keep his place in popular favour. (56)

In trying to gain command of the id by means of identification, the ego behaves just like a psychoanalyst attempting to master a patient through transference. This extraordinary statement reveals a great deal about Freud's own anxieties and ambivalences. It shows that Freud was not at all unaware of the analyst's need to be loved and of his own desire to win favor with his patients. It demonstrates that Freud was as wary of the practical dangers of countertransference as he was confident of its clinical benefits. And, most importantly, it suggests to us that Freud's highly anthropomorphized theory of subjectivity is actually modelled on the conflictual structure of his psychoanalytic encounters with patients, *rather than the other way around.* The analytical scene, in other words, does not reproduce a universal or inherent psychological structure but rather produces the prototype for it. In a sense, Freud's theory of identification is a *projection* of the struggle for power and the process of negotiation that organizes every professional relation between doctor and patient. In circular fashion, psychoanalytic theory and practice confirm

one another, as the clinical encounter restages a psychical conflict which is itself fashioned after the clinical encounter. One begins to see how Freud's statement on object-choice—"the finding of an object is in fact a refinding of it"[60]—might be neatly applied to psychoanalysis itself.

This is not to say that Freud's theory of identification is completely compromised; rather, it is to suggest that the compromise which *is* identification has political, historical, and ideological, as well as linguistic determinants. In the following chapters, I intend to track the social inscriptions of identification through the sediments of its dominant metaphorizations. Metaphor, however, is not simply one approach among many to the problem of identification. To the extent that identification is a desire to be *like* or *as* the other, to the extent, in other words, that identification is fundamentally a question of *resemblance* and *replacement*, metaphor provides the most direct point of entry into the internal workings of a complex cultural and psychical process. While identification ultimately constitutes for psychoanalysis something much more than a trope, Freud's work makes it clear that there can be no mechanism of identification without a metaphoric structure of substitution and exchange. Freud's entire theory of sexuality is predicated on the assumption that such figurative transfers between selves and others are not only possible but indispensable to the construction of the human personality. Given this centrality of figuration to the operation of identification, it seems particularly important to ask what precise metaphors Freud relies upon in his own work to conceptualize the self-other, subject-object relation.

NOTES

1. Freud, Letter to Fliess, May 2, 1897, *Standard Edition*, 1:248–49.

2. Cited in Peter Gay, *Freud: A Life For Our Time* (New York: Doubleday, 1988), 49.

3. For more on the subject of Freud's homoerotic friendships, see my introduction to "Pink Freud," *GLQ* 2:1–2 (1995):1–9.

4. Freud, Letter to Fliess, November 14, 1897, *Standard Edition*, 1:268.

5. Otto Fenichel, "Identification," in *Collected Papers of Otto Fenichel: First Series* (New York: W. W. Norton & Co., 1953), 104.

6. Helene Deutsch, "The Psychology of Woman in Relation to the Functions of Reproduction" (1925), in *The Therapeutic Process, the Self, and Female Psychology: Collected Psychoanalytic Papers*, ed. Paul Roazen, trans. Eric Mosbacher and others (New Brunswick, NJ: Transaction Publishers, 1992), 8–9. While the limitations of a biological model for figuring identification in social terms are obvious, I would draw particular attention to Deutsch's problematic attempts to read psychological difference according to an assumed distinction between *how* men and women identify: men actively "take possession" of the object, women passively "absorb" it; men return to the uterus through primary identification achieved in coitus, women through primary identification satisfied in pregnancy, and so on. See also *Totem and Taboo* (1913), *Standard Edition*, 13:82, for Freud's implied reading of pregnancy as a form of autocannibalism.

7. Gay, 163, 514. Elsewhere, in the famous "navel of the dream" passage, Freud analogizes the dream itself to a mushroom: "the dream-wish grows up (*erhebt sich*), like a mushroom out of its mycelium." *The Interpretation of Dreams* (1900), *The Standard Edition*, 5:525. In a detailed reading of this complicated passage, Samuel Weber uncovers the "knot" or "shadowy tangle" in which the dream-wish "surges" into view, branching out in every direction; once again the mushroom functions explicitly as a feminine metaphor which is linked, through the navel of the dream, to the maternal body. *The Legend of Freud* (Minneapolis: University of Minnesota Press, 1982), 75–78. Later, Freud reinterprets the mushroom, somewhat predictably, as a protruding phallic symbol, the exact opposite of a "shadowy tangle." *Introductory Lectures on Psycho-Analysis* (1916–1917), *Standard Edition*, 15:164. It is particularly fascinating, in this regard, to recall Ernest Jones' comment

that the only recorded sign of discord in Freud's marriage to Martha Bernays was "a temporary difference of opinion over the weighty question whether mushrooms should be cooked with or without their stalks." *The Life and Work of Sigmund Freud*, eds. Lionel Trilling and Steven Marcus (New York: Basic Books, Inc., 1961), 108. I thank Lee Edelman and Eduardo Cadava for drawing these passages to my attention.

8. I am thinking specifically of Freud's analysis of the Ibsen drama about a servant who jealously wishes to usurp the position of her childless mistress in order to marry the master with whom she has fallen in love. See Freud's "Some Character-Types Met With in Psycho-Analytic Work" (1916), *Standard Edition*, 14:309–333. One can find the "character-type" of the ambitious, day-dreaming servant-girl as early as the case history of Lucy R. in *Studies on Hysteria* (1895), 2:106–25. Freud also mentions, in another letter to Fliess, a dream of one of his own servants, a nursery governess, who wished that Martha would die so that Freud could marry her instead. Letter to Fliess, May 31, 1897, *Standard Edition* 1:255. We might well ask to what degree this recurrent image of the romantic servant-girl infatuated with her employer operates as a denial and displacement of the sexual and economic exploitation of the servant-girl by the master—by Freud's own admission, an all too common situation in Victorian households.

9. Freud, Letter to Fliess, December 17, 1896, in *The Complete Letters of Sigmund Freud to Wilhelm Fliess, 1887–1904*, trans. and ed. Jeffrey Moussaieff Masson (Cambridge, MA: Harvard University Press, 1985), 217–18.

10. Cited in Henry Abelove, "Freud, Male Homosexuality, and the Americans," in *The Lesbian and Gay Studies Reader*, eds. Henry Abelove, Michèle Aina Barale, and David Halperin (New York and London: Routledge, 1993), 386. For more on the Freud-Putnam correspondence, see Nathan G. Hale, Jr., ed., *James Jackson Putnam and Psychoanalysis*, trans. of the German texts by Judith Bernays Heller (Cambridge, MA: Harvard University Press, 1971).

11. Freud, Letter to Fliess, October 3 and 4, 1897, *Standard Edition*, 1:263.

12. One move in this direction is Madelon Sprengnether's *The Spectral Mother: Freud, Feminism, and Psychoanalysis* (Ithaca and London: Cornell University Press, 1990). Freud's identifications with various historical, literary, and biblical figures (including, most prominently, Moses, Joseph, Brutus, Hannibal, and Karl Moor) is also of considerable interest for a study of Freud's own fantasy identifications, although this latter subject has already been exhaustively researched, most interestingly by William J. McGrath in *Freud's Discovery of Psychoanalysis: The Politics of Hysteria* (Ithaca and London: Cornell University Press, 1986).

13. Freud, *The Interpretation of Dreams* (1900), *Standard Edition*, 4:147.

14. Freud, Letter to Fliess, October 15, 1897, *Standard Edition* 1:264.

15. Jacques Lacan, "The Direction of the Treatment and the Principles of Its Power," in *Écrits*, trans. Alan Sheridan (New York and London: W. W. Norton and Company, 1977), 264.

16. Catherine Clément, *The Lives and Legends of Jacques Lacan*, trans. Arthur Goldhammer (New York: Columbia University Press, 1983), 130.

17. Cynthia Chase, "The Witty Butcher's Wife: Freud, Lacan, and the Conversion of Resistance to Theory," *MLN* 102:5 (December 1987): 1000. This essay provides the groundwork for Chase's next discussion of the beautiful butcheress in "Desire and Identification in Lacan and Kristeva," in *Feminism and Psychoanalysis*, eds. Richard Feldstein and Judith Roof (Ithaca and London: Cornell University Press, 1989), 65–83.

Hereafter all page numbers cited in the text after WB ("The Witty Butcher's Wife") or DI ("Desire and Identification").

18. In "The Witty Butcher's Wife," Chase swerves away from the Lacanian reading of the phallus as object of the woman's desire, arguing instead that it works quite the other way around: "what the woman wants—what the mother wants—counts as the phallus" (1003).

19. Freud, "Femininity," in *New Introductory Lectures on Psycho-analysis* (1933), *Standard Edition,* 22:130.

20. Freud, "Some Neurotic Mechanisms in Jealousy, Paranoia and Homosexuality" (1922), *Standard Edition,* 18: 221–32.

21. As Shoshana Felman demonstrates by her own powerful rereadings of Lacan, the emphasis in psychoanalytic interpretation is precisely on "the displacement operated by the interpreting." See *Jacques Lacan and the Adventure of Insight: Psychoanalysis in Contemporary Culture* (Cambridge, MA: Harvard University Press, 1987), 21.

22. Freud, *Totem and Taboo,* 141–42. Freud repeatedly returns to the story of the cannibal sons in his later works, including *Group Psychology and the Analysis of the Ego* (1921), *Standard Edition,* 18:122–28; *The Future of an Illusion* (1927), 21:21–24; and *Moses and Monotheism: Three Essays* (1939), 23:80–92.

23. Freud, "A Special Type of Choice of Object Made by Men" (1910), *Standard Edition,* 11:171.

24. Freud, Letter to Fliess, October 15, 1897, *Standard Edition,* 1:265.

25. I thank Elin Diamond for this especially economical definition of subjectivity. Jacques Derrida provides another useful way of thinking about the subject as "the finite experience of nonidentity to self" (103). See "'Eating Well,' or the Calculation of the Subject: An Interview with Jacques Derrida," interviewed by Jean-Luc Nancy, in *Who Comes After the Subject?*, eds. Eduardo Cadava, Peter Connor, and Jean-Luc Nancy (New York: Routledge, 1990): 103.

26. Freud, "From the History of an Infantile Neurosis" (1918 [1914]), *Standard Edition,* 17:106.

27. Freud, *Beyond the Pleasure Principle* (1920), *Standard Edition,* 18:54.

28. For a more comprehensive discussion of Freud's Darwinian views, see Edwin R. Wallace's *Freud and Anthropology* (New York: International Universities Press, Inc., 1983) and Lucille B. Ritvo, *Darwin's Influence on Freud: A Tale of Two Sciences* (New Haven: Yale University Press, 1990). And for an excellent reading of how cultural theories of temporality govern the construction of the anthropological Other, see Johannes Fabian's *Time and the Other: How Anthropology Makes Its Object* (New York: Columbia University Press, 1983).

29. Freud, *Three Essays on the Theory of Sexuality* (1905), *Standard Edition,* 7:139 and 146.

30. For a reading of the concept of mimetic prowess, specifically in the context of colonial history, see Michael Taussig, *Mimesis and Alterity: A Particular History of the Senses* (New York and London: Routledge, 1993).

31. See especially Part Three, "'They Are All Sodomites': The New World," in Jonathan Goldberg, *Sodometries: Renaissance Texts, Modern Sexualities* (Stanford: Stanford University Press, 1992), 179ff.

32. Or again, in *Group Psychology*, Freud remarks, "it may perhaps also be assumed that the sons, when they were driven out and separated from their father, advanced from identification with one another to homosexual object-love, and in this way won freedom to kill their father" (124).

33. Mary Ann Doane, *Femmes Fatales: Feminism, Film Theory, Psychoanalysis* (New York and London: Routledge, 1991), 211.

34. Freud, *The Ego and the Id* (1923), *Standard Edition*, 19:3–66.

35. Freud, "Mourning and Melancholia" (1917), *Standard Edition*, 14:243.

36. Sandor Ferenczi coins the term *Introjektion*, as a correlative to Freud's *Projektion*, in a 1909 paper entitled "Introjection and Transference," in *Sex and Psychoanalysis*, trans. Ernest Jones (New York: Basic Books, 1950), 35–93. Freud first uses Ferenczi's term in "Instincts and Their Vicissitudes" (1915), *Standard Edition* 14:136, as a synonym for incorporation (*Einverleibung*). Although Freud uses introjection and incorporation interchangeably, I will be following J. Laplanche's and J. B. Pontalis's more precise definitions of the terms in *The Language of Psycho-Analysis*, trans. Donald Nicholson-Smith (New York and London: W. W. Norton and Company, 1973). Incorporation is the process whereby the subject "has an object penetrate his body and keeps it 'inside' his body" (211), and introjection is the process whereby the subject "transposes objects and their inherent qualities from the 'outside' to the 'inside' of himself" (229). Laplanche and Pontalis consider introjection the broader of the two terms since it does not necessarily refer to bodily boundaries, but they also see in incorporation the corporeal model for introjection.

37. Julia Kristeva, *Black Sun: Depression and Melancholia* (New York: Columbia University Press, 1989), 12.

38. Avital Ronell, *The Telephone Book: Technology, Schizophrenia, Electric Speech* (Lincoln: University of Nebraska Press, 1989), 342; Laurence Rickels, *Aberrations of Mourning: Writing on German Crypts* (Detroit: Wayne State University Press, 1988), 265.

39. Laurence Rickels, *The Case of California* (Baltimore: Johns Hopkins University Press, 1991), 5 and 19.

40. Cathy Caruth, "Interview with Robert Jay Lifton," in *American Imago* 48:1 (Spring 1991): 153–75.

41. See, for example, Jacques Derrida, *Memoires for Paul de Man*, revised ed., trans. Cecile Lindsay, Jonathan Culler, Eduardo Cadava, and Peggy Kamuf (New York: Columbia University Press, 1988), and "Psyche: Inventions of the Other," in Lindsay Waters and Wlad Godzich, eds. *Reading De Man Reading* (Minneapolis: University of Minnesota Press, 1989): 25–65.

42. Dori Laub, "Bearing Witness or the Vicissitudes of Listening," in Shoshana Felman and Dori Laub, *Testimony: Crises of Witnessing in Literature, Psychoanalysis, and History* (New York and London: Routledge, 1992), 82.

43. Freud, *Group Psychology*, 69.

44. Mikkel Borch-Jacobsen makes a similar point in the final chapter of *The Freudian Subject*, trans. Catherine Porter (Stanford: Stanford University Press, 1988): "Freud intends . . . to establish a (psycho)sociology based on an archisociology that is ultimately no more and no less than *psychoanalysis*. There is no need to expand psychoanalysis or to 'apply' it to the field of sociology; it is itself more sociological than any sociology" (131). In my mind, Borch-Jacobsen's "The Primal Band" remains the most exhaustive and intelligent reading of Freud's *Group Psychology*. My own reading of this difficult text differs from Borch-Jacobsen's primarily in the importance I attribute to the homosocial nature of the group bond and to its sexual "contaminations."

45. Friedrich Nietzsche, *The Will to Power*, trans. Anthony M. Ludovici. Vol 15 of *The Complete Works* (New York: Russell and Russell, Inc., 1964), 255. For an excellent reading

of the philosophical problem of exemplarity, see Thomas Keenan's *Fables of Responsibility* (Stanford: Stanford University Press, 1995).

46. Freud, *Totem and Taboo*, 35.

47. Cited in Freud, 75. See Gustav Le Bon's *Psychologie des foules* (1895), translated into English as *The Crowd: A Study of the Popular Mind* (New York: Viking, 1973). Freud was also greatly influenced by the work of W. McDougall in *The Group Mind* (New York: Putnam's, 1920) and of Gabriel Tarde in *The Laws of Imitation* (Gloucester, MA: Peter Smith, 1962). The 1890 edition of Tarde's monumental attempt to outline what he calls "a pure sociology" is especially influential in impressing upon Freud the idea that "wherever there is a social relation between two living beings, there we have imitation" (xiv).

48. Freud believes that Tarde, for example, uses "imitation" as simply another word for suggestion (88), and that McDougall invokes the principle of suggestibility under cover of his theory of "primary induction"—"the intensification of emotion by contagion" (96).

49. Freud, "On Narcissism: An Introduction" (1914), *Standard Edition*, 14:69–102.

50. Fenichel, 97.

51. Freud, "The Dynamics of Transference" (1912), *Standard Edition* 12:108.

52. Freud, *The Ego and the Id*, 56.

53. See, for example, Freud's *The Ego and the Id*, 30, or a later essay, "Anxiety and Instinctual Life," in *New Introductory Lectures* (1933), *Standard Edition*, 22:91.

54. Freud, "Findings, Ideas, Problems" (1941 [1938]), *Standard Edition* 23:299.

55. Freud, *The Ego and the Id*, 31.

56. Jacques Lacan, "The Mirror Stage as Formative of the Function of the I as Revealed in Psychoanalytic Experience," in *Écrits*, 2.

57. Borch-Jacobsen, *Lacan: The Absolute Master*, trans. Douglas Brick (Stanford: Stanford University Press, 1991), 65.

58. Fenichel, 99.

59. Freud, *Moses and Monotheism*, 125.

60. Freud, *Three Essays*, 222.

2

FALLEN WOMEN: "THE PSYCHOGENESIS OF A CASE OF HOMOSEXUALITY IN A WOMAN"

THIS CHAPTER SELECTS FOR DISCUSSION one of the most underdiscussed texts in the psychoanalytic library, Sigmund Freud's case history of 1920, "The Psychogenesis of a Case of Homosexuality in a Woman."[1] Working from my initial premise that no scientific language can escape the pull of metaphor, I would like to suggest in the following reading that the cognitive paradigm of "falling," which Freud provides in this case study to "explain" female homosexuality, is already a rhetorical figure. The allegory of the fall—upon which Freud's entire theory of female inversion hinges—activates in psychoanalysis a certain Newtonian metalogics of force, counterforce, attraction, repulsion, and reversal. These figurative traces of psychodynamics in psychoanalytic theory name more than the subject's fall into (or out of) sexuality; they critically define and delimit the operations of the two psychical mechanisms Freud locates as central to the formation of any sexual identity, identification and desire. Specifically for Freud, a gravitational fall back into preoedipality, secured through an identification with the father and a concomitant desire for the mother, accounts for the "psychogenesis of a case of homosexuality in a woman." The case history Freud published under this name represents his most sustained attempt to engage with the subject of female homosexuality. Freud's efforts to trace and to codify the "preoedipalization" of the homosexual subject is largely responsi-

ble for establishing the perimeters of a sexology which is founded upon questions of space, time, duration, gravity, and motion, and which continues to set the terms of the psychoanalytic debates on sexuality today.

In the history of psychoanalysis, female homosexuality is theorized almost exclusively in terms of the "pre": the preoedipal, the presymbolic, the prelaw, the premature, even the presexual. The critical presupposition that female homosexuality occupies the space and time of an origin—that it is widely assumed to be, in a word, pretheoretical—could account for its long-term neglect in revisionist theoretical work ordinarily devoted to challenging normative definitions of sexual desire. Part of the general critical disregard for homosexuality in contemporary theories of sexual difference may well be occasioned by a judicious devaluation of false foundationalisms and a healthy suspicion of theories of primacy—those very theories of primacy within which homosexuality has historically been understood. However, such antifoundationalisms, while crucially challenging the dangerous ideology of natural origins, need also to investigate how a concept like "preoedipality" is itself constituted as an effect of a cultural symbolics and, more particularly, to ask how homosexuality comes to be so routinely assigned to the regressive, conservative space of this fictive origin. How and why do psychoanalytic theories of female homosexuality position their subjects *as* foundational, as primeval, as primitive, and indeed as presubjects, presubjects before the normative, heterosexualizing operations of the Oedipus complex, that "legal, legalising coordinate."[2] This chapter will attempt to confront the limits and the dangers of preoedipality as an explanatory model for female homosexuality, focusing specifically upon the instrumental role identification and desire play in Freud's theorization of sexual identity formation.

Liminal Foundations

Let me begin by posing the following historical and institutional question: where is female homosexuality to be found in psychoanalysis? The answer is in psychoanalysis's very foundations. Of the six case studies Freud completed, both the first case study, *Fragment of an Analysis of a Case of Hysteria* (1905), and the last, "The Psychogenesis of a Case of Homosexuality in a Woman" (1920), are studies of inversion in women, studies of deviations with respect to a woman's object choice. Jacques Lacan's dissertation on paranoid psychosis, his 1932 thesis in medicine,

betrays a similar fascination with female paranoiacs whose lack of distance from other women and from themselves (attributed by Lacan to their presymbolic, prelinguistic, preseparation relation to the mother) constitutes the very source of their paranoia. So deep is Lacan's early preoccupation with the question of homosexuality in women that one would have to amend Catherine Clément's general observation, "In the beginning Lacan was interested only in women,"[3] to the more precise formulation, "In the beginning Lacan was interested only in *homosexual* women." More recently, Julia Kristeva's work on sexual difference is noteworthy for its relative disinterest, not to say dismissal, of female homosexuality, work that addresses the question of homosexuality in women only in occasional postscriptural asides. But it is in her earliest books where female homosexuality emerges as "foundational" and as preparatory to her later depreciation of it—especially in *About Chinese Women* (1974) where the first third of the book defers the question of the Orient to elaborate instead a theory of orientation.[4]

From Sigmund Freud to Julia Kristeva, preoedipality defines the fundamental psychical organization of the homosexual subject who never, it seems, fully accedes to the position of subject but who remains in the ambiguous space of the precultural. Beginning with Freud's study of the "sexual aberrations," upon which he bases his entire theory of sexuality, moving through Lacan's thorough subsumption of female homosexuality into a preoedipalized paranoid psychosis, and reaching toward Kristeva's theory of female homosexuality as a refusal, rather than a fulfillment, of the revolutionary potential of the semiotic, we see in psychoanalysis's positioning and repositioning of homosexuality a critical fall back to the earliest stages of the subject's formation. The progressive movement in psychoanalysis is backward, deep into the subject's prehistory. The most recent work on the question of subjectivity has pushed back the point of sexual identity formation to a time before the preoedipal; the trajectory from Freud to Lacan to Kristeva advances a fast fall from oedipal to preoedipal to semiotic (or what one might call the pre-preoedipal). The very history of the institution of psychoanalysis enacts a critical temporal inversion: the preoedipal is theorized after the oedipal, suggesting that any "pre" is a construct of the "post."[5] Ironically, psychoanalysis itself performs the very regressive movement which Freud, and Lacan in his famous "return to Freud," describe as constitutive of what might be called homosexuality's "devolutionary" process— that is, a temporal fall back, a return to a time before the beginning of

time, before culture, before oedipality, and before history. Inverted in its progression, psychoanalysis uncannily follows a developmental path strikingly similar to the etiology of homosexuality first set out by Freud.

What this essay does not address is the question of female homosexuality's "etiology" (the "cause" or "origin" of inversion)—a question that can only assume in advance what it purports to demonstrate. Rather it seeks to understand how female homosexuality is not only structurally situated in the inaugural moments of psychoanalysis but theoretically located at the site of an origin, the origin of *any* female sexual identity. These latter questions will tell us far more about what Patricia Williams has recently termed "inessentially speaking"[6] than what even Freud recognizes as the pointless resuscitation of debates over etiology (i.e., is homosexuality innate or acquired?)[7] Inessentiality is a particularly useful figure for describing homosexuality's foundational yet liminal position in psychoanalytic accounts of identity formation. The preposition "in" in "inessential," which here doubles as a prefix, connotes at once a relation of exteriority or nonessentiality (in the sense of incidental, superfluous, peripheral, unimportant, immaterial, lesser, minor, secondary . . .) and a relation of interiority, of being inside essentiality (in the sense of indispensable, central, important, fundamental, necessary, inherent, vital, primary . . .). Homosexuality is "inessential" in this double sense, positioned within psychoanalysis as an essential waste ingredient: the child's homosexual desire for the parent of the same sex, essential to the subject's formation as sexed, is nonetheless simultaneously figured as nonessential, a dispensable component of desire that ultimately must be repudiated and repressed. Could repeated emphasis on the essential inessentiality of homosexuality, its status as repressed excess, reflect a secondary reaction-formation against psychoanalysis's own attraction to an economy of the same, its desire for the homo, and indeed its narcissistic fascination with its own origins?

Homosexuality, Law, Excess

I want to turn now to Freud's "The Psychogenesis of a Case of Homosexuality in a Woman"[8] to begin to work through this question of the essential inessentiality of homosexuality in women. We are faced immediately with a certain ambiguity in the title, where "The Psychogenesis of a Case of Homosexuality in a Woman" can be glossed as either the psychogenesis of an *instance* of homosexuality in a woman or

the psychogenesis of Freud's own *study* of homosexuality in a woman. In the first case, Freud characteristically bases an entire theory of female sexual inversion on a single case history: that of an eighteen-year-old girl, "beautiful and clever," from a family of "good standing," who has become infatuated with a woman ten years her senior, a "lady" of "fallen" circumstances known for her "promiscuous" behavior. In the second case, Freud traces, also in characteristic fashion, the genesis of his own work, reminding us that psychoanalysis has always been fascinated with beginnings, especially its own, and preoccupied with its relation to the law, indeed its status *as* law. The case begins: "Homosexuality in women, which is certainly not less common than in men, although much less glaring, has not only been ignored by the law, but has also been neglected by psychoanalytic research" (147). In their specific relation to the question of homosexuality in women, psychoanalysis and the law are analogously related: neither is able to see what is immediately before it. Homosexuality constitutes not an absence, strictly speaking, but an over-presence, an excess, a surplus, or an over-abundance; homosexuality may be "less glaring" in women than in men, but it is still "glaring" (*lärmend*). Freud's choice of the word *lärmend* (riotous, noisy, unruly) to describe homosexuality insinuates that the blindness issues from homosexuality itself, its very excess an assault upon the senses, a blinding and deafening spectacle. The law has "ignored" homosexuality in women and psychoanalysis has "neglected" it not because homosexuality is invisible but because, apparently, it is too visible, too audible, too present. The precise characterization of homosexuality as "glaring" permits Freud to deflect psychoanalysis's concentrated "work of elucidation" (171) away from its own powers of definition and concealment, for it is the law of psychoanalysis to establish the frame of reference, the conditions of visibility and audibility, by which sexual identities can be seen and heard in the first place and, in the case of homosexuality, *as* first places, as sites of origin.

Freud continues: "The narration of a single case, not too pronounced in type, in which it was possible to trace its origin and development in the mind with complete certainty and almost without a gap may, therefore, have a certain claim to attention" (147). Although elsewhere, in *Three Essays on the Theory of Sexuality*, Freud theorizes three different kinds of inverts—absolute (inverts whose "sexual objects are exclusively of their own sex"), amphigenic ("psychosexual hermaphrodites" whose "sexual objects may equally well be of their own or of the opposite

sex"), and contingent (inverts who "under certain external conditions
... are capable of taking as their object someone of their own sex"),[9] he
prefers to psychoanalyze in his practice only the latter kind, contingent
inverts, cases "not too pronounced in type," where libidinal change is
possible and a turn away from the same-sex love object can be effected
by the analysis. It is crucial to point out here that there is at least an
implied distinction in Freud's work between "homosexual women" and
"homosexuality in women." At the end of this particular case study
Freud concludes that "a very considerable measure of latent or uncon-
scious homosexuality can be detected in all normal people" (171), that
"latent" homosexuality is, in fact, a central precondition of all "mani-
fest" heterosexuality. But whereas homosexuality can be found in all
women, not all women are homosexual. For Freud there must be some
"special factor" (168), some libidinal remainder or surplus, which con-
verts the contingent homosexuality in women into homosexual women.

Here we need to turn to the case history itself to understand the
dynamics of this object conversion. Freud's patient is an adolescent girl,
the only daughter in a family with three sons, brought to Freud by a
strict and puritanical father in the hopes that analysis might "cure" his
daughter of an infatuation with a lady of questionable social standing
and loose sexual mores. In the course of the analysis Freud uncovers the
girl's "exaggeratedly strong affection" in early puberty for a small boy,
not quite three years old, an affection which gradually evolved into an
interest in "mature, but still youthful women" (156) who are themselves
mothers. The motivation for this curious shift in the girl from a "mater-
nal attitude" (156) (wanting to *be* a mother) to a homosexual one (want-
ing to *have* a mother) Freud attributes to the unexpected pregnancy of
the girl's own mother and the birth of her third brother. The girl is, in
short, in love with her own mother and redirects this tabooed desire
toward a series of mother-substitutes. Freud immediately disavows,
however, this homosexual daughter-mother incest by reading it as a
displacement of a preceding heterosexual daughter-father incest. The
"origin" of the girl's (preoedipal) mother-love is a prior (oedipal) father-
love; she turns away from her father and toward her mother out of dis-
appointment and resentment that it is her "hated rival," her mother, and
not herself who can give the father what it is assumed he most desires,
a son. The daughter, in Freud's account, to diffuse the identificatory
rivalry with her mother, falls back, "retires in favor of" her mother and
renounces men, in effect removing the obstacle hitherto responsible for

her mother's hatred by taking her mother instead of her father as love object (159). The daughter's desire for the mother is read by Freud as a ruse or a screen to protect the girl against her frustrated oedipal desire for the father. But why is it presumed from the outset that desire for the mother is a displaced articulation of unfulfilled desire for the father, and not the other way around? Why is the daughter's "disappointment" imagined to be provoked by her inability to have the father's baby and not her failure to give her mother one (a possibility Freud later allows for in "Femininity")? Why is the daughter's resentment and bitterness surmised to be directed toward the mother as competitor for the father's affections and not toward the father as interloper into the mother-daughter relation? Why, in short, is the daughter's "rivalry" assumed to be with the mother and not with the father?

Falling

Freud deploys a complicated rhetoric of "turns" in his work to explain these ambiguous shifts in sexual object choice, theorizing sexual identities and the sexual identifications that produce them in terms of returns, revivals, regressions, retirements, renunciations, and restorations. In the present case history, the analysand's turn toward a same-sex love object is triggered in adolescence by a change in the family configuration (the mother's pregnancy and the birth of a new brother) and a coinciding "revival" of the girl's infantile Oedipus complex. For Freud a revival is a peculiar kind of return: every revival of the girl's unresolved Oedipus complex is a regression—a fall back into a preoedipal identification with the father and desire for the mother. In "Femininity," Freud explains the turn back towards the mother as a response to an "inevitable disappointment" from the father:

> ... female homosexuality is seldom or never a direct continuation of infantile masculinity. Even for a girl of this kind it seems necessary that she should take her father as an object for some time and enter the Oedipus situation. But afterwards, as a result of her inevitable disappointments from her father, she is driven to regress into her early masculinity complex.[10]

Freud was not, of course, the only psychoanalyst to understand female homosexuality as a backward motion, although his theory of regression remains one of the most elaborately developed. Helene Deutsch, for example, also reads the female homosexual's apparent preoedipal attach-

ment to the mother as a postoedipal regression—"not a question of a simple fixation on the mother as the first love object, but rather a complicated process of returning." And Otto Fenichel puts the case even more bluntly:

> In women, the turning away from heterosexuality is a regression that revives memory traces of the early relations to the mother. Female homosexuality therefore has a more archaic imprint than male homosexuality. It brings back the behavior patterns, aims, pleasures, but also the fears and conflicts of the earliest years of life.[11]

For the homosexual presubject, every "pre" contains the spectre of a "re": female homosexuality is posited as regressive and reactive, primitive and primal, undeveloped and archaic. Moreover, any gesture of "retirement" signals a form of renunciation, a refusal to compete and a retreat from conflict; inability to sustain psychical conflict and desire to ward off "open rivalry" (195) actuate the girl's return to the preoedipal. Turning back in this reading is always read as a turning away, a retrenchment rather than an advance, a retreat *from* the father rather than a move *toward* the mother.

But there is a second and equally important sense of "turning" in Freud's work on homosexuality, namely psychoanalysis's own attempts to effect a conversion in the homosexual patient, a turning of one genital organization into another through the actual work of analysis. In his discussion of the proper conditions for a successful analysis, Freud admits that such conversions of sexual identifications in the subject are futile; the most psychoanalysis can do, he writes, is to "restore" the invert to his or her "full bisexual functions" (151). The earlier the inversion takes hold, the less likely a conversion can be effected: "It is only where the homosexual fixation has not yet become strong enough, or where there are considerable rudiments and vestiges of a heterosexual choice of object, i.e. in a still oscillating or in a definitely bisexual organization, that one may make a more favorable prognosis for psychoanalytic therapy" (151). Just as homosexuality is figured as a return, a fall back, so is its apparent psychoanalytic resolution, but whereas the one is posited as a regression, a retiring in favor of a rival, the other is presented as a restoration, a process of recuperation and reconsolidation. One can legitimately ask here why the return to a homosexual object-choice is seen as "regressive" when the return proferred as the means to "cure" homosexuality is seen as "restorative."[12] What marks

the difference between these two types of returns? And how, exactly, is a turn from one sexual object to another produced in the subject?

A third sense of "turning" in psychoanalysis speaks to these questions: the turn as fall. For Freud, a woman's return to desire for the mother enacts a fall—not a prelapsarian fall which was, after all, a fall into heterosexuality, but a postlapsarian fall into homosexuality. The female subject passes through the Symbolic, through the process of oedipalization, but because of a series of "inevitable disappointments from her father" lapses back into the preoedipal. It is hardly insignificant to Freud that the event that immediately precedes the beginning of the analysis, and indeed the crisis that occasions it, is the girl's attempted suicide. Strolling on the street one day in the company of the lady, the girl encounters her father who passes the couple by with "an angry glance" (148) [*zornigen Blick*]; incurring the sudden wrath of both father and beloved, the infatuated girl throws herself over a wall and falls onto a suburban railway track. Freud reads the suicide attempt as the fulfillment of the girl's unconscious wish—"the attainment of the very wish which, when frustrated, had driven her into homosexuality—namely, the wish to have a child by her father, for now she 'fell' through her father's fault" (162). Freud here plays on the double signification of the German word for "fall," *niederkommen*, which means both "to fall" and "to be delivered of a child" (162). The girl's fall back into a homosexual desire for the mother actually constitutes a particular kind of maternity in Freud's reading—a fall equivalent to a deliverance.

Cathy Caruth has suggested that "the history of philosophy after Newton could be thought of as a series of confrontations with the question of how to talk about falling,"[13] a proposition that takes on considerable force in light of Freud's own compulsive returns to the problem of the subject's "fall" into sexual difference. Scenes of falling in Freud's work frame sexuality as an injurious event. While working on "A Case of Homosexuality in a Woman," Freud added a passage to *The Interpretation of Dreams* that recounts one of his earliest childhood memories of an accident which befell him between the ages of two and three years old:

> I had climbed up on to a stool in the store-closet to get something nice that was lying on a cupboard or table. The stool had tipped over and its corner had struck me behind my lower jaw; I might easily, I reflected, have knocked out all my teeth.[14]

A lesson of the retribution inflicted upon young boys attempting to reach covertly into their mothers' cupboards, this remembrance of an early fall functions as a parable for the symbolic threat of permanent injury that precipitates Freud's own painful and sudden entry into oedipality. For the already castrated woman, however, *falling* symbolically registers another kind of injury. In "Dreams and Telepathy" (1922), published shortly after "A Case of Homosexuality in a Woman," Freud recounts a woman patient's recurrent nightmare of falling out of bed, where falling is taken to represent specifically a "fresh representation of childbirth"[15]—for Freud, the very mark of female heterosexual desire. "If a woman dreams of falling, he explains in *The Interpretation of Dreams*, "it almost invariably has a sexual sense: she is imagining herself as a '*fallen woman*'" (202). Or elsewhere, unable to resist summoning an old misogynistic proverb, Freud concludes that "when a girl falls she falls on her back."[16] And in the case history presently under discussion, "A Case of Homosexuality in a Woman," Freud notes with more than a physician's anecdotal detail that his homosexual patient "paid for this undoubtedly serious attempt at suicide with a considerable time on her back in bed" (148). Fear of falling for a woman apparently represents in this thinking both a fear of heterosexuality and a dread of one of its potential consequences, pregnancy, and yet it is precisely the motion of falling that Freud takes as constitutive of female homosexuality. The theoretical problem that insistently poses itself to any reader trying to make sense of Freud's often incoherent writings on female homosexuality is the question of what a woman's *homosexual* identity formation has to do with *maternity*, with "fresh representations of childbirth."

It cannot be a matter of indifference to feminist readers of Freud that "A Case of Homosexuality in a Woman" begins with the word "homosexuality" and concludes with the word "motherhood"—perhaps the most obvious staging of Freud's inability to think homosexuality outside the thematics of maternity. But how do we read the relation between these two poles of sexual identity formation: between homosexuality and motherhood, or between, in Freud's questionable theoretical alignment, same-sex desire and same-sex identification? Freud could be suggesting a symmetrical relation between the two, an irresolvable psychical tension in the young girl's life between wanting to *be* a mother and wanting to *have* her. Or he could be following a more conventional Victorian logic that posits motherhood as a possible antidote to homosexuality, the "answer" to the question that female homosexuality poses

for that psychoanalysis which sees itself as a science of restoration. Still another possibility to explain the homosexuality-motherhood alliance in this particular case study could be Freud's attempt to formulate an evolutionary sexual continuum with homosexuality as the originary "before" and motherhood as the developmental "after." Then again, Freud could also be suggesting that homosexuality represents a regressive return *to* the mother—a desire to have the mother by figuratively becoming the mother—a return achieved through a literal fall enacting a symbolic delivery. Details of the case history rule out none of these possibilities; in fact, the analyst's contradictory twists and turns in logic appear to mimic the unfolding drama of the analysand's own infinitely reversible and reactive identifications. The more difficult question for interpreters of Freud is determining precisely how the agencies of identification and desire are invoked to fashion this particular structural relation of dependency between homosexuality and motherhood, and why the first term (homosexuality) must always be read in relation to, and must eventually give way to, the second term (motherhood).

Identification and Desire

The return as fall, as deliverance, marks female homosexuality as not simply the subject's return *to* the mother but the subject's turn *as* mother. But this reading of the homosexual turn suggests that the daughter must *become* the mother in order to *have* her. It undermines one of the fundamental laws of psychoanalysis, preserved from Freud through Kristeva, which holds that desire and identification are structurally independent of one another, the possibility of one always presupposing the repression of the other. A subject's desire for one sex can only be secured through a corresponding identification with the other sex; a simultaneous desire for and identification with the same object would be a logical impossibility for Freud.[17] A year after publication of his "Homosexuality in a Woman" case study, Freud completed *Group Psychology and the Analysis of the Ego* (1921), where he first begins to systematize the complicated dialectical relation between identification and object-choice in the formation of the sexed subject:

> It is easy to state in a formula the distinction between an identification with the father and the choice of the father as an object. In the first case one's father is what one would like to *be*, and in the second he is what one would

like to *have*. The distinction, that is, depends upon whether the tie attaches to the subject or to the object of the ego. The former kind of tie is therefore already possible before any sexual object-choice has been made.[18]

To identify with the father is to wish to be him, whereas to desire the father is to wish to have him. The very notion of identification appears to be gendered for Freud, modeled on a masculine oedipality even when Freud is most concerned with theorizing the child's preoedipal (presexual) identification with the mother. Philippe Lacoue-Labarthe's shrewd observation that Freud "cannot help 'identifying' the figure of identification with the father figure"[19] further strengthens the suspicion that it is a postoedipal "secondary" identification that instantiates and organizes the preoedipal "primary" identification in the first place. A woman's desire for a woman, Freud maintains throughout his work, can only be thought in terms of the subject's fall back into a preoedipal identification with the father. But even Freud comes eventually to recognize, in *New Introductory Lectures on Psycho-Analysis* (1932–33), that the structural "independence" of identification and object-choice is never so neatly symmetrical as this "formula" would suggest, and is only ever precariously achieved. It is desire, for Freud, which continually risks turning (back) into identification:

> Identification and object-choice are to a large extent independent of each other; it is however possible to identify oneself with someone whom, for instance, one has taken as a sexual object, and to alter one's ego on his model.[20]

This turn from object-choice to identification is no simple turn; it operates, in fact, as a *return* and more properly a *regression*; "object-choice has regressed to identification," Freud writes on thinking back to his first case study of homosexuality in a woman, the Dora case.[21]

But Freud still needs to account for what motivates these turns in sexual object-choice, for what provokes the fall of desire into sexual identification. The answer to the problem of the turn in the "Homosexuality in a Woman" case study comes, as so many answers do in Freud, in a footnote:

> It is by no means rare for a love-relation to be broken off through a process of identification on the part of the lover with the loved object, a process equivalent to a kind of regression to narcissism. After this has been accomplished, it is easy in making a fresh choice of object to direct the libido to a member of the sex opposite to that of the earlier choice (158).[22]

Freud attributes the turn to an excess of desire, a surplus of love, or some other "overcompensation" (158). Why do some subjects have this "overness," this essential inessential psychical component, and not others? Freud is unable to answer the question he himself implicitly poses, but what is perhaps even more significant is that in the very attempt to prove that identification and desire are counterdirectional turns, Freud in fact demonstrates their necessary collusion and collapsability, the ever-present potential for the one to metamorphose into, or turn back onto, the other. The instability of sexual identity lies in the capacity of its psychical mechanisms *to desire and to identify with each other.*

Identification in Freud's work is typically figured in terms of height: identification works as a displacement *upward*; the ego elevates itself through identification, imagines itself always in relation to a higher ideal.[23] Situated at the very bottom of Freud's developmental scale, homosexuals are caught in the Sisyphean labor of pulling themselves up towards the ego-ideal only to be repeatedly disappointed by the object once attained. Sexuality in this scene of falling is neither given nor achieved but *lost*. Desire continually collapses back into identification under the weight of the subject's "disappointment," a disappointment prompted by the inadequacy of the object to fill the measure of its desire. This fall appears to be no different from the deflation any subject experiences when the fantasized object of desire is finally encountered. Slavoj Žižek rightly points out that the found object never coincides with the referent of desire; when faced with the object of desire, the desiring subject inevitably experiences a feeling of "this is not it."[24] What makes this homosexual fall, this fall into homosexuality, more precipitous is the fact that the subject's aspirations are more ambitious. This particular subject has overstepped its bounds and desired too much. Those who progress farthest in oedipalization apparently tumble hardest, with enough momentum and force to reenter the preoedipal stage, leaving desire, lack, and even injury behind. But what kind of fall, in this pseudo-scientific gravitational model, produces a homosexual subject? "We do not . . . mean to maintain," Freud insists, "that every girl who experiences a disappointment such as this of the longing for love that springs from the Oedipus attitude at puberty will necessarily on that account *fall a victim to homosexuality*" (168, emphasis added). Do some subjects carry within them a kind of Icarus complex,[25] an inherent proclivity for falling? Or are certain unpredictable Newtonian forces at work to pull any subject at any moment back into the center of gravity

Freud calls primary identification? If falling is the tropological model
Freud selects to describe homosexual identity formations, then what can
be said exactly to precipitate the fall?

Freud's excesses make their reentry at this point, for falling is concep-
tualized as a response to a heavy burden: one falls under an excessive
weight, the weight of desire—a desire that can only ultimately function
in such a symbolics as synonymous with heterosexuality. For Freud,
homosexual desire is oxymoronic; like women, homosexuals (male and
female) lack lack,[26] or lack a certain mature relation to lack. By tempo-
rally positing homosexuality as antecedent to the lack that inaugurates
desire, Freud in effect drops the sexuality out of homosexuality. It is not
lack that defines a homo(sexual) subject but excess, the lack of lack: the
surplus that precedes and delimits need, the unintelligible remainder
that circumscribes the boundaries of the rational, the overness that
must always come first to mark off the deviant from the normal. The
excess associated with homosexuality, in Freud's inversive logic (his
logic of inversion), holds the position of a "left-over" which comes
"right-before," with homosexuality assigned to the place of the firstness
of any supplement.

In its popular incarnations, the surfeit that marks off homosexuality
from its normative Other, heterosexuality, is "gleaned" from the surface
of the body: homosexuals are said to distinguish themselves by their
extravagant dress, their exaggerated mannerisms, their hysterical into-
nations, their insatiable oral sex drives, and their absurd imitations of
"feminine" and "masculine" behavior.[27] What we have in Freud's gram-
mar of excess is a critical displacement of excess from the exterior to
the interior; no longer a catalog of enculturating signs such as clothes,
language, or style, excess shifts from surface index to subterranean
force. Freud writes that his own patient betrayed none of the outward
signs a Viennese medical profession expected to find in a homosexual
woman, showing "no obvious deviation from the physical type, nor
any menstrual disturbance" (154). It is true, Freud confesses, that the
"beautiful and well-made girl" had her father's tall figure and sharp
facial features, as well as his intellectual acuity, but "these distinctions
are conventional rather than scientific" he concludes (154). Moreover,
unlike her famous predecessor Dora, Freud's latest homosexual patient
"had never been neurotic, and came to the analysis without even one
hysterical symptom" (155). In every superficial respect, his new patient
strikes Freud as completely unexceptional. Yet it is the very absence

of conventional hysterical symptoms (coughing, aphasia, weeping, spasms, tics . . .) or other external signs of neurosis that draw Freud ultimately to the conclusion that this woman's very normality is most irregular, her lack of "even one hysterical symptom" an indicator of the most abnormal or peculiar of states for a woman. This particular woman is excessively normal, her deviancy secured through an apparent psychological refusal of abnormality. Mimicry is transposed from the surface of the body to its psychical infrastructure as excess comes to designate something more than a style or a performance; excess for Freud marks a certain internal relation that defines the very structure of an emotional identification.

Mikkel Borch-Jacobsen, following Freud, explains the desire-identification dynamics this way: identification always *anticipates* desire: identification, rather than an object, "governs" (32), "orients" (34), "induces," and "predicts" desire (47). Identification, in effect, comes first, and the subject "dates" itself from this mimetic turn:

> Desire (the desiring subject) does not come first, to be *followed* by an identification that would allow the desire to be fulfilled. What comes first is a tendency toward identification, a primordial tendency which then gives rise to a desire; and this desire is, from the outset, a (mimetic, rivalrous) desire to oust the incommodius other from the place the pseudo-subject already occupies in fantasy. . . . Identification brings the desiring subject into being, and not the other way around.[28]

This approach de-essentializes sexuality in a particularly useful way, for to show that desires are never originary is also to imply that there are no "natural" or "normal" libidinal impulses that may later get rerouted or "perverted" through an identification gone astray. However, what remains completely ungrounded in this explanation of desire and identification is the problematical notion of *identification* as a "primordial tendency." Freud leans heavily on a scientific model of entropy that posits the motor force of psychological change and sexual development as a drive toward sameness, a tendency towards mimesis: homophilic identification. While crucially naming the indispensability of homophilic identification to the production of sexual identity, Freud nonetheless sees mimeticism as a continual threat to the stability and the coherency of that identity. For Freud, I would suggest, the real danger posed by the desire/identification co-dependency is not the potential for an excess of desire to collapse back into an identification, but the possibility for

71

new forms of identification to generate ever proliferating and socially unmanageable forms of desire.

"A Case of Homosexuality in a Woman" attributes the girl's sexual interest in young mothers to the eventual, perhaps even inevitable, collapse of her "strong desire to be a mother herself" (156), a change in object-choice brought about by the girl's oedipal disappointment at her failure to have her father's child—a failure made all the more visible by her own mother's mid-life pregnancy. The first objects of the girl's sexual desire after the birth of her youngest brother, Freud tells us, are therefore "really mothers, women between thirty and thirty-five whom she had met with their children," and even though the girl eventually gives up actual motherhood as the *"sine qua non* in her love object," analysis proves to Freud "beyond all shadow of doubt that the lady-love was a substitute for—her mother" (156). While Freud directs his theoretical remarks, and the reader's attention, to the problem of an excess of desire reverting (back) into an identification, the example proffered by the details of the case history itself demonstrates exactly the opposite phenomenon: the possibility for an overly-zealous identification ("the strong desire to be a mother") to give way to an equally powerful desire ("motherhood as a *sine qua non* in her love-object"). Apparently Freud's patient assumes her role too well, her excessive desire to be a mother the very trigger for her sudden desire to sleep with one. Yet the lurking danger posed by a too successful oedipalization signals exactly the paradox Freud refuses to see in his own reading, for to recognize this possibility would involve also, at the very least, entertaining the idea of heterosexuality as an inessential supplement and originary excess, or, in an even more radical (and, for Freud, untenable) formulation, allowing for the possibility that it is "absolute" or "exclusive" *hetero*sexuality which may be intolerable to the ego.[29] Moreover, Freud's tactical misreading of the actual workings of identification and desire in this particular case history permits him to deflect attention away from the enculturating and normative work of psychoanalysis: the attempt to effect "curative restorations" by carefully monitoring and limiting the range of a subject's identifications. The job of psychoanalysis, after all, is typically to reorient a culturally tabooed desire by first redirecting the identification that produced it—a task usually accomplished through the therapeutic use of transference.

Fallen Women

Freud's insistence upon the homosexual woman's "fall" into primary identification (preoedipal absorption with the mother) works effectively to exclude the woman who desires another woman from the very category of "sexuality," and it does so by ensuring that any measure of sexual maturity will be designated as heterosexual object-choice "achieved" through the act of secondary identification (oedipal incorporation of a parental ideal). Freud sustains the notion of female homosexuality's presexual status by assuming, first, that same-sex desire is principally and finally an act of primary identification and, second, that primary identification is completely uninflected by the cultural markers associated with secondary identification. When the girl leaves the Oedipus complex, which marked her original entry into history and culture, and falls into the shadowy nether world of primary identification, she drops out of sexual difference as well. But "primary" identification is itself a social process, already presupposing in the subject prior knowledge of the culturally weighted distinction between maternal and paternal roles, and assuming in advance at least an "intuition" of sexual difference.[30] Preoedipality is firmly entrenched in the social order and cannot be read as before, outside, or even after the Symbolic; the mother-daughter relation, no less than the father-daughter relation, is a Symbolic association completely inscribed in the field of representation, sociality, and culture.

Freud explains his patient's homoerotic attachment to older women of child-bearing age as a rehearsal of the girl's early "mother-complex," a preoedipal, presexual state of nondifferentiation with the mother, while at the same time making this homosexual object-choice entirely dependent upon a (preceding) paternal identification. This contradictory insistence upon homosexuality's postoedipal return to a precultural fixation flatly contradicts the case history's repeated disclosures of the importance, in the formation of the girl's sexual identity, of specifically social ties between the girl, her family members, and the extra-familial objects of her affections. Exactly whom the girl identifies *with* in her homosexual attachment to the lady is never entirely clear. While Freud ostensibly concludes that a masculine, paternal identification permits the girl's homosexual object-choice ("she changed into a man and took her mother in place of her father as the object of her love," (158)), his patient's suicidal plunge, which temporarily replaces the father's puni-

73

tive anger with parental solicitude, suggests a feminine, maternal identi-
fication in which the girl continues to compete with her mother as rival
for her father's love and attention (the mother "had herself suffered for
some years from neurotic troubles and enjoyed a great deal of consider-
ation from her husband," (149)). Equally indeterminate is the gendered
identity of the love object, insofar as the lady corresponds as much to
the girl's masculine as to her feminine ideal: "her lady's slender figure,
severe beauty, and downright manner reminded her of the brother who
was a little older than herself" (156).[31] With what in the other does the
subject identify if not a particular familial or social ideal? Put slightly dif-
ferently, what does the subject desire in the other if not a cultural reflec-
tion of what she herself aspires to be?

The scale of identification, in which the desiring subject rises and falls
according to the strength of the pull and resistance of its elusive object,
carries along with it a strong class connotation for Freud's patient. The
girl, a member of the rising middle class, finds herself irresistably
attracted to "fallen women." Her current object of desire, a "demi-
mondaine" (153) who has lost her reputation and fallen into "ignoble
circumstances," inspires in the enamored young girl fantasies of chival-
ric rescue. The case history provides a strong suggestion that the "lady"
is, in fact, a "lady-of-the-evening," a woman who maintains some sem-
blance of her former class status by earning a living as a high-class pros-
titute: "she lived simply by giving her bodily favours." But even before
her devotion to the lady, the girl's "first passions had been for women
who were not celebrated for specially strict propriety" (161). These early
infatuations include "a film actress at a summer resort" (who first incites
the ire of the girl's father, (161)) and "a strict and unapproachable mis-
tress" (who, Freud adds, is "obviously a substitute mother," (168)). For
the girl, "bad reputation" in the love object is "positively a 'necessary
condition for love'" (161). All three of these mother-substitutes—the
prostitute, the actress, and the teacher—occupy a class below the girl,
but they also represent collectively a class of women who earn their liv-
ing independently, outside of marriage and the heterosexual contract.
Could it be that the force of the attraction exerted on the girl by these
figures of desire is, in part, the lure of the economic independence and
social mobility which they represent? The real provocation of the girl's
impassioned devotion to these working ladies may issue not simply
from the sex of her love objects but from their "low" social standing as
well. To a class-conscious Viennese society, the greatest threat posed by

the girl's "homosexual enthusiasms" (168) is the ever present possibility of what Freud diagnoses elsewhere as "the dangers of sexual relations with people of an inferior social class."[32]

This figuration of identification as a problem of height and scale, a matter of the ego's striving to reach up to an elevated object, further recalls the image of the young Freud reaching for the unattainable goods in his mother's cupboard. That one of Freud's earliest memories should summon up a fall during the preoedipal stage, a fall that inflicted a wound whose scar he bears with him into adulthood, may suggest Freud's unconscious fear that he has already been castrated and placed on a homosexual continuum along with the mother. Indeed, what Freud seems most anxious to disavow in his analysis of the young girl is his own identification with the feminine. Freud more or less admits directly to an identification with his patient's stern but loving father, "an earnest, worthy man, at bottom very tender-hearted" (149), and he seems convinced that his patient, as he tellingly puts it, "intended to deceive me just as she habitually deceived her father" (165). But this masculine identification masks a deeper, more disturbing feminine identification with the mother who "enjoyed her daughter's confidence concerning her passion" (149). The transferential role Freud frequently found himself playing in his therapeutic sessions was not exclusively nor even principally the familiar role of paternal prohibitor but more often the less comfortable role of maternal educator: substitute mother figure imparting sexual knowledge to adolescent girls. In fact, as a male doctor speaking candidly on sexual subjects to girls in his professional care, regularly opening himself to charges of social impropriety and sexual prurience, Freud could not entirely escape (despite his best attempts to seek refuge behind the mantle of scientific knowledge) the "taint" of a feminine identification with the mother whose proper role is to educate her daughter on matters of sexual and social conduct. This is not the first time Freud has disavowed a strong feminine identification. For example, in addition to Freud's much-discussed identification with Dora's hysteria, Jim Swan has uncovered Freud's unconscious identification with a pregnant woman in the dream of Irma's injection and an equally strong identification with his childhood nurse in the dream of "a little sheep's head." Freud himself was unable to make these connections, even though, as Swan points out, the idea of the therapist as a nurse to his patients is not in the least an uncommon theme in psychoanalytic literature.[33]

Fighting continually against the "low estimation" (149) in which psychoanalysis is held in Vienna, Freud perhaps more closely resembles the lady than any other stock figure in this extended family romance. Freud's own marginal social standing and his life-long economic anxieties, in addition to his frank discussion of sexuality, all situate him structurally in the position of the lady, the fallen woman. But unlike the lady, Freud is unable to achieve any stature or prominence in his patient's eyes:

> Once when I expounded to her a specially important part of the theory, one touching her nearly, she replied in an inimitable tone, "How very interesting," as though she were a *grande dame* being taken over a museum and glancing through her lorgnon at objects to which she was completely indifferent. (163)

This overly-clever comparison of his patient to a *grande dame* glancing through her lorgnon betrays Freud's sensitivity to the girl's cutting pretenses to class superiority. When, in a psychodrama like this one, the look carries such potent and castrating powers, not even Freud is immune to the discomfiture provoked by his patient's class condescension—an irritation that ultimately leads Freud to terminate the girl's treatment and to counsel his patient to see a woman doctor instead (164). "Retiring in favor of someone else" (159),[34] Freud beats a fast retreat, acting out the very rhetorical move which he identifies in this case history as one of the "causes" of homosexuality (159). Fixed by his patient's arrogant glance, much like the girl is herself arrested on the street by her father's disapproving look, Freud "falls" through his patient's fault. In a case history where reversible and elastic identifications keep the family neurosis in motion, Freud interestingly gets to play all the principal parts: father, mother, beloved, *and* girl.

Conclusion

The subject, governed by a drive to consume and to possess the object of its desire, must resist the call of primary identification (homophilia) if it is to succeed in its climb toward maturity, defined as object-relatedness (heterophilia). Primary identification—something of a redundancy in Freud—operates as the gravitational pull that perpetually threatens to capsize the subject under the excessive weight of its own regressive desires. In short, identification both precedes desire and strives to

exceed it, propelled by its insatiable oral drive to swallow desire whole. In Freud's reading of identification and desire, homosexual desire is not even, properly speaking, desire. Rather, homosexuality represents an instance of identification gone awry—identification in overdrive (or, one might say, oral drive). This overdrive is also implicitly a death drive: *cadere* (Latin for "to fall") etymologically conjures cadavers. For Freud every fall into homosexuality is *inherently suicidal* since the "retreat" from oedipality entails not only the loss of desire but the loss of a fundamental relation to the world into which desire permits entry—the world of sociality, sexuality, and subjectivity.

While desire is the province and the privilege of heterosexuals, homosexuals are portrayed as hysterical identifiers and expert mimics.[35] By strategically aligning "homo" with identification and "hetero" with desire, Freud, in spectacularly circular fashion, resubmits homosexuality to its own alleged entropic "tendencies," so that "homo" subsumes "sexuality" and identification incorporates desire. What Freud gives us in the end is a Newtonian explanation of sexual orientation in which falling bodies are homosexual bodies, weighted down by the heaviness of multiple identifications, and rising bodies are heterosexual bodies, buoyed up by the weightlessness of desires unmoored from their (lost) objects. This chapter has attempted to demonstrate that such a mechanistic explanatory model is itself overburdened and constrained by the heaviness of its terms, terms which increasingly come to exceed the bounds and conditions of their founding logic. Precisely because desire and identification cannot be securely separated or easily prevented from turning back on one another, Freud's persistent attempt to read sexual orientation according to the laws of gravity and motion ultimately falls apart, splintering under the pressure of its own rhetorical weight.

NOTES

1. Sigmund Freud, "The Psychogenesis of a Case of Homosexuality in a Woman" (1920), *Standard Edition,* 18:145–72. The original text, "Über die Psychogenese eines Falles von weiblicher Homosexualität," can be found in volume 12 of *Gesammelte Werke* (Frankfurt am Main: S. Fischer Verlag, 1968), 271–302.

2. The phrase is Jacques Lacan's, from Seminar I on *Freud's Papers on Technique, 1953–1954,* ed. Jacques-Alain Miller, trans. John Forrester (New York and London: W. W. Norton and Company, 1988), 198. In its interest in the inverted, disorientating logic of the "pre" and the "post," this essay addresses, albeit from a different direction, many of the same theoretical problems discussed in Lee Edelman's analysis of the Wolf Man. In "Seeing Things: Representation, the Scene of Surveillance, and the Spectacle of Gay Male Sex," Edelman returns to the question of "sexual suppositions" in the psychoanalytic constitution of male subjectivity, while my own reading of female homosexuality anticipates the problem of sexual presuppositions. A comparative reading might also conclude that Edelman's (be)hindsight finds an epistemological counterpart in my own focus upon a circumscribed (be)foresight. While the cultural representations of lesbian sexuality as "foreplay" and gay male sexuality as "behindplay" (see Edelman, 104) may well overdetermine the staging of these particular theoretical "scenes," it strikes me that such investigations of the before and the behind (my own confrontation with the before post-dating Edelman's entry into the behind) might more profitably be read back-to-back. See Lee Edelman's contribution to *Inside/Out: Lesbian Theories, Gay Theories,* ed. Diana Fuss (New York and London: Routledge, 1991).

3. Catherine Clément, *The Lives and Legends of Jacques Lacan,* trans. Arthur Goldhammer (New York: Columbia University Press, 1983), 60.

4. See Sigmund Freud, *Dora: Fragment of an Analysis of a Case of Hysteria* (1905), *Standard Edition,* 7:125-243; Jacques Lacan, *De la psychose paranoïaque dans ses rapports avec la personalité suivi de Premiers écrits sur la paranoïa* (Paris: Editions du Seuil, 1975); and Julia Kristeva, *About Chinese Women,* trans. Anita Barrows (New York and London: Marion Boyars, 1977).

5. Judith Butler is especially adept at relentlessly interrogating the specious logic of a before and an after, exposing how every before (what ostensibly comes first) is really an effect of the after (what it was thought to precede): for example, the preoedipal an effect of the oedipal, the prediscursive an effect of the discursive, the prejuridical an effect of the juridical, and so on. *Pre*formatives are read as *per*formatives in Butler's deconstruction of false foundationalisms. See *Gender Trouble: Feminism and the Subversion of Identity* (New York and London: Routledge, 1990).

6. I am grateful to Patricia Williams for her suggestion of this particular term and for her invitation to think more about the figure of inessentiality at the annual meeting of the American Association of Law Schools; some of the following remarks were formulated for that occasion on a panel devoted to the problem of "inessentially speaking."

7. Although unable to resist speculating on etiological foundations throughout his work on sexual inversion, Freud nonetheless seems peculiarly aware of the futility of doing so. He writes in the present case history: "So long as we trace the development from its final outcome backwards, the chain of events appears continuous, and we feel we have gained an insight which is completely satisfactory or even exhaustive. But if we proceed the reverse way, if we start from the premises inferred from the analysis and try to follow these up to the final result, then we no longer get the impression of an inevitable sequence of events which could not have been otherwise determined" (167).

8. "The Psychogenesis of a Case of Homosexuality in a Woman" may well be Freud's most overlooked case study; certainly compared to the volume of criticism generated by the Dora case history, the "Psychogenesis" paper has received surprisingly little attention. For some important exceptions to this critical silence, see Luce Irigaray, "Commodities Among Themselves" in *This Sex Which Is Not One*, trans. Catherine Porter (Ithaca: Cornell University Press, 1985); Mandy Merck, "The Train of Thought in Freud's 'Case of Homosexuality in a Woman,'" *m/f* 11/12 (1986): 35–46; Judith A. Roof, "Freud Reads Lesbians: The Male Homosexual Imperative," *Arizona Quarterly* 46:1 (Spring 1990): 17–26; Diane Hamer, "Significant Others: Lesbians and Psychoanalytic Theory," *Feminist Review* 34 (Spring 1990): 134–51; and Mary Jacobus, "Russian Tactics: Freud's 'Case of Homosexuality in a Woman,'" in *First Things: Reading the Maternal Imaginary* (New York and London: Routledge, 1995).

9. Sigmund Freud, *Three Essays on the Theory of Sexuality (1905)*, *Standard Edition*, 7:136–37.

10. Sigmund Freud, "Femininity," in *New Introductory Lectures on Psychoanalysis* (1933), *Standard Edition*, 22:130.

11. Helene Deutsch, "On Female Homosexuality," in *Psychoanalysis and Female Sexuality*, ed. Hendrik Ruitenbeek (New Haven: College and University Press, 1966), 125. Deutsch's essay was originally published in *The International Journal of Psychoanalysis* 14 (1933), the same year Freud's *New Introductory Lectures* appeared in print. See also Deutsch's *The Psychology of Women*, vol. 1 (New York: Bantam, 1973), 332–361. The Fenichel citation is taken from his volume on *The Psychoanalytic Theory of Neurosis* (New York: W.W. Norton and Company, 1945), 340.

12. For an interesting inversion of the regression/restoration binary, see John Fletcher's "Freud and His Uses: Psychoanalysis and Gay Theory," in *Coming On Strong: Gay Politics and Culture*, eds. Simon Shepherd and Mick Wallis (London: Unwin Hyman, 1989), 90–118. Fletcher sees lesbianism, and not its proposed psychoanalytic "cure," as the true

restoration. To the degree that lesbianism *contests* castration, it can be read as "a restorative strategy which seeks to repair the losses, denigrations, thwartings that a patriarchal culture inflicts on the girl in her primary relation to the mother" (105).

13. Cathy Caruth, "The Claims of Reference," *The Yale Journal of Criticism* 4:1 (Fall 1990): 194.

14. Freud, *The Interpretation of Dreams* (1900), *Standard Edition*, 5:560. See also "Dreams and Telepathy" (1922), *Standard Edition*, 18:198.

15. Freud, "Dreams and Telepathy," 213.

16. Sigmund Freud, *The Psychopathology of Everyday Life* (1901), *Standard Edition*, 6:175.

17. I have discussed the implications of Freud's persistent attempts to dichotomize desire and identification in "Fashion and the Homospectatorial Look," *Critical Inquiry* 18 (Summer 1992): 713–737. For a similar critique of Freud's insistence on the mutual exclusivity of subject and object, which focusses by contrast on Freud's theorization of *male* sexuality, see Michael Warner's "Homo-Narcissism; or, Heterosexuality," in *Engendering Men: The Question of Male Feminist Criticism*, eds. Joseph A. Boone and Michael Cadden (New York and London: Routledge, 1990), 190–206. Warner points out that the argument Freud offers to explain why a subject might choose one secondary identification over another is based entirely on recourse to the suspect notion of congenital predispositions: "only the child's 'sexual disposition'—i.e., its 'masculine' or 'feminine' bent—will determine the relative *weight* of these identification axes" (196, emphasis mine).

18. Freud, *Group Psychology and the Analysis of the Ego* (1921), *Standard Edition*, 18:106.

19. See *Typography: Mimesis, Philosophy, Politics*, ed. Christopher Fynsk (Cambridge, MA: Harvard University Press, 1989), 114. Lacoue-Labarthe is one of the most astute readers of identification's inscription in the social field.

20. Sigmund Freud, *New Introductory Lectures*, 63.

21. Freud, *Group Psychology*, 107.

22. A simpler way to put this problem of desire slipping over and into identification is to say that it is possible to love someone so excessively and exclusively that one gradually becomes that person.

23. Kaja Silverman, "White Skin, Brown Masks: The Double Mimesis, or with Lawrence in Arabia," in *Differences: A Journal of Feminist Cultural Studies* 1:3 (Fall 1989): 25. Silverman helpfully suggests that we think of identification "not so much as the 'resolution' of desire as its perpetuation within another regime" (24).

24. Slavoj Žižek, *Looking Awry: An Introduction to Jacques Lacan Through Popular Culture* (Cambridge, MA: MIT Press, 1991), 92.

25. I am indebted to Alan Stoekl's identification of the Icarian complex, an "unconscious and pathological desire to fall," in the work of Georges Bataille. See Stoekl's introduction to Bataille's *Visions of Excess: Selected Writings, 1927–1939* (Minneapolis: University of Minnesota Press, 1985), xv.

26. Michèle Montreley, "Inquiry into Femininity," *m/f* 1 (1978): 83–102.

27. There can perhaps be no better, more playful, more mimetic response to such excessive parodies than more excess—a politics of mimesis. As recent work on camp, butch-femme, hermaphrodism, transvestism, and transsexualism has powerfully and per-

formatively demonstrated, to be excessively excessive, to flaunt one's performance as performance, is to unmask all identity as drag. Central to each of these studies is Irigaray's distinction between "masquerade" and "mimicry" where the critical difference between them—between the "straight" imitation of a role and a parodic hyperbolisation of that role—depends on the degree and readability of its excess (see Chapter 5). But without the telltale signs of excess, encoded in the mimic's walk, speech, or dress, mimicry would be indistinguishable from masquerade and the political utility of mimesis would be negligible. Excess, in other words, is all that holds the two apart, for to fail in mimesis is usually to fail in being *excessive enough*. Currently, three of the most important works which attempt to theorize the problematics of excess in the politics of mimesis are Carole-Anne Tyler's *Female Impersonators* (New York and London: Routledge, 1996-), Marjorie Garber's *Vested Interests: Cross-Dressing and Cultural Anxiety* (New York and London: Routledge, 1991), and Judith Butler's *Bodies That Matter* (New York and London: Routledge, 1994).

28. Mikkel Borch-Jacobsen, *The Freudian Subject*, trans. Catherine Porter (Stanford: Stanford University Press, 1988), 47.

29. Sandor Ferenczi's 1909 "More About Homosexuality" contains one of the earliest suggestions in psychoanalysis that homosexuality may be the effect of an "excessively powerful heterosexuality." See Ferenczi's *Final Contributions to the Problems and Methods of Psychoanalysis*, ed. Michael Balint, trans. Eric Mosbacher (New York: Basic Books, 1955). Cited in Kenneth Lewes, *The Psychoanalytic Theory of Male Homosexuality* (New York: New American Library, 1988), 146.

30. For an excellent discussion of the differences between primary and secondary identification, see Mary Ann Doane's "Misrecognition and Identity" in *Explorations in Film Theory: Selected Essays from Ciné-Tracts*, ed. Ron Burnett (Bloomington and Indianapolis: Indiana University Press, 1991), 15–25. Regarding the problem of primary identification, Doane reasonably wonders: "does it really define a moment which is neuter, which predates the establishment of sexual difference?" (21)

31. Lines like these, which suggest (on the part of the girl) a masculine object-choice in addition to a masculine identification, lead Judith Roof to conclude that Freud's theory of lesbianism amounts in the end to little more than a displaced analysis of *male* homosexuality. See Roof's "Freud Reads Lesbians."

32. Freud, *Interpretation of Dreams*, 305. One of Freud's most interesting readings of class conflict can be found in this analysis of a male patient's "sapphic dream" where "above" and "below" refer not only to sexual parts but to social positions as well. His patient's dream of laborious climbing reminds Freud of Alphonse Daudet's *Sappho*, a book that Freud understands as a powerful "warning to young men not to allow their affections to be seriously engaged by girls of humble origin and a dubious past" (286).

33. Jim Swan, "*Mater* and Nannie: Freud's Two Mothers and the Discovery of the Oedipus Complex," *American Imago* 31:1 (Spring 1974): 39. Swan hypothesizes that Freud's resistance to acknowledging publically his fear of a feminine identification has everything to do with his anxieties over homosexuality (27). Swan's essay remains one of the best and most suggestive readings of why Freud waited until shortly after the death of his mother in 1930 to "discover" the critical importance of preoedipality and the infant's primary erotic identification with the mother.

34. Mandy Merck asks: "In insisting upon a woman analyst isn't Freud acting precisely as he accuses his homosexual patient of doing?" (44). In "Russian Tactics," Mary Jacobus also provides a fascinating reading of Freud's feminine identifications, arguing that "even

more than the woman doctor in whose favour Freud 'retires,' the lady turns out to be a rival authority on lesbian and bisexual matters." Both Merck and Jacobus provide particularly useful accounts of the case history's opening rhetoric of courtly love and its closing allusion to surgical sex-change. I thank Mary Jacobus for generously sharing with me her work in progress.

35. I am indebted to Marcia Ian for seeing the implications of my reading of Freud here better than I did.

3

ORAL INCORPORATIONS:
The Silence of the Lambs

> Human life is still bestially concentrated in the mouth.
> Georges Bataille, *Visions of Excess*[1]

IF, IN THE POPULAR IMAGINARY, gay male sexuality can be said to have an erotogenic zone of its own, its corporeal "repository" may well be the spectacularized site of the anus. Currently, some of the most provocative readings of male sexuality focus on interrogating the cultural priority attributed to the anus across a spectrum of iconographic representations of homosexuality—representations that variously eroticize, hystericize, and demonize the orifice behind. D. A. Miller, for instance, in a dazzling reading of Hitchcock's *Rope* (entitled, appropriately, "Anal *Rope*") uncovers a phobic terror of the eroticized backside "wound" as the very spur to Hitchcock's fantasy of a film without cuts, a movie without a single "penetrable hole in the celluloid film body."[2] Lee Edelman's "Seeing Things: Representation, the Scene of Surveillance, and the Spectacle of Gay Male Sex" is an elegantly nuanced reading of the idea of "behindsight" in Freud's analysis of the Wolf Man and the role the anus plays in inciting castration anxiety; as a site of penetration, the anus operates for men as a "phobically charged" orifice that Freud suggests must be actively repudiated if the male subject is to submit to the law of castration and to the imperative of heterosexualiza-

tion.³ And Leo Bersani, in an ambitious exposé of anal politics, reminds us in his essay called "Is the Rectum a Grave?" that even "in cultures that do not regard sexual relations between men as unnatural or sinful, the line is drawn at 'passive' anal sex."⁴ Bersani's immediate concern is with contemporary public discourse about AIDS, specifically the abjectification of the rectum as a site of criminality and certain fatality—a contaminated, contaminating vessel. The anus routinely figures as the overdetermined cultural localization of male homoerotic desire, thanks in large part to Freud's insistence that it is specifically the body orifice of the bowels that plays a major role in strengthening the "passive trend" necessary for the development of a "homosexual" object-choice.⁵

I would like to suggest that alongside the scene of intercourse *per anum* between men, modernist culture offers quite another spectacle of male homosexuality, one based on oral, rather than anal, eroticism. This other sodomitical scene, organized around the sexual practice of fellatio, does not displace so much as extend and stretch the priority accorded to anality in symbolic configurations of male homosexuality. Notions of anal incorporation cannot help but to invoke tropes of orality; the anus operates in many ways as a kind of displaced mouth or second oral cavity, an organ that can take in as well as eject, just as the mouth can expel as well as receive. Mouth substitutes for anus, and anus for mouth, as each comes to symbolize the gaping, grasping hole that cannibalistically swallows the other. I will be discussing in this chapter two recent media spectacles that create public terror in large part by summoning this archaic definition of gay sexuality as oral insatiability. Jonathan Demme's 1991 Oscar-winning horror film, *The Silence of the Lambs*, and the sensational story of Milwaukee serial killer Jeffrey Dahmer ("a real-life *Silence of the Lambs*," in the words of *People* magazine)⁶ together demonstrate how the advent of a new public fear of cannibal murder and the intensification of an old and especially virulent form of homosexual panic can converge in a potent, explosive, and dangerous way to brand homosexuality itself as "serial killing." Before turning directly to the subject of serial killing, I would like to take a closer look at the psychoanalytic narratives of oral eroticism and sexual perversion that give these contemporary stories of human monstrosity their peculiar representational power. In the history of Western psychoanalytic representations of the ravenously hungry, insatiably promiscuous male invert, *gay sex has always been cannibal murder.*

Heads or Tails?

Like the wing of stamin (death), the membranous partition [*cloison*] that is called the soft palate, fixed by its upper edge to the limit of the vault, freely *floats*, at its lower edge, over the base of the tongue. Its two lateral edges (it has four sides) are called "pillars." In the middle of the floating edge, at the entrance to the throat, hangs the fleshy appendix of the uvula [*luette*], like a small grape. Jacques Derrida, *Glas*[7]

The most archaic of the sexual organs and the least developed of the libidinal zones, the sensitive mucous membrane of the mouth provides us with our earliest sexual experience: "sucking at the mother's breast is the starting-point of the whole of sexual life, the unmatched prototype of every later sexual satisfaction, to which phantasy often enough recurs...."[8] Each of Freud's oral, anal, and phallic phases of infantile sexuality corresponds to a different bodily function, with the satisfaction the child obtains from eating preceding the pleasure it later derives from either rectal stimulation or phallic masturbation. But despite the originary status accorded to the mouth in this developmental hierarchy of erotogenic zones, Freud's theoretical "discovery" of the anal phase precedes that of the oral phase by a full two years, and that of the phallic phase by almost a decade. Freud's famous theory of the three partial drives makes its dramatic entry onto the psychoanalytic stage *arse backwards*; the anus comes first, in the context of his 1913 work on male homosexuality and the critical role its repression plays in the obsessional neuroses. Not until the third edition of *Three Essays on the Theory of Sexuality* in 1915 does Freud finally distinguish between the "oral or cannibalistic phase" and the "sadistic anal phase," adding the "phallic phase" much later in a 1923 rethinking of the question of "the infantile genital organization."[9]

In the adult subject, the libidinal impulses are themselves coterminous, simultaneously active as each sexual drive fights to achieve dominance over the other. Commentators on Freud's theory of the drives tend to emphasize their dynamism and porousness: "oral fantasies about assimilating objects through the mouth will be connected with anal fantasies about assimilation through the anus, and similarly anal fantasies about defecating will correspondingly be associated with phallic fantasies about losing the penis."[10] The mouth, in other words, provides at

least as much castration anxiety as the anus, with the latter once again assuming the properties of a second oral orifice. Mouth and anus, both fated in this sexual allegory to yield to the dominion of the phallus, are less opposite than analogous, and, as such, infinitely substitutable. The intimate relations between these two orifices may well explain their conspicuous absence from those catalogs of symbolic polarities that cultural theorists identify as upholding normative sexual behavior. For instance, Eve Sedgwick's self-described "bravely showy list of binarized cultural nexuses,"[11] totaling nearly forty pairs, includes active/passive, private/public, health/illness, natural/unnatural, subject/object, in/out, and masculine/feminine (to name just a handful)—but not oral/anal. And rightly so: the mouth/anus opposition was never really part of a symmetrical pair to begin with, perhaps because the shadow of the phallus already loomed large in Freud's corpus as a potential third term, permanently disorganizing the equation. Freud, while refining his theory of succession to acknowledge that each early phase persists alongside of and behind the later configurations, nonetheless insists that as organs of sexual desire, mouth and anus must be "abandoned"[12] in favor of the genitalia if the subject is to attain sexual maturity. Failure to relinquish these "primitive" and "primordial" zones accounts for the appearance of what Freud calls the human sexual perversions.

Perversion for Freud is fundamentally a question of how organs are used and with what degree of "exclusiveness" and "fixation."[13] These two latter criteria are the distinguishing features that separate "normal" from "perverse" sexual acts, *even if these acts are structurally identical.* Oral and anal eroticism, in this account, are not in themselves perverse; Freud attempts to clarify in *Three Essays on the Theory of Sexuality* that the "differences separating the normal from the abnormal can lie only in the relative strength of the individual components of the sexual instinct and in the use to which they are put in the course of development" (205). Thus Freud can assert, with no apparent fear of contradiction, that "preference" for anal intercourse "is in no way characteristic of inverted feeling": "on the contrary, it seems that *paedicatio* with a male owes its origins to an analogy with a similar act performed with a woman" (152). And looking back on the fantasy of fellatio in the Dora case (a fantasy that arguably is more Freud's than Dora's), Freud can reassure us that "there was no need to be too much horrified at finding in a woman the idea of sucking at a male organ," for after all this "repellent impulse" has "a most innocent origin, since it was derived from

sucking at the mother's breast."[14] Only when mouth and anus become the *exclusive* sites of sexual activity does the subject who performs these acts cross the invisible border into the lawless terrain of the sexual perversions. It appears that Freud, in the end, wants to have his phallus and eat it too.

Initially, intercourse *per anum* seems to constitute for Freud the central defining feature of a homosexual erotics for men. Anal fixation is offered as the key to unlocking the secret of the Wolf Man's fear of being eaten by a wolf and the Rat Man's terror of rats boring into his rectum—two animal phobias Freud associates in his clinical writings with unresolved homosexual desire for the penetrating, castrating, devouring father. Anal eroticism also plays a bit part in Little Hans's fantasy of babies born through the anus, and a more central role in Schreber's transvestic desire to become a woman and to be penetrated by the rays of God.[15]

However, all of these analysands are merely "contingent" inverts in Freud's sexual typology, men who engage in homosexual acts only "under certain external conditions."[16] Freud's first extended discussion of a "manifest" homosexual—his psychoanalytic biography of Leonardo da Vinci—isolates oral rather than anal eroticism as the principal residual drive that organizes and sustains the homosexual identity formation. In Freud's enthusiastic estimation, Leonardo was the "rarest and most perfect" homosexual type, the "ideal" homosexual[17]—ideal because he sublimated his homoeroticism into acts of adventurous intellect and breathtaking artistry. "Ideal" homosexuality can only be achieved, paradoxically, through its own ruthless repression. The artist's "frigidity" and "abstinence" (69–70) serve as the very precondition of his genius; Leonardo embodies for Freud "the cool repudiation of sexuality" (69), a man whose every passionate impulse has been rerouted into an "insatiable and indefatigable thirst for knowledge" (75). How then, on the basis of his subject's presumed lifelong chastity (70), does Freud retrospectively arrive at the thesis of Leonardo's *manifest* homosexuality?

Freud bases his reading of Leonardo's "manifest, if ideal [sublimated] homosexuality" (98) on the single memory from infancy recounted in the artist's notebooks—a memory, not insignificantly, of orality: "It seems that I was always destined to be so deeply concerned with vultures; for I recall as one of my very earliest memories that while I was in my cradle a vulture came down to me, and opened my mouth with its tail, and struck me many times with its tail against my lips" (82). The "memory" of the vulture's tail beating about inside the child's mouth,

Freud goes on to explain, actually corresponds to a later homosexual fantasy of fellatio transposed back into a childhood memory of suckling at the mother's breast. By reading the bird's tail as a figure for both penis and breast (elsewhere Freud describes the penis as the "heir of the mother's nipple"),[18] Freud thinks he has uncovered the psychical connection between homosexuality and the maternal, the symbolic link that makes every act of fellatio a reexperiencing or reenactment of the pre-oedipal nursing phase. The symbolic importance of the vulture—in Christian legend a female bird and in Egyptian hieroglyphs a symbol for motherhood—is the sole evidence supporting Freud's hypothesis that fellatio is no more than an emotional relic of the oral-cannibalistic phase. For his historically belated analysis of this oral fantasy, however, Freud relies upon a faulty German translation of Leonardo's scientific notebooks. The Italian *"nibbio"* refers not to a magnificent vulture, with all its rich mythological, religious, and cultural associations, but to an ordinary *kite*, a small or medium-sized bird of the falcon family with a weak bill and a forked tail. We also know that Freud was informed of his mistake by Pfister as early as 1923 but refused (uncharacteristically) to make any significant revisions in the Leonardo paper, a work that he believed, in an act of unconscious identification with his artistically gifted subject, to be "the only beautiful thing" he had ever written.[19]

Is it any coincidence that 1923, during which Freud learned of his embarrassing gaffe, is the same year he discloses the importance of the phallic phase in infantile sexuality and the very same year he is diagnosed with cancer of the mouth? By spring of this eventful annum, the throbbing pain in his mouth, from a malignant growth on the palate too swollen to be ignored, finally convinced Freud to submit to the surgeon's knife in a botched operation where the injured doctor-patient nearly bled to death on the operating table. Little wonder that the mouth became for Freud a traumatized site, a zone where physical and psychical pain were centrally concentrated in the sore, tender, and afflicted mucous membrane of the oral cavity.[20] Could it be that the decidedly phallic protuberance on his palate pushing down into the throat left more than a slight taste of fellatio in Freud's mouth? And what are we to make of the fact that if something did stick in his throat, its removal—the cut of castration—nearly proved fatal?

To pose one final question before turning to two more contemporary, and more literal, narratives of oral-cannibalism, how does this psychoanalytic model account for a homosexuality that is *not* fully sublimated

into acts of high intellectual or artistic achievement—that is, for a "mani-
fest" homosexuality truly deserving of the name? What happens when
the oral and anal erotogenic zones are not "abandoned" but enjoyed, not
"relinquished" but accommodated, not "repressed" but gratified? For
Freudian psychoanalysis, there is another "class of perverts" who, "in
their multiplicity and strangeness ... can only be compared to the
grotesque monsters painted by Breughel." This group of "monsters"
includes (in this precise order): those who "replace the vulva, for instance,
by the mouth or anus"; those who eroticize "the excretory functions";
those who desire part objects and can properly be called "fetishists"; and
finally, the most heinous group of all, those who "require the whole
object indeed, but make quite definite demands of it—strange or horrible—
even that it must have become a defenceless corpse, and who, using crim-
inal violence, make it into one so that they may enjoy it. But enough of
this kind of horror!"[21] That oral and anal sex, which inevitably carry with
them the "taint" of homosexuality, find themselves on the same list as
necrophilic murder, with only coprophilia (abnormal obsession with
excrements) and fetishism between them, suggests a "slippery-slidey
slope" model for the so-called sexual perversions. This startling juxtapo-
sition is not the only occasion homosexuality finds itself in such unsavory
company; casual asides such as "whether a man is a homosexual or a
necrophilic ..."[22] are commonplace in the psychoanalytic literature and
speak powerfully to a careless conflation of two terms assumed to be not
exactly identical, but not significantly different either. The psychoanalytic
morbidification of homosexuality upholds and lends scientific legitimacy
to a wider cultural view of gay sexual practices as inherently necrophilic.

In the psychoanalytic model of sexual perversion I have been dis-
cussing, male homosexuality is represented as fixated at the earliest
stage of the libidinal organization—the oral-cannibalistic stage—in which
the recalcitrant subject refuses to give up its first object (the maternal
breast and all its phallic substitutes). Instead, the male homosexual
ingests the (m)other, "puts himself in her place, identifies himself with
her, and takes his own person as a model in whose likeness he chooses
the new objects of his love."[23] Oral-cannibalistic incorporation of the
mother not only permits a homosexual object-choice but unleashes
sadistic impulses. All aggression in sexuality is "a relic of cannibalistic
desires,"[24] an expression of the subject's primal urge to avenge itself on
the object by sinking its teeth into and devouring it. Violence, mutila-
tion, and disfigurement are structurally internal to the psychical act of

identification. In order to analyze more carefully the critical role identification plays in establishing this symbolic association between homosexuality and cannibalism, I turn first to a film that offers us not one but two different versions of the oral sadist as sexual deviant. I conclude this chapter with a brief coda on the Jeffrey Dahmer coverage—another cultural narrative of identification gone horribly awry—which revives some of the same metaphors of orality, perversion, and morbidity that impel its cinematic predecessor. Freud's definition of identification as "the oral-cannibalistic incorporation of the other person"[25] comes centrally to define a film like *The Silence of the Lambs* where the psychiatrist, whose very profession is based on the proper reading of identifications, perversely literalizes the act, orally incorporating his victims with "fava beans and a nice Chianti."

Serial Killing, Close Up

In his unconscious he was homosexual, and in his neurosis he was at the level of cannibalism.

> Freud, *From the History of an Infantile Neurosis*[26]

Film has always been a technology of dismemberment and fragmentation. The contemporary horror film recalls cinema not only to its violent historical beginnings but to the abject materiality of its very form.[27] In the famous shower sequence of *Psycho*, Alfred Hitchcock films the murder of Marion Crane in a manner designed to create the impression of "a knife slashing, as if tearing at the very screen, ripping the film."[28] Film, after all, is no more than dead matter, bits and pieces of perforated celluloid slashed, spliced, and taped together. A system of "cuts" and "sutures," the cinema borrows much of its technical vocabulary from the discourses of surgical medicine and pathology. The "cut-in," the "cut-away," the "splice," "dissecting editing"—all suggest the capabilities of filmmakers to investigate the human body with the same kind of accuracy, precision, and close scrutiny that pathologists call upon to perform human autopsies. This formal correspondence between medical pathology and film production may explain why, in narratives of serial killing, the film director has virtually become a cliché, second only to another stock character of the genre, the psychiatric doctor, who generally stands first in the lineup of potential murder suspects.[29] In films like

Michael Powell's *Peeping Tom* (1960), Michael Mann's *Manhunter* (1986), or John McNaughton's *Henry: Portrait of a Serial Killer* (1986/ 1990), the killers are often amateur filmmakers, filming their kills so they can watch them over and over again, trying to recapture, through cinematic replay, the experience of the actual kill. Serial killing is in many ways a self-reflexive topic for the cinema, as this satirical one-liner, which circulated after the opening of Demme's film, wittily confirms: "I was cast as a victim of a serial killer in *The Silence of the Lambs*, but my body parts ended up on the cutting room floor."

The violence encoded in cinematic form finds its most dramatic articulation with the historical invention of the close-up. Lillian Gish recalls in her autobiography that when D. W. Griffith first moved the camera closer to an actor in order better to capture his facial expression, the studio managers were enraged, prompting one executive to exclaim: "We pay for the whole actor, Mr. Griffith. We want to see *all of him*."[30] Another anecdote, recounted by Noël Burch, paints the association between cinematic form and bodily dismemberment even more plainly: "a woman who went to see a film shortly after the introduction of close-ups emerged completely traumatized by what she thought of as a horror film: 'All those severed hands and heads!'"[31] Film technology at first appears to offer a mirror stage reflection of the body as a fully intact entity; it promises the symbolization of a coherent corporeal image that will assist the spectator in shoring up his or her own precarious identity through a series of secondary identifications with the screen image. However, film can only satisfy the spectator's infantile desire to see the body whole and up close by cutting up the body and presenting it piecemeal. In point of fact, the filmic experience is less a reprisal of the infant's mirror stage encounter with the fantasy of a totalized ego than it is a reproduction of the infant's pre-mirror stage assimilation of the body as a collection of discrete part objects. Film technology always bears traces of this early traumatic event, the occasion of the child's own retroactive experience of itself as a body-in-pieces.

A film like Jonathan Demme's *The Silence of the Lambs* exploits the potentiality of dissecting editing to create terror in the spectator by shooting the scenes between Special Agent Clarice Starling (Jodie Foster) and Doctor Hannibal Lecter (Anthony Hopkins) almost entirely in close-up and tight shot/reverse shot sequence. Unlike cutting on movement, which tends to decrease the visibility of the cuts,[32] the cutting in these claustrophobic jail cell scenes happen when the two figures

are immobilized or stationary, making the dissecting editing sharper and more visible. The relentless shot/reverse shot movement of these intimate face-offs, the sustained back-and-forth rhythm of the camera's head-on, level gaze, creates a structure of symbolic exchange whereby the two heads eventually become interchangeable, substitutable, switchable. The grotesquely embalmed head of Benjamin Raspail discovered in the storage garage of Miss Hester Mofet (Lecter's anagram for "Miss the rest of me") stands as the film's iconic reminder of the detachability of human body parts and the cut of castration: no exchange without detachment; no identification without disfiguration. The technique of the cinematic close-up, which Demme relies upon so heavily to figure the identification between Lecter and Starling, in effect decapitates the subject, reducing it in scale to the level plane of the face by simultaneously enlarging the face to fill the screen's entire visual field. The face, the surface upon which subjectivity is figured, is also the zone of bestiality and primordial hunger, the overinvested corporeal site of not just an ocular but an oral identification.

The Silence of the Lambs, viewed close up, is a film all about the horrors of identification—identification as self-mutilation, identification as decapitation, identification as oral cannibalistic incorporation. The psychiatrist and the detective, the law breaker and the law enforcer, the male mentor and the female student are the classic transferential couple. Both skilled in the art of playing head games, both trained in the exercise of inference, deduction, and detection, the psychiatrist and the detective do, in fact, take on one another's identities as Lecter becomes an assistant to the FBI and Starling becomes an amateur shrink. We can even mark exactly where the switch takes hold: in the third encounter between Lecter and Starling immediately following the discovery of death's head moths in two of the victim's heads, the scene in which Starling officially enlists Doctor Lecter's help in the search for Buffalo Bill. During the discussion of transsexuality in this scene's climactic moment, Starling's and Lecter's weirdly disembodied heads swim dangerously close together, Lecter's face reflected on the glass behind which Starling's own face stares at us intensely. The reflection, however, is neither an exact superimposition nor a dissolve; instead, Lecter's visage hovers slightly to the side and to the back of Starling's, creating the trick illusion that he is sitting directly behind her, like a psychoanalyst positioned behind a patient on a couch. The film's jail cell mise-en-scène simulates an analytic session, with analysand Starling learning to think

like her evil mentor if she is to catch her quarry. Success in solving the case is wholly dependent upon the novice's ability to identify fully with the killer, to learn (like any good detective of the genre) to desire what the other desires, to inhabit the place of the other's identifications. In narrative terms, identification is as much a plot device as anything else; identification both sets this drama of serial killing in motion and provides its ultimate resolution.

Identification is itself an act of serial killing. Viewed through the lens of psychoanalysis, "seriality" and "killing" denote the defining poles of the identificatory process. As we have seen, Freud theorizes psychical identification throughout his work in terms of bodily appetite. The following passage from *Group Psychology and the Analysis of the Ego* (1921) might serve as a representative example:

> Identification, in fact, is ambivalent from the very first; it can turn into an expression of tenderness as easily as into a wish for someone's removal. It behaves like a derivative of the first, *oral* phase of the organization of the libido, in which the object that we long for and prize is assimilated by eating and is in that way annihilated as such. The cannibal, as we know, has remained at this standpoint; he has a devouring affection for his enemies and only devours people of whom he is fond.[33]

At the base of every identification lies a murderous wish: the subject's desire to cannibalize the other who inhabits the place it longs to occupy. But as Freud also reminds us, identifications are at best "partial" and "extremely limited" (107); they must be continually renewed and serially reenacted, for the ego's appetite is voracious and unappeasable. Identification is an endless process of killing off and consuming the rival in whom the subject sees itself reflected. In the words of Borch-Jacobsen, "the other-me is never anything but a rival, all the more detested for being admired, all the more violently negated for being amorously incorporated."[34] When Borch-Jacobsen speaks of the two "faces" of identification, he means to invoke (pace Freud) both the unconscious superego that prohibits identification ("Do not be like me") and the conscious ego-ideal that encourages identification ("Be like me") (36). These two faces represent the difference between good totemic and bad totemic identifications, normative and neurotic identifications, socializing and desocializing identifications (40-41). They distinguish between a lawful identification, which inserts the subject into the symbolic order, and a tabooed identification, which disturbs the very foundations of the law.

But what a serial killer film like *The Silence of the Lambs* insists upon is that sometimes it is simply impossible to tell the difference. This film's two faces of identification, Clarice Starling's good totemic identification with her mentor/father policemen, and Hannibal Lecter's bad totemic identification with his student/rival surrogates, are separated by no more than a transparently thin boundary that Lecter succeeds in crossing by putting on the very face of the law, flaying the policeman and wearing his features as if identification were no more than "a limit or a sack: a sack of skin."[35]

The notion of wearing another's skin—as Jame Gumb (Ted Levine) does quite literally in fashioning for himself a suit made of real women—also invokes the earliest form of identification, primary or narcissistic identification, in which a boundary between inside and outside, while sustained through the activity of introjection (the assimilation of an object), is *initially* formed through the mechanism of projection (the externalization of the object).[36] Jame Gumb's sexuality, rather than localized in a single organ, is spread out across the body. For him, the entire corporeal surface is a potential area of excitation; skin is "the erotogenic zone *par excellence*."[37] Are we to believe that in wearing the skin of the women he kills, Jame Gumb becomes, in fantasy, the object he both fears and desires most? In classic psychoanalytic terms, tearing, eating, sucking, and biting specifically signal the ambivalent infantile relation to the mother. Oral sadism operates as a defense against the child's early fear that he will be eaten or flayed by the figure whom he is himself entirely dependent upon for nourishment.[38]

Why is Freud's theory of primary identification so important for a reading of *The Silence of the Lambs*? Because if the characterization of Jame Gumb is "homophobic,"[39] the force of this charge derives from more than a cursory representation of the serial killer as a woman-identified, woman-hating, cross-dressing, disco-dancing, poodle lover. The film's camerawork (its own projection apparatus) labors to call up and to strengthen the classic psychoanalytic association of homosexuality with the morbidity, orality, and boundary confusion that define primary identification. Demme reserves nearly all of his *extreme* close-ups in the film for shots of Buffalo Bill, so named by police investigators for the professional way in which he flays his victims. The extreme close-up functions in the cinema as a technological analogue for primary identification. Film's capability to represent the human body as a disparate collection of part objects corresponds to the subject's earliest

attempts at oral incorporation. From our first introduction to Gumb wearing night vision glasses to the controversial scene in which he crosses over to the other side of the lens and dances narcissistically in front of a videocamera, more than ten extreme close-ups fetishize different parts of Gumb's body: eyes, hands, neck, nipples, and lips (variously adorned with makeup, tatoos, and jewelry). In the presentation of Jame Gumb, the camera is at its cruelest—and its most cutting; Gumb is optically dismembered as savagely as he is known to have mutilated his victims. Only one kind of body can sustain such thorough inspection or close scrutiny from the camera: the corpse. Autopsy pictures and crime photographs of dead bodies provide the only other instances of extreme close-up in the film. This identical camerawork makes it impossible not to acknowledge in the end a certain insidious equation established in *The Silence of the Lambs* between homosexuality and pathology, between perversion and death.

Even so seemingly inconsequential a detail as the name "Mrs. Lippman" (in whose home Starling eventually stumbles upon her killer) draws attention to the camera's fetishization of Jame Gumb's painted mouth, one of the film's privileged signifiers of transvestic identification ("lip man"). Tight close-ups of Gumb's lips recall an earlier instance of technonecrophilia in the autopsy scene: the shot of the pathologist's protruding camera invasively entering the corpse's mouth. The disembodied eye of the camera is associated throughout the film with dead matter, with decaying corpses and with flayed skin, while the orifice of the mouth, with its lethal incisors, is associated with both castration and oral/sexual gratification. The paradigmatic model of orality, the infant feeding at the mother's breast, is explicitly invoked by Lecter when he delivers his most merciless line to the film's sole mother character, Senator Ruth Martin, comparing the removal of the nursing child to the "tickling" sensation an amputee might feel after the loss of his leg. While under physical restraint, Lecter's oral-sadistic impulses seem to find temporary outlet in the psychiatrist's biting tongue and cutting intellectual acuity; Lecter, after all, is capable of a rhetorical savagery powerful enough to induce a man to swallow his own tongue. *The Silence of the Lambs* is a film obsessed with orality—with mouths, lips, teeth, tongues, and, of course, "gumbs."

Oral sadism provides perhaps too tame an epithet for the behavior of the film's most terrifying character, a figure whose ferocious orality and perverse appetite make him the very incarnation of the fairy tale ogre.

Although more erudite and sophisticated than his former patient Jame Gumb, Hannibal Lecter nonetheless acts out the most instinctual and primitive of libidinal impulses, coding him within the filmic narrative as yet another dangerous pervert whose sexual desire is sublimated into compulsive acts of aggressive identification. Curiously, little critical attention has been paid to Hannibal Lecter's enigmatic sexuality in the film, with the noteworthy exception of Adrienne Donald's characterization of the aristocratic psychiatrist as a "gay dandy" and Elizabeth Young's equally suggestive description of Lecter as a mannered aesthete with a "near-camp delivery."[40] Even without any such denotative signs of a "gay identity," the specter of a perverse and monstrous homosexuality would still haunt the representation of Hannibal Lecter as insatiable oral sadist. It is Lecter who "eats tongue" in the movie's most horrifying and, not uncoincidentally, most homoerotic scene; cupping Sergeant Pembry's face in his hands, Lecter bestows upon the man whose insides he intends to devour (and whose skin he later wears) the very kiss of death. "Hannibal the Cannibal" covets and feeds on human flesh in one of the most serious transgressions against the social prohibition separating the inedible from the edible, the human from the animal, the cultural from the natural. Hannibal Lecter's violation of cultural food interdictions admits him into the "homosexual brotherhood"[41] of Freud's "cannibal savages" who, out of fear and envy, murder and ingest the father to strengthen their identification with him. In Freud's myth of cultural origins, outlined in his pseudoanthropological work *Totem and Taboo*, the feeding frenzy that follows the parricidal deed permits the lawless brothers to assimilate the father's strength and power. Like the story of incest and oedipal desire to which it is closely related, the primal scene of identification (a scene in which the sexual is still indistinguishable from the alimentary) is founded by a criminal act—an act of carnal desire and corporeal violence.

In this context, it seems entirely appropriate to read Hannibal Lecter as the "high priest" of human sacrifice and cannibalism as "communion made literal."[42] Freud himself understands the Christian Eucharist, the ritual consumption of the flesh and blood of the deity (the "lamb" of Christ), as an important revival of the ancient totemic meal.[43] However, equally compelling is a reading of Hannibal Lecter as not the jealous son of *Totem and Taboo* but the omnipotent father of the Wolf Man's childhood nightmares—the parent who, in a form of "affectionate abuse," threatens to gobble up and wolf down the child. Cannibal son or ogre

father, Hannibal the Cannibal frightens by the way he literalizes our sexual colloquialisms. "Permanent marks" (teeth marks?) have been left by the oral phase of sexuality, Freud observes, and so it is not uncommon in everyday language to speak of "an 'appetizing' love object" or to refer to the person we love as "sweet."[44] Pulled from the darkest corners of the unconscious, the eerily bloodless Doctor Hannibal Lecter is a nightmare figure of terrifying mythic proportions.

Coda: "The Milwaukee Anthropophagite"

He was spiritually dead, but had become a vampire, a kind of walking dead who existed only to prey on his next victim. He was the closest thing to a *nosferatu.* Joel Norris, *Jeffrey Dahmer*[45]

The psychoanalytic narrative of the central role oral eroticism plays in the formation of gay male desire reveals more about the cultural determinations at work in the revival of a late nineteenth-century, early modern notion of the lawless and lustful sexual "invert" than about any timeless organization of psychosexual libidinal desires. The trope of orality circulated as a privileged sign of social abnormality in fin-de-siècle science, figuring perhaps most prominently in anthropological discussions of the origin of criminality. For example, Cesare Lombroso, an Italian professor of criminal anthropology, identified a natural predisposition to orality as the cause of deviant behavior in what he termed the "born criminal"—"an atavistic being who reproduces in his person the ferocious instincts of primitive humanity" and who desires "not only to extinguish life in the victim, but to mutilate the corpse, tear its flesh, and drink its blood."[46] Significantly, both the Freudian invert and the Lombrosian criminal were figured as vampire/cannibals. It bears emphasizing that the Freudian conception of sexual deviance that we have inherited today was formulated in complex relation to other emerging historical discourses, including the new science of criminology. In fact, Robert Nye has persuasively argued that the medicalization of crime in the nineteenth century prepared the way for the pathologization of other social differences: "once it could be shown how criminals were in part biological anomalies, it proved a relatively simple matter to medicalize other kinds of deviance as well."[47] Sensational murder cases are often the trial arenas for reconfiguring, reconsolidating, and reinventing

the cultural categories of criminality and deviance. In the specific case of Jeffrey Dahmer, the "homosexual-murderer-necrophilic-cannibal" equation has proved particularly fertile ground in the late twentieth century for activating old phobias and breeding new justifications for the recriminalization and repathologization of gay identity.

Frequently shot in close-up, photographs and drawings of Dahmer purport to image nothing less than the modern face of human monstrosity. Few graphic artists have been able to refrain from superimposing onto Dahmer's image the figure of the death's head, a vivid reminder of the human skulls that Dahmer preserved as totems from his killings. At the same time, these pictorial profiles present Dahmer's own head on a platter—decapitated, disembodied, mutilated, spectral, abject. The media feed us images of our worst nightmare: Jeffrey Dahmer's gaze fixed menacingly, hypnotically, upon the spectator, as if to remind us that we are not only the subjects of identification, but the objects as well—food for the other's insatiable oral appetite. In these media representations, color, lighting, and graphics are typically used to fragment, overexpose, and disfigure Dahmer's face, framing his image much in the manner of a photographic negative or a medical x-ray. An *NYQ* cover image, for example, represents Dahmer as the object of a clinical gaze that mathematically sections his face into surface parts and colored grids.[48] Yet what this mock medical close-up reveals is a pair of less than scientific bloody fangs, a detail that inadvertently confuses the figure of the cannibal with that of the vampire.

Dahmer's nighttime shift at the Ambrosia Chocolate Company and his earlier job as a bloodtaker at a local Milwaukee blood bank might seem to lend a certain playful logic to the transformation of Jeffrey Dahmer from human cannibal into supernatural vampire. Even the most responsible of Dahmer's biographers cannot resist describing him as "a kind of walking dead . . . the closest thing to a *nosferatu*." But more than anything else, these misidentifications ultimately speak powerfully to the enduring cultural representation of the gay man as nocturnal oral predator and compulsive bloodsucker. As Ellis Hanson has commented in a powerful reading of the late Victorian vampirism at work in media constructions of AIDS, "to comprehend the vampire is to recognize that abjected space that gay men are obliged to inhabit; that space unspeakable or unnameable, itself defined as orifice, as a 'dark continent' men dare not penetrate. . . ."[49]

The *racialization* of the sexual orifice in psychoanalysis recalls us once again to the history of Western anthropology, this time in a more explicitly colonialist context. A *Newsweek* cover story on Jeffrey Dahmer, entitled "Secrets of a Serial Killer,"[50] is accompanied by an illustration that can only be described as a displaced Western fantasy of cannibalism. A flat cardboardlike cutout of Jeffrey Dahmer's head, severed at the neck and hanging suspended against a black backdrop, shows Dahmer again staring directly at the viewer with a mesmerizing intensity. Brightly colored lines swirling around his facial features like ceremonial paint, together with eight ghostly indistinct photographs (presumably of Dahmer's victims) stuck to his face with pins, are details intended to code the killer's atrocities as a secret and deadly form of African voodoo. While the cultural category of cannibalism is emphatically an *anthropological invention,* and while even anthropologists have recently begun to question whether cannibalism *as a cultural system* has ever existed anywhere in the world,[51] the fiction of African cannibalism still persists in the West as the prevailing indicator of human savagery.

Descriptions of Jeffrey Dahmer as "the Milwaukee anthropophagite"[52] bring the entire weight of Western anthropology to bear on the reading of one man's personal disorder, revealing little about Dahmer's psychological state of mind and quite a bit about continuing Western phobias of the man-eating savage. Representations of Jeffrey Dahmer as stereotypical African savage spectacularly repress the obvious fact in the Milwaukee case that a white man of German descent was the killer and that black, Asian, and Hispanic men were the principal victims.[53] We may never know why Dahmer killed outside his racial group, but we do know that Dahmer's professed hatred of effeminate black men masked a deeper desire to appropriate the sexual threat they embodied. Dahmer's attempts to introject the *color* of his victims suggests a powerful unconscious identification with the racial other; the cannibal killings also mark specifically an aggressive identification based on a will to dominate and to sexually humiliate the object secretly coveted. Dahmer's sexual identifications work precisely as modes of racial imperialism.[54]

Real and fictional accounts of sexually motivated murderers who methodically stalk, torture, mutilate, and sometimes eat their victims have become as familiar to a modern American public as the popular serialized stories of famous criminals and outlaws were to a previous century's cultural imagination. Indeed, tales of serial killers in our newspa-

pers have become our new serial literature, with regular installments, stock characters, behavioral profiles, and a fascinated loyal readership. To what degree is it possible that we could identify with a figure of abjection—with a Jame Gumb, a Hannibal Lecter, or a Jeffrey Dahmer? Could the tremendous popularity and appeal of the serial killing genre lie in the form's ability to discharge us of our own misogyny, homophobia, or racism by locating guilt in the killer alone? The success of America's new serial literature may well lie in its double, gratification/exculpation function. If we are all killers in our unconscious, as psychoanalysis would have it, then identification with a psychotic murderer provides gratification of a death wish against others while simultaneously ensuring exculpation through the projection of all guilt onto the selfsame cultural anomaly: "the monster of perversion."[55]

NOTES

1. Georges Bataille, *Visions of Excess: Selected Writings, 1927–1939*, ed. Allan Stoekl (Minneapolis: University of Minnesota Press, 1985), 59.

2. D. A. Miller, "Anal *Rope*," in *Inside/Out: Lesbian Theories, Gay Theories*, ed. Diana Fuss (New York and London: Routledge, 1991), 134.

3. Lee Edelman, "Seeing Things: Representation, the Scene of Surveillance, and the Spectacle of Gay Male Sex," in Fuss, *Inside/Out*, 106. See also Edelman's "Piss Elegant: Freud, Hitchcock, and the Micturating Penis," *GLQ* 2:1–2 (1995): 149–77.

4. Leo Bersani, "Is the Rectum a Grave?" in *AIDS: Cultural Analysis, Cultural Activism*, ed. Douglas Crimp (Cambridge, MA: MIT Press, 1988), 212. For a reading of the anus as a culturally occluded site of women's active desire, see Eve Sedgwick's "A Poem Is Being Written," *Representations* 17 (Winter 1987): 110–43.

5. Freud goes so far as to locate the "origins" of male homosexuality in the passive anal stage, hypothesizing that in male inverts the considerable erotic importance attached to the anus was simply never relinquished: "a *stressing* of this anal eroticism in the pregenital stage of organization leaves *behind* a significant predisposition to homosexuality in men" (emphasis mine). Sigmund Freud, "The Disposition to Obsessional Neurosis" (1913), *Standard Edition*, 12:322.

6. "The Door of Evil," *People*, August 12, 1991, 32–37. Citation from cover.

7. Jacques Derrida, *Glas*, trans. John P. Leavey, Jr., and Richard Rand (Lincoln and London: University of Nebraska Press, 1986), 142.

8. Freud, *General Theory of the Neuroses* (1917), *Standard Edition*, 16:314.

9. See, respectively, Freud, "The Disposition to Obsessional Neurosis" (1913), *Standard Edition*, 12:311–26; *Three Essays on the Theory of Sexuality* (1905), 7:123–245, and "The Infantile Genital Organization" (1923), *Standard Edition*, 19:139–45.

10. Ole Andkjaer Olsen and Simo Koppe, *Freud's Theory of Psychoanalysis*, trans. Jean-Christian Delay and Carl Pedersen (New York and London: New York University Press, 1988), 275.

11. Eve Sedgwick, *Epistemology of the Closet* (Berkeley and Los Angeles: University of California Press, 1990), 12.

12. Freud, *Extracts from the Fliess Papers* (1892–1899), *Standard Edition*, 1:269. See also *New Introductory Lectures on Psycho-Analysis* (1933), 22:100.

13. Freud, *Three Essays*, 161.

14. Freud, *Analysis of a Phobia in a Five-Year-Old Boy* (1909), *Standard Edition*, 10:7. For Freud's reading of Dora's cough and sore throat as somatic symptoms of an unconscious fellatio fantasy, see *Dora: Fragment of an Analysis of a Case of Hysteria* (1905), 7:51–52. Although Freud is concerned here with distinguishing "normal" perversions (heterosexual oral sex) from "abnormal" perversions (homosexual oral sex), the Dora analysis makes clear that the one is always "contaminated" by the other, that no performance of fellatio can escape the stigma of male homosexuality.

15. See, respectively, Freud's *From the History of an Infantile Neurosis* (1918), *Standard Edition*, 17:1–123; *Notes Upon a Case of Obsessional Neurosis* (1909), 10:151–320; *Analysis of a Phobia*; and *Psycho-Analytic Notes on an Autobiographical Account of a Case of Paranoia (Dementia Paranoides)* (1911), 12:1–82.

16. Freud, *Three Essays*, p. 137.

17. Freud, *Leonardo Da Vinci and a Memory of His Childhood* (1910), *Standard Edition*, 11:80.

18. Freud, *New Introductory Lectures*, 101.

19. For more on Freud's famous mistake, see Peter Gay, *Freud: A Life for Our Time* (New York: Anchor Books, 1989), 267–74.

20. Ibid., chapter 9. See also Avital Ronell's "Goethezeit," in *Taking Chances: Derrida, Psychoanalysis, and Literature*, ed. Joseph H. Smith and William Kerrigan (Baltimore and London: Johns Hopkins University Press, 1984) for an excellent reading of the naming and renaming of this traumatized oral cavity.

21. Freud, *General Theory of the Neuroses*, 305–6.

22. Freud, *New Introductory Lectures*, 141.

23. Freud, *Leonardo*, 100. Jean Laplanche thus sees a double displacement at work in Freud's theorization of male homosexuality: "the homosexual situates himself in his mother's place, and his 'object' in the place of the child he once was." Laplanche, *Life and Death in Psychoanalysis*, trans. Jeffrey Mehlman (Baltimore and London: Johns Hopkins University Press, 1976), 75. Simultaneously playing the roles of both mother and child, the male homosexual allegedly embodies the collapse in boundaries said to characterize the child's preoedipal state of nondifferentiation from the mother. In this way, Freud identifies primary identification as the constitutive element, the sine qua non, of male homosexuality, linking it indissociably to narcissism, perversion, and oral eroticism.

24. Freud, *Three Essays*, 159.

25. Freud, *New Introductory Lectures*, 63.

26. Freud, *From the History of an Infantile Neurosis*, 64.

27. Contemporary serial killer films represent not so much the emergence of a new or mutant cinematic form as the revival of an old or dormant one. These films return us to the earliest stages of the cinema and to the medium's fascination with the mutilation, fragmentation, and reconstitution of body parts. Amputations, decapitations, and other forms of bodily disfigurement were commonplace in early cinema; indeed they were one of the stock themes of the trick shorts by Edison, Biograph, Méliès, and Pathé.

28. Quoted in Donald Spoto, *The Dark Side of Genius: The Life of Alfred Hitchcock* (New York: Ballantine, 1983), 419.

29. Brian De Palma's *Dressed to Kill* (1980) provides the best example of this subgenre in the cinema. In the growing body of pulp fiction works that takes serial killing as its theme, several include filmmakers and/or psychiatrists as recurrent suspects: David Lindsey, *Mercy* (New York: Bantam, 1990); William Bayer, *Switch* (New York: Signet, 1984); Mary Higgins Clark, *Loves Music, Loves to Dance* (New York: Simon and Schuster, 1991), and Ira Levin, *Sliver* (New York: Bantam, 1991).

30. Lillian Gish, *The Movies, Mr. Griffith, and Me* (London: W. H. Allen, 1969), 59–60. Also cited in Stephen Heath, *Questions of Cinema* (Bloomington: Indiana University Press, 1981), 184. Contrary to anecdotal history, Griffith did not invent the close-up. Examples of the true film close-up can be found as early as "Fred Ott's Sneeze" (Edison, 1894). See Noël Burch, *Life to Those Shadows*, trans. and ed. Ben Brewster (Berkeley and Los Angeles: University of California Press, 1990), 41.

31. Burch, *Life,* 269.

32. Mary Ann Doane, *Femmes Fatales: Feminism, Film Theory, Psychoanalysis* (New York and London: Routledge, 1991), 146.

33. Freud, *Group Psychology and the Analysis of the Ego* (1921), *Standard Edition,* 18:105. See also *Totem and Taboo* (1913), 13:1–162; "Mourning and Melancholia" (1917), 14:237–58; and *New Introductory Lectures.*

34. Mikkel Borch-Jacobsen, *Lacan: The Absolute Master,* trans. Douglas Brick (Stanford: Stanford University Press, 1991), 32.

35. Laplanche, *Life,* 81.

36. "The ego is ultimately derived from bodily sensations, chiefly those springing from the surface of the body. It may thus be regarded as a mental projection of the surface of the body...." Freud, *The Ego and the Id* (1923), *Standard Edition,* 19:26.

37. Freud, *Three Essays,* 169.

38. The theory of oral-sadism belongs properly to Karl Abraham who splits Freud's first phase of libidinal development into two stages—early oral (sucking) and oral-sadistic (biting). Melanie Klein refines the theory of oral sadism further, rejecting Abraham's distinction and hypothesizing instead that infantile aggression always characterizes the infant's relation to the maternal breast. See Abraham, "A Short Study of the Development of the Libido, Viewed in the Light of Mental Disorders" (1924), in *Selected Papers* (London: Hogarth Press, 1927), and Klein, "Some Theoretical Conclusions Regarding the Emotional Life of the Infant" (1952), in *Developments in Psycho-Analysis* (London: Hogarth Press, 1952).

39. See, for example, the lively commentaries by nine writers in the *Village Voice,* March 5, 1991, 49, 56, 58–59.

40. Adrienne Donald, "Working for Oneself: Labor and Love in *The Silence of the Lambs,*" *Michigan Quarterly Review* 31:3 (Summer 1992): 347–60, and Elizabeth Young, "*The Silence of the Lambs* and the Flaying of Feminist Theory," *Camera Obscura* 27 (September 1991): 5–35. Judith Halberstam, in another perceptive reading of this film, joins Young in cleverly identifying the root of Lecter's pathology as an unresolved "edible complex." See Halberstam's "Skin-Flick: Posthuman Gender in Jonathan Demme's *The Silence of the Lambs,*" *Camera Obscura* 27 (September 1991): 37–52.

41. In Freud's mythological formulation of the basis of culture, homosociality replaces homosexuality as the founding repression of the law. The brothers, while outside the primal horde, base their organization on homosexual acts; once the father has been usurped,

and the exchange of women has been established, homosocial acts govern the group. See Chapter 1.

42. Kathleen Murphy, "Communion," *Film Comment* 27:1 (January-February 1991): 31–32.

43. See Freud's *Totem and Taboo,* 154, and *Moses and Monotheism: Three Essays* (1939), *Standard Edition,* 23:83–84.

44. Freud, *From the History of an Infantile Neurosis,* 106–7.

45. Joel Norris, *Jeffrey Dahmer* (New York: Pinnacle Books, 1992), 39.

46. Cesare Lombroso, introduction to Gina Lombroso-Ferrero, *Criminal Man According to the Classification of Cesare Lombroso* (New York: G. P. Putnam's Sons, 1911), xiv–xvi.

47. Robert Nye, *Crime, Madness, and Politics in Modern France: The Medical Concept of National Decline* (Princeton: Princeton University Press, 1984), 99.

48. *NYQ,* February 16, 1992.

49. Ellis Hanson, "Undead," in Fuss, *Inside/Out,* 325.

50. "Secrets of a Serial Killer," *Newsweek,* February 3, 1992, 44–49.

51. To my knowledge, the first researcher to expose the inadequacy of the anthropological documentation on cannibalism and to question whether cannibalism even exists, except in rare cases of survivalism and psychotic behavior, was W. Arens in *The Man-Eating Myth: Anthropology and Anthropophagy* (New York: Oxford University Press, 1979). While some anthropologists think Arens overstates the case, few disagree that the charge of cannibalism has been leveled against virtually every culture in history and that it often functions as the rationale for genocide and national imperialism. For two sympathetic critiques and revisions of Arens's work, see Peggy Reeves Sanday, *Divine Hunger: Cannibalism as a Cultural System* (Cambridge, UK: Cambridge University Press, 1986), and Gananath Obeyesekere, "'British Cannibals': Contemplation of an Event in the Death and Resurrection of James Cook, Explorer," in *Critical Inquiry* 18:4 (Summer 1992): 630–54.

52. "So Guilty They're Innocent," *National Review,* 44:4, March 2, 1992, 17. The persistent equation in Freud's thinking between "the homosexual" and "the primitive" is based on his assumption that both "types" are developmentally arrested in the oral-cannibalistic stage (see Chapters 1 and 5). We should perhaps not be surprised to discover that in anthropological research influenced by classical psychoanalysis, the explanation of human cannibalism sounds suspiciously like Freud's theory of male homosexuality. For example, in *Cannibalism: Human Aggression and Cultural Form* (New York: Harper Torch Books, 1974), Eli Sagan argues that cannibalism in tribal cultures is the result of absent fathers and overly protective mothers who nurse their children for prolonged periods of time instilling in them a tendency toward oral aggression.

53. The fact that all but two of Dahmer's seventeen victims were gay men of color from economically impoverished backgrounds prompted an indifferent and, many have charged, racist and homophobic Milwaukee police department to pay scant attention to the growing number of missing persons reports and to overlook completely the obvious links among them.

54. At least one commentator on the Dahmer case has found the killer's ethnic background worthy of note. Andrew Holleran quips in *Christopher Street* that there is something "very Sweeney Todd" about the Dahmer story, something "very Grimm Brothers" in the details of Dahmer's German background, his army service in Baumholder, West

Germany, his job in the chocolate factory. The more serious connection, which goes unspoken in Holleran's allusion to ethnic and racial conflict in the Dahmer case, is the Nazi experiments on Jews, homosexuals, and other "social undesirables" during the Holocaust, a historical precedent that provides a far more frightening context in which to read Dahmer's postmortem mutilations and his fascination with medical pathology. See Andrew Holleran's "Abandoned," *Christopher Street,* June 22, 1992, 3.

55. Or, as Slavoj Žižek puts it,"Our desire is realized and we do not even have to pay the price for it." Looking Awry: *An Introduction to Jacques Lacan through Popular Culture* (Cambridge, MA: MIT Press, 1991), 59. Žižek's thesis that a need for a communal discharge of guilt drives the detective novel works equally well with true crime narrative, which draws extensively on many of the same devices and themes as the classic detective genre: "the role of the detective is . . . precisely to dissolve the impasse of this universalized, free-floating guilt by localizing it in a single subject and thus exculpating all others" (59).

4

SEXUAL CONTAGIONS:
DOROTHY STRACHEY'S *OLIVIA*

SCHOOLS IN LATE NINETEENTH-CENTURY EUROPE were widely regarded as places of illness and contagion—enclosed social containers of infectious diseases. This cultural view of the school as a place of epidemic issued not only from a very real public fear of outbreaks of tuberculosis or influenza, which could spread rapidly and with devastating effects in overcrowded and poorly heated classrooms, but also from a growing suspicion that running rampant among the adolescent population was an equally dangerous social contaminant: the sexual perversions. The representation of the girls' boarding school as a site of moral and sexual contagion appears as early as Mary Wollstonecraft's *A Vindication of the Rights of Woman* (1792), where Wollstonecraft's disgust with the "gross degree of familiarity" between girls in single-sex institutions is a recurrent and anxious theme. Over a hundred years later, Havelock Ellis voices a similar concern when he pronounces that "the school is undoubtedly the great breeding-place of artificial homosexuality among the general population."[1] Responding to an unusually public airing in the newspapers of charges that the secondary schools had become "hotbeds of vice" and modern-day "cities of the Plain" (37), Ellis cautions that only physical and social "hygiene" can prevent "the acquisition of homosexual perversity" in the schools (141-42). Others argued that education itself provided the most effective antidote for homosexuality; the more rigorous the curriculum the less time for sexual fantasy and experimentation. But this curative treatment was believed

to work only with boys, around whom the discussion of sexual immorality in the schools predominantly centered. In the words of the headmaster of Britain's Clifton College, "vicious boys" could, through a superior training of the mind, "become Cabinet Ministers, statesmen, officers, clergymen, country gentlemen ... nearly all of them fathers of thriving families."[2] If intellectual training among schoolboys was seen to provide inoculation against a sudden outbreak of the sexual perversions, among schoolgirls it was identified as one of the prime causations of sexual degeneracy. "Vicious" girls, unlike "vicious" boys, were understood to experience intellectual exertion as a stimulant rather than a suppressant of homosexual desire. Ellis believed that intelligence played a critical etiological role in the development of sapphism: "the congenital anomaly occurs with special frequency in women of high intelligence who, voluntarily or involuntarily, influence others" (100). In short, education was considered one of the principal social factors contributing to the spread of sexual vice among women.[3]

In the highly-charged erotic climate of the single-sex school, the institution is a progenitor of sexual vice, homosexuality is a contaminating agent, and adolescents are subjects at perpetual risk of moral infection. So goes what we might call the "germ theory" of homosexual identity formation, a theory that reaches its most insidious dimensions in the contemporary vilification of people with HIV/AIDS. Public hysteria centered on the specter of "the homosexual" as AIDS "carrier" draws its force from an enduring representational history that posits homosexuality itself as an opportunistic infection, a communicable, contaminating, and fatal disease.

The modern view of homosexuality as sexual contagion fixates on the question of how sexuality *moves*. If desire circulates, like a virus, what route does it travel, who is most vulnerable to its influence, and how can one best immunize oneself against the invading infection? These are the anxious questions underlying the historical debates over the "epidemic" of homosexuality in the European schools. As we will see, they surface again in Freud's *Group Psychology and the Analysis of the Ego* where the discussion of the girls' boarding school as the privileged example of "mental infection" is by no means a random example. Freud himself was an ocassional participant in the debates on sexual vice in the schools, a debate which in Germany was played out in the context of an even broader dispute over the role and responsibility of the school in adolescent suicides. "A secondary school should achieve more than not driving

its pupils to suicide," Freud insisted in his own published remarks on educational reform. Hinting broadly at the too rigid regulation of adolescent homosexuality in the German Gymnasium, Freud writes in a somewhat more pedagogical vein that "the school must never forget that it has to deal with immature individuals who cannot be denied a right to linger at certain stages of development and even at certain disagreeable ones."[4]

It is helpful to remember in this context that "adolescence" and "homosexuality" come of age together at the end of the nineteenth century with the emergence of not only psychoanalysis but criminal anthropology, ethnology, sociology, and a whole series of related discourses organized around the problem of discriminating, isolating, and distributing social identities. John Neubauer's work on the fin-de-siècle culture of adolescence offers, for my purposes here, a particularly compact definition of adolescence as "a middle-class social formation in industrial societies generated by the expansion of secondary education."[5] Neubauer points out that the explosive growth of the secondary school system in the late nineteenth century created the conditions for the new social formation called adolescence. This particular institutional change also, I would add, directly contributed to the construction of homosexuality as simultaneously the principal defining feature *and* the main enemy of the new youth subculture. Adolescence and homosexuality are historically conjoined, in large part through the new sciences of sexuality.

But do science and medicine completely dominate modernism's discourse on sexuality? Critics of Radclyffe Hall's *The Well of Loneliness* (1928) have widely and erroneously assumed that Hall, whose famous novel is prefaced by an introduction by Havelock Ellis, never questions the sexological literature that gives her protagonist Stephen Gordon her identity as "invert." The sheer volume of (largely negative) critical attention devoted to Hall's controversial novel may mistakenly convey the impression that all literature on the subject of lesbians coming of age during the early twentieth century uncritically incorporated the sexological or psychoanalytic models of sexual identity formations.[6] Early modernist novels about lesbians (not all necessarily *by* lesbians) actually cover a spectrum of responses to the new sciences of sexuality, responses that range from immediate interest and tacit acceptance to cautious skepticism and open disdain. The diversity of this literature's critical engagements with medical science ultimately highlights the radical insufficiency of a simple rejection/acceptance model in which to read the encounter of

science and letters. In this chapter I want to shift attention away from Radclyffe Hall's *The Well of Loneliness* (implicitly putting into question its privileged status as the representative lesbian novel of the modern period)[7] and turn to a consideration of an identifiable subgenre in modernist literature, the girls' boarding school novel.

As one of the main institutional locales associated with single-sex communities, the school has long been a favorite setting for European narratives of "sapphic" love. One of the earliest such works, Denis Diderot's *La Religieuse* (1796)—an eighteenth-century French novel that traces the degenerative effects of schooling and enforced celibacy on young women in a convent—earns from Jeanette Foster the dubious opprobrium of "a landmark in the literature of female sex variance."[8] Adolphe Belot's *Mlle Giraud, Ma Femme* (1870) is the first French novel, according to Foster, to explicitly attack inversion in women as a medical problem, an abnormality attributed directly to sexual segregation in the boarding schools. Dubut de Laforest's *La Femme d'Affaires* (1890) and Charles Montfont's *Le Journal d'une Saphiste* (1902) follow suit in warning French schoolgirls, their teachers, and their parents that sexual excess among girls can lead to moral degeneracy, insanity, and even death.[9]

Frank Wedekind's German novel *Mine-haha* (1905), the story of a schoolgirl's romantic adoration of her ballet teacher, is a somewhat more sympathetic treatment of adolescent lesbian love than either the contemporary French novels I have just noted or Wedekind's own later more disparaging handling of the same theme in his plays *Pandora's Box* (1918) and *Franziska: A Modern Mystery* (1913).[10] One of the last works on sexual inversion to be published in Germany before the Nazi purge of homosexual literature, Christa Winsloe's *The Child Manuela* (1933)— a novelization of Winsloe's successful play *Children in Uniform* (1930) and Leontine Sagan's even more popular film *Maedchen in Uniform* (1931)—remains perhaps the best known German example of the boarding school romance.[11] In England, Charlotte Brontë's dramatization of schoolgirl devotion in *Jane Eyre* (1847) is in many ways a more interesting text to read for its complicated encoding of desire in identification than most of the English school novels with explicitly lesbian themes that come well after it, novels including A. T. Fitzroy's *Despised and Rejected* (1918), Rosamund Lehmann's *Dusty Answer* (1927), and Wanda Fraikan Neff's *We Sing Diana* (1928). The Lowood section of *Jane Eyre* provides the paradigmatic scene of the school as site of desire and contagion (a potent combination with particularly lethal consequences for the

emotionally consumptive Helen Burns).[12] But the most influential prede-
cessor of the genre is Colette's published recollections of her French
schoolgirl infatuations in *Claudine a l'école* (1900), a book that became a
considerable commercial success on the basis of its "wickedly licen-
tious" lesbian scenes that were quite possibly written not by Colette at
all but by her husband Willy, who wished to "hot" things up a bit.[13] At
first rejected by Willy as a "mistake," Colette's school narrative lan-
guished in a desk drawer for two years before Willy rediscovered the
manuscript and decided to launch the highly successful Claudine series,
which quickly became a staple of the genre.

I will be focusing here on one particular autobiographical fiction writ-
ten by a British writer: Dorothy Strachey's *Olivia*, a text published in
1949, written pseudonymously sixteen years earlier in 1933, and set in
the 1880s.[14] Like Colette's first novel, Strachey's *Olivia* remained forgot-
ten in the desk drawer of her literary mentor, André Gide, to whom she
had first nervously confided it; not until Strachey found the courage fif-
teen years later to show the manuscript to Leonard Woolf did the novel
find a publisher with the Hogarth Press. It seems fitting that the publish-
ing house most responsible for introducing Freud's theory of sexuality
to an English-speaking public also published Strachey's novel of adoles-
cent lesbian desire. In her passion for older women, her fantasies of
chivalric rescue, and her class pretensions, Strachey's protagonist Olivia
in many ways resembles the "girl" of Freud's "The Psychogenesis of a
Case of Homosexuality in a Woman." The latter connection serves to
remind us that the girls' boarding school narrative, like psychoanalysis,
is a bourgeois discourse. More than simply being *about* middle-class
desires, both psychoanalysis and the boarding school novel participate
in the discursive production of the very concept of "sexuality" as a mid-
dle-class formation.[15]

By way of setting up my discussion of Strachey's boarding school
romance, I turn first to a short psychoanalytic narrative of schoolgirl
hysteria included in chapter seven of Freud's *Group Psychology*. This
fragment of a case history, which tells the story of how hysteria might
be communicated along the channels of an infectious identification, is
implicitly reworked and recast by modernist women writers redeploying
the very literary trope that gave these scientific narratives of sexual hys-
teria such cultural potency—the trope of contagion. Strachey's novel
Olivia, and others like it, also give us what Freud's psychoanalytic case
histories occlude: the voice of the bourgeois woman narrating her own

adolescent schoolgirl experiences. A reading of this nearly forgotten novel may help answer the question I am chiefly concerned with here: what were these upper-class and middle-class women saying about their boarding school romances? How were they remembering, filtering, narrativizing, and fictionalizing their adolescent relations to teachers, parents, friends, and rivals?[16]

While what follows does not purport to be a historical inquiry, Strachey's novel nonetheless insists that we pay attention to the very feature that Freud's clinical account of the girls' boarding school completely ignores—the immediate and unfolding institutional context in which the sexual identifications take place. As one of the specific institutions in which a new kind of sexual subject emerges in the modern period, the secondary school takes on added importance as a dynamic site of social and historical change.

The Politics of Hysteria

I begin then with the following passage from *Group Psychology* where Freud chooses as his privileged model of group hysteria the hypothetical case of identification in a girls' boarding school:

> Supposing, for instance, that one of the girls in a boarding school has had a letter from someone with whom she is secretly in love which arouses her jealousy, and that she reacts to it with a fit of hysterics; then some of her friends who know about it will catch the fit, as we say, by mental infection. The mechanism is that of identification based upon the possibility or desire of putting oneself in the same situation. The other girls would like to have a secret love affair too, and under the influence of a sense of guilt they also accept the suffering involved in it. It would be wrong to suppose that they take on the symptom out of sympathy. On the contrary, the sympathy only arises out of the identification, and this is proved by the fact that infection or imitation of this kind takes place in circumstances where even less preexisting sympathy is to be assumed than usually exists between friends in a girls' school. One ego has perceived a significant analogy with another upon one point—in our example upon openness to a similar emotion; an identification is thereupon constructed on this point, and, under the influence of the pathogenic situation, is displaced on to the symptom which the one ego has produced. The identification by means of the symptom has thus become the mark of a point of coincidence between the two egos which has to be kept repressed.[17]

A girl in a boarding school falls into a jealous fit of hysterics after receiving a letter from someone with whom she is in love; through a process of

psychical infection her friends "catch the fit" and the hysteria spreads from one girl to another. This particular model of hysteria suggests that, in a group, we have little or no control over our identifications. Group members catch the infection involuntarily and find themselves seized or claimed by something outside themselves. This particular type of identification differs markedly from Freud's two previous tropological models of self-other relations—falling and ingestion. Here, identification is neither accident nor appetite but a viral infection traveling the circuits of the desire of the other. Though not necessarily unpleasurable, this form of psychical identification is experienced as a sudden and inexplicable affliction, a surprise occupation or seizure, a violent incursion from without.

Group Psychology's hypothetical example of girls in a boarding school bears certain striking resemblances to the story of a hospital ward recounted twenty years earlier in *The Interpretation of Dreams.* Freud's discussion of hysteria among a group of hospital patients—included as part of his first published treatment of the problem of identification—is important enough for its similarities to the boarding school narrative to be cited here in full:

> Supposing a physician is treating a woman patient, who is subject to a particular kind of spasm, in a hospital ward among a number of other patients. He will show no surprise if he finds one morning that this particular kind of hysterical attack has found imitators. He will merely say: "The other patients have seen it and copied it; it's a case of psychical infection." That is true; but the psychical infection has occurred along some such lines as these. As a rule, patients know more about one another than the doctor does about any of them; and after the doctor's visit is over they turn their attention to one another. Let us imagine that this patient had her attack on a particular day; then the others will quickly discover that it was caused by a letter from home, the revival of some unhappy love-affair, or some such thing. Their sympathy is aroused and they draw the following inference, though it fails to penetrate into consciousness: "If a cause like this can produce an attack like this, I may have the same kind of attack since I have the same grounds for having it." If this inference were capable of entering consciousness, it might possibly give rise to a *fear* of having the same kind of attack. But in fact the inference is made in a different psychical region, and consequently results in the actual realization of the dreaded symptom. Thus identification is not simple imitation but *assimilation* on the basis of a similar aetiological pretension; it expresses a resemblance and is derived from a common element which remains in the unconscious.[18]

In both hypothetical scenarios of group hysteria, mental infection originates with a woman, reinforcing the cultural representation of women

as repositories of disease and carriers of contagion; in the chronologically later example of the boarding school, women are also the exclusive *recipients* of the infection. Although Freud elsewhere admits the possibility of male hysteria (including, most famously, his own), he comes to believe that hysteria circulates more easily among women because of their greater powers of sympathy and suggestibility. But whereas in the case of the hospital patients sympathy is the *cause* of the hysterical identification, in the case of the boarding school girls sympathy is simply one of its many possible *effects* (and, for Freud, the most likely outcome for highly suggestible adolescents).

Some twenty years of clinical and theoretical work separate Freud's two brief case narratives of group hysteria; the theoretical ground covered between *The Interpretation of Dreams* (1900) and *Group Psychology and the Analysis of the Ego* (1921) opens up a conceptual gap between "sympathy" and "identification," "emotion" and "mechanism," "hypnosis" and "psychoanalysis." The concept of identification assumes increasing importance and clear analytical priority for Freud as he gradually moves away from the position that hysteria is a product of suggestion or auto-suggestion that can be treated by hypnosis, and comes to understand hysteria instead as a more complicated psychical disorder with traceable "mechanisms" that can be uncovered and addressed through analysis. Freud's later work seeks to replace the nineteenth-century notion of "sympathy" with a more scientific, rigorous, and modern theory of "identification." Speaking of the structure of the hysterical identification among the schoolgirls, Freud writes that "it would be wrong to suppose that they take on the symptom out of sympathy. On the contrary, the sympathy only arises out of the identification." Identification now precedes and produces sympathy; identification is constructed on the point of "analogy" not emotion; identification represents "the mark of a point of coincidence" between egos, while sympathy is simply a byproduct to which young girls, because of their "openness" to emotions, are especially susceptible.[19]

As I have noted in Chapter One, these theoretical categories are completely gender-inflected: an "emotion" not a "mechanism," sympathy comes under suspicion as a peculiarly feminine attribute. By the time of *Group Psychology*, Freud understands identification as a phallicizing process (the erection of the ego) that must be firmly distinguished from the feminizing emotion of sympathy (the splitting or diffusion of the ego) if psychoanalysis is to define itself successfully against the pseudo-

science of hypnosis. Freud's politics of hysteria is itself based upon a repression; the repudiation of hypnosis in the treatment of hysterics constitutes the founding act of prohibition that institutes the "new" science of psychoanalysis. Later in this chapter it may be possible to demonstrate that, in the theory of transference that emerges out of Freud's work on hysteria, hypnosis continues to infect psychoanalysis. But for now I am interested in posing the question of the politics of hysteria *for women* and why it has been possible for feminist commentators of Freud to interpret the hysteric's psychical "flight into illness"[20] as an act of social resistance.

Freud understood that hysteria, while injurious to the subject, is often the least harmful way out of a psychical dilemma. The hysteric's flight into illness constitutes not so much a means to resolve a conflict as a way to evade *the task* of resolving it. To preserve this psychical advantage gained from the illness, the hysteric distorts the source of the neurosis by playing more than one part in the underlying sexual fantasy. Since Charcot's dramatic staging of his patients' hysterical performances at the Salpêtrière (not insignificantly, for this reading, a *teaching* hospital), hysteria has been read as something of a theatrical event, a one-woman show in which the hysteric plays all the roles. Freud's favorite example of hysteria is the story of a hysterical patient who plays both parts of a sexual seduction at once, tearing her dress off with one hand ("as a man") while pressing it to her body with the other ("as a woman").[21] The astonishing *mobility* and *plasticity* of hysterical identification accounts for the many difficulties that confront the psychoanalyst in trying to cure it, since the hysterical patient, under pressure to reveal what role she is playing in fantasy, can at any moment switch her identification onto "an adjoining track."[22] In group hysterical identification, the problem of performativity is magnified and further complicated, since the subjects involved "express in their symptoms not only their own experiences but those of a large number of other people; it enables them, as it were, to suffer on behalf of a whole crowd of people and to act all the parts in a play single-handed."[23] One senses that, for Freud, group hysteria is especially dangerous, and not only because of the dizzying multiplication of identificatory roles and transferential possibilities available to the hysteric. In the phenomenon of group hysteria, the hysteric is not merely the object of interested medical study, as in Charcot's theatrical demonstrations, but its subject as well. The hysteric is both a participant in the ensemble performance and a spectator of the

performances of the other group members. Spectatorship actually constitutes the point of entry *into* the illness, blurring the line between medical surveillance and pathological performance, between healthy doctor and sick patient.

At the center of the two theatrical scenes of group identification that Freud discusses, we find the same prop serving as dramatic trigger for the chain reaction of hysterical mimesis: a letter received by one of the inmates. The inclusion of the letter raises several points of interest for a reading of hysteria. First, like Poe's famous purloined letter, the message of the letters received by Freud's hypothetical patients is never actually revealed; each letter's content, though not its form, remains concealed from view, a topic of Freud's relatively disinterested conjecture ("a letter from home, the revival of some unhappy love-affair, or some such thing"). In this respect the letter functions much in the manner of a hysterical symptom, encrypting and concealing the meaning of the fantasy that produced it. Second, the trope of the letter suggests that the critical question for an analysis of group identification is *communicability*: how is the symptom transmitted from person to person and under what conditions? The "mental infection" is evidently carried along the circuits of an open correspondence between desiring subjects. The letter itself works metonymically to communicate the work of metaphor, here defined classically as a form of transport based upon a correspondence.[24] Finally, as a figure for a more literal correspondence, the letter introduces into these scenes of psychical contagion the importance of reading. What does reading have to do with hysterical identification? The hysteric speaks through her symptom, transforming the body into a textual utterance. Although the hysteric's somatic symptom ostensibly works to block interpretation by leading the analyst through a thicket of confusing and shifting identifications, its very unreadability provokes, even coerces, a reading. Reading Freud reading hysteria, Mary Jacobus observes that "where hysteria is concerned it is impossible to overread."[25] The symptom, in other words, is always only *apparently* inaccessible, intractable, indecipherable, unreadable. Hysteria necessitates reading.

Reading the politics of hysteria is one of the central leitmotifs of the many excellent feminist commentaries on Freud's *Dora*. At issue in the debate over hysteria's social meaning is the relation of the hysteric to the group and the inclusion of the doctor in the sexual politics of the family romance. Dora's hysteria is read, alternatively, as a silent revolt against patriarchal control of women's bodies and as an unconscious capitula-

tion to an oppressive social-sexual regime. On one side of the debate are those who read hysteria as a woman's defiance of family and physician, a somatic release of repressed anger and frustration. On the other side are those who agree that hysteria is used as a weapon but who maintain that the real object of the hostility is the hysteric herself, the figure who, after all, is the one who suffers most. Nothing in the case history, of course, prevents us from subscribing to both these readings at once. Dora's hysteria enacts a passive-aggressive refusal of oedipality at the same time that the particular form that it takes, illness, conforms entirely to a socially acceptable norm of femininity.[26] It is interesting to note that feminism's somewhat anxious question, Is hysteria political or not?, more than faintly echoes the binary structure of the hysteric's dilemma, Am I a woman or not? The theoretical question that underwrites the issue of hysteria's politics mimics its subject, reproducing the preoccupation with the law that characterizes the law of hysteria.

Hysteria seems to me notable for its political unintelligibility; its importance lies in its own resistance to recuperative readings. This is not to say that hysteria stands outside politics, only that the exercise of reading the unreadable hysterical body forces us to think politics differently, without reliance upon simple oppositions. In the case of Dora, the hysteria that exposes the sexual economics at work in the formation of the family's libidinal organization also permits the group ties to reconstitute themselves around (and by means of) the hysterical illness. Dora, in other words, is herself a symptom for a larger group neurosis. This is the general import of Lacan's cryptic remark that Dora, in her relation to her family members, is a "prop for their common infirmity."[27] As Madelon Sprengnether notes in her reading of this case history as a group illness, "nearly everyone in Dora's family circle occupies the role of nurse or invalid, and sometimes both."[28]

In light of this ready exchange and conflation of roles, it becomes difficult, if not impossible, to speak of health and illness as opposites; we might say instead, along with Nietzsche, that the question is rather one of degree, "that we are [all] relatively sick." This indeed seems to be the case in each of Freud's case histories where, to cite Nietzsche again, "those things also which have been regarded as the *remedies* of degeneration are only *palliatives* of certain effects thereof: the 'cured' are *types of the degenerate*."[29] The problem with identifying hysteria as either illness or remedy in relation to the social group is that the group is itself involved in the neurotic formation and is, in a very real sense, "sick."

The difficulty in reading the politics of hysteria can therefore be attributed to one notable problem: strictly speaking, *every* hysterical formation is a group phenomenon. The psychical gain from the illness is not just the hysteric's alone.

Nevertheless, the spectacle of group hysteria can be read, at the same time, as a clear act of resistance. At least to Freud, group hysteria is far more disturbing than seemingly isolated cases such as Dora's, simply because it holds out the unsettling possibility of collective or even *organized* resistance. In the story of psychical infection in the hospital ward, Freud is chiefly concerned with how patients influence one another when outside the doctor's direct surveillance: "as a rule, patients know more about one another than the doctor does about any of them; and after the doctor's visit is over they turn their attention to one another." Through the greater intimacy that physical proximity affords in this institutional setting, the patients are more susceptible to each other's psychological influence than to the physician's professional care. Freud may well have taken a warning from these scenes of collective resistance to medical expertise when he arranged his psychoanalytic sessions in the structural format of a one-on-one dyadic encounter, completely ruling out the clinical viability of group analysis. But must hysteria be organized to be "political"? Can resistance forged through unconscious identification with a particular group of subjects properly be said to have political effects? If the hysteric's resistance is unconscious, is it still resistance?

These questions issue from a certain theoretical confusion surrounding the concept of resistance, a confusion that emerges when feminist definitions of resistance as a political tactic of refusal collide with psychoanalytic theories of resistance as a psychical strategy of denial. While feminism apprehends resistance as a powerful form of effecting change, psychoanalysis understands resistance as a dangerous strategy of refusing change. Can unconscious resistance in the psychoanalytic sense be usefully read as political resistance in the feminist sense? Yes and no. As a means of repudiating all psychical development painful to the ego, the mechanism of unconscious resistance has self-protective and thus inherently conservative aims. And yet, hysterical identification, and the resistance that incites and sustains it, need not be fully conscious in order to be socially disruptive; on the contrary, the very fact that the identification *is* unconscious protects it from outside interference. If the identification were capable of entering consciousness, Freud explains, it could also give rise to fear—fear of the hysterical symptom itself or fear of pun-

ishment for the social transgressions it permits. The more difficult question then may be not Is hysteria a form of resistance? but How does Freud extract a theory of resistance out of hysteria?[30]

Freud extracts his theory of resistance directly from a clinical analysis of his hysterical patients, concluding that resistance is one of the ego's most powerful and effective strategies of defense. Resistance, if undetected, can pose the greatest obstacle to the success of the therapeutic process. If true psychical change is to take place, Freud maintains, resistance should be neither naively dismissed nor bluntly counterresisted but directly confronted and utilized as a way into the unconscious. Indeed, the success of any analysis depends upon the clinician's ability to identify and to accurately interpret the nature and strength of the patient's strategies of resistance. Resistance, the key that can eventually unlock the neurosis, becomes the heart of the psychoanalytic method, distinguishing it, in Freud's mind, from the practice of hypnosis, which seeks to circumvent the patient's resistance rather than to work through it. But as critical to analytical technique as the concept of resistance may be, the political question still remains: *who or what resists,* and why?[31] What, precisely, is being resisted? Under what material conditions does resistance occur? To what extent can prohibited identifications and the desires they produce be considered a form of social resistance?

In the two specific cases of group hysteria I have been discussing, the answer to the question "who or what resists?" may have everything to do with the disciplinary spaces in which the resistance occurs: the hospital and the school. A Foucaultian reading of these mirror scenes of infection provides a valuable corrective to Freud's theory of group identification, reminding us that group ties are formed in particular physical spaces that are already sociopolitical ones. Both the hospital and the school are sites of social classification, disciplinary spaces organized for the observation, regulation, and supervision of their subjects. The function of these two institutions is to produce subjects whose progress can be isolated, individualized, examined, charted, measured, and systematically classified. But these institutions also *produce* the identities they are socially instituted to manage, installing at the center of the disciplinary project their own resistances. Read from a Foucaultian perspective, social institutions organize groups through a distinctly spatial ordering of subjects. We can thus redefine the question of both resistance and group identification as fundamentally a problem of *how bodies circulate*, of how subjects act upon, influence, or repel one another in a given social space.

Infectious Desires

While Freud was studying the homosocial scene of the girls' boarding school to understand the phenomenon of group hysteria, a growing number of Anglo-European women were publishing thinly-disguised autobiographical narratives that told a different story of adolescent schoolgirl infatuations. Like Freud's brief case history of "mental infection," Dorothy Strachey's *Olivia* takes the girls' boarding school as the setting for her narrative of group relations. But the parallels end here, for ultimately what is important in dovetailing Freud's *Group Psychology* with a novel like Dorothy Strachey's *Olivia* is not that Strachey's narrative portrays scenes of group hysteria similar to those recounted by Freud but that it emphatically does *not*—which is not to say that hysteria plays no role at all in the boarding school novel. In *Olivia*, hysteria operates *within* and *as* the law, inverting the conventional psychoanalytic understanding of both terms and subjecting psychoanalysis itself to a different kind of reading.

Dorothy Strachey (1866–1960), today eclipsed by the fame of her two younger brothers, Lytton and James, at first appears to be another forgotten Dorothy in British literature, present only to literary history in the traces of a formative influence on her more famous siblings. But Dorothy Strachey was neither literary muse, domestic helpmate, nor erotic object to her brothers as Dorothy Wordsworth appears to have been to brother William; nor was she largely invisible to the literary world of Bloomsbury. Shortly before Lytton Strachey garnered fame as a literary essayist and biographer, and well before James Strachey and his wife Alix made a name for themselves as translators of Freud's *Collected Papers*,[32] Dorothy (over fifteen years Lytton's senior and over twenty years James') had already established her own reputation in English letters as Gide's chief English translator. Like most European intellectuals in the post-war period, Dorothy was well-versed in at least the rudiments of psychoanalysis, and she may well have read her brother James' 1922 English translation of *Group Psychology and the Analysis of the Ego*.[33] But in *Olivia*, her only novel, Dorothy Strachey professed serious reservations about this science of emotion which appeared to her to be the harbinger rather than the cure of a new kind of cultural neurosis.

Strachey begins her boarding school narrative as an exercise in evasion, an attempt to take refuge, in her writing, from a storm that threatens to overwhelm all Europe: "The world, I know, is changing. I am not

indifferent to the revolution that has caught us in its mighty skirts, to the enormity of the flood that is threatening to submerge us" (9). Whether the breaking storm is, for Strachey, cultural, political, or both is not entirely clear, but the passages that immediately follow suggest that these enigmatic lines could refer as easily to the intellectual "revolution" ushered in by psychoanalysis as to the more ominous social upheaval signalled by the rise of political turmoil in Europe. Rather than confront this revolution head-on, Strachey prefers to escape into her memories of another tumultuous time of her life, an adolescent love affair with a beloved French schoolmistress. That the "revolution" is personified as female should alert us from the outset that this novel is not interested in opposing the active stage of history to the insulated world of the girls' boarding school. Instead, the boarding school becomes for Strachey the arena in which larger cultural forces are very much at work and in which the interpersonal conflicts of the school participate in the very revolutionary changes the narrator at first claims to be escaping.

We learn early in the novel's introduction that the writer's imagined audience includes psychoanalytically informed readers, if not psychoanalysts themselves: "I have condensed into a few score of pages the history of a whole year when life was, if not at its fullest, at any rate at its most poignant—that year when every vital experience was the first, or, if you Freudians object, the year when I first became conscious of myself, of love and pleasure, of death and pain, and when every reaction to them was as unexpected, as amazing, as *involuntary* as the experience itself" (9). The parenthetical concession to "you Freudians" sets the tone for the narrative that follows and forewarns us that Strachey's relation to the intellectual tradition, which has won the lifelong apprenticeship of her youngest brother, is for her more profoundly ambivalent. Freud's name next appears in a list of those who "poison the sources of emotion"—namely, "the psychologists, the physiologists, the psycho-analysts, the Prousts and the Freuds" (10). Strachey invokes a metaphorics of illness to describe not just the lethal character of strong feelings but the dangers attendant upon those cultural practices designed to diagnose and to cure them. Those who would dare scientize the emotions ultimately succeed in offering no more than "the poisonous antidotes of the poison of passion" (11).

But what of the striking association of Freud with Proust? For Strachey, literature no less than science conspires to strip us of the originality of our experiences, the novelty of our emotions. Of her first feel-

ings of passion, Strachey asks: "Was this stab in my heart, this rapture really mine or had I merely read about it? For every feeling, every vicissitude of my passion, there would spring into my mind a quotation from the poets. Shakespeare or Donne or Heine had the exact phrase for it. Comforting, perhaps, but enraging too. Nothing ever seemed spontaneously my own" (10). No feeling without literary precedent; no emotion outside mimesis. In Strachey's estimation, experience itself is fundamentally *literary*: "Literature! Mere literature! Nothing to make a fuss about!" the narrator exclaims, immediately adding, "But so Mercutio jested as he died!" (10) The narrator acknowledges that even her "discovery" of the literary citationality of experience is, inevitably, a citation, ironically calling into question the originality of her own autobiography.

Language and science, literature and psychoanalysis, Proust and Freud are presented by Strachey as cultural allies in the conspiracy to deprive us of the singularity of our experiences: "It was deeply interesting, this withdrawal of oneself from the scene of action, this lying in ambush, waiting and watching for the prowling beasts, the nocturnal vermin, to come creeping out of their lairs, to recognize this one and that, to give it its name, to be acquainted with its habits—but what was left of oneself after this relinquishing of one's property? Wasn't one a mere field where these irresponsible animals carried on their antics at their own free will?" (11) This impassioned recitation on the emotions and their would-be interpreters is particularly interesting for the impossible confusion of its referents. Do the "prowling beasts" and "nocturnal vermin" refer to the unruly emotions or to the scientists who seek to make them the empirical objects of their study? At first we are tempted to read the "irresponsible animals" as allegorical figures for all the various pathologies a Freud or a Proust might inventory and analyze in the human subject. But the ambiguity of the syntax permits a second equally plausible reading in which it is the poets and psychoanalysts who are the night prowlers (interpreters of dreams perhaps?) raiding the private "property" of the unconscious. The double reading permitted by this curious passage poses one of the novel's most trenchant, intricate, and important questions: how does one tell the cure from the disease, the poison from the antidote?

For the sixteen-year-old girl in love with her schoolmistress, there can be no antidote for the passion that afflicts her because her case is "so different, so unheard of": "Really no one had ever heard of such a thing, except as a joke. Yes, people used to make joking allusions to

'school-girl crushes.' But I knew well enough that my 'crush' was not a joke" (11). Bereft of the "comfort" that the male poets of romantic passion might otherwise offer, the young Olivia is overwhelmed by the force of her emotions, feelings that appear to her at the time to have no literary precedent. Looking back on her younger self, the elder narrator writes that "the poison that works in a girl of sixteen—at any rate in the romantic, sentimental girl I then was—has no such antidote, and no previous inoculation mitigates the severity of the disease. Virgin soil, she takes it as the South Sea islanders took measles—a matter of life and death" (11). Strachey invokes a powerful cross-racial identification to describe the sudden impact of her first lesbian desire.[34] The metaphorics of poison and inoculation, colonization and occupation, suggest that the young Olivia's body is invaded from without, taken over and inhabited by an infectious agent that the adolescent girl feels powerless to combat. In this respect, Strachey's definition of desire might well be Freud's description of identification, insofar as both choose the precise figure of a viral infection to explain a particular affective relation of other to self. This convergence of identification and desire at the anxious site of the adolescent girl's body I take to be the theme of Strachey's novel. As if in response to Freud's hygenic distillation of emotional tie and object-cathexis, *Olivia* powerfully dramatizes how same-sex identification can actually foment the homosexual desire Freud insists it contravenes. Equally important, Strachey's boarding school narrative shows how desire circulates and moves along the very channels of group identification.

If psychoanalysis is right in suggesting that our earliest identificatory relations frame all the rest, establishing a pattern and direction for subsequent individual and group ties, then once we enter into this network of identifications there is no simple way out of the circuits of desire that it sets in motion. *Olivia*'s opening chapter begins with a brief description of a Victorian family romance writ large. The narrator remembers her father as a man of "science" who "passed his time in investigating with heroic patience and the strictest independence of judgment one or two of the laws of nature" and her mother as a woman of "letters" who "knew most of the Elizabethans more or less by heart" (13). Like Freud and Proust, Olivia's parental ideals (here symbolized by "science" and "letters") impress the adult narrator as less antagonists than allies in the combined repression of what she calls "the sensual element." Recalling the rich intellectual influences upon her upbringing, Olivia nonetheless

laments the "anomolous lack" that structured all her family relations—her parents' "insufficient sense ... of humanity and art." Even her mother, "with all her love of literature and music and painting ... never felt them otherwise than with her mind."

The "lack" or "insufficiency" at the heart of the family configuration produces in Olivia a strong identification with her mother's only sister, Aunt E., a woman who "was sensitive to art to the very finger-tips of her beautiful hands." It was Aunt E. who could conjure about her an atmosphere of "'ordre et beauté, luxe, calme et volupté'" (14).[35] Olivia's mysterious maternal aunt is yet another of the shadowy background figures in the bourgeois family romance whose presence pries open the oedipal family triangle. Every Victorian family, it seems, has its "spinster" aunt, an Aunt E. whose castrated name on the family tree is so often followed by another familiar nominal amputation, "d.unm." Even now it may not be possible to register the full weight of the unspoken meanings carried by the postmortem social designation "died unmarried." At the very least, the label poignantly summons up a life lived outside the circle of normative heterosexuality, a life whose final reckoning is officially registered, in the end, as no more than the termination of a genealogical branch on the family tree. But Olivia's Aunt E., the Baudelairian connoisseur of all things sensuous, the very figure of "Frenchness," embodies in the narrator's imagination the possibility of desire itself. In this novel, French—the language first taught to Olivia by her mother and by a childhood nursery maid—is the sign of both sexual desire and maternal instruction. It is therefore something less than a surprise when, of all the language instructors that Olivia studies with in the boarding school, it is the French teacher, the maternal friend, with whom she falls in love.

Les Avons, a small finishing school with thirty British, Belgian, and American students and an international staff, is actually run by two acquaintances of Olivia's mother: Mlle Julie and Mlle Cara.[36] To Olivia, these newest maternal substitutes are romantic figures, quite "like a wedded couple" (59). Partners and cofounders of a fashionable Parisian girls' school, "*ces dames*" have lived and worked together for fifteen years: "They were a model couple, deeply attached, tenderly devoted. ... They were happy" (54). But by the time of Olivia's arrival the school is embroiled in an emotional drama so intense that it rivals in the narrator's mind the plays of Racine, the dramatist whose work instills in the younger Olivia her "first conception of tragedy" (28). Olivia records an

early conversation between her new school friends that enigmatically signals the storyline's chief conflict:

> "Oh, that's Signorina, the Italian mistress. She's on Mademoiselle Julie's side."
> "And just think!" said someone else, "the German mistress is a *widow!*"
> "Yes, and *she's* all for Mademoiselle Cara!" (19)

This brief dialogue hints at strong attachments, secret passions, and open rivalries in the school, a place where (as the Penguin book jacket rather sensationalistically announces) "emotional liaisons and jealousies form the hidden curriculum." In a school divided into "Cara-ites" and "Julie-ites," Olivia is "all for" Mlle Julie whose success as a teacher of French literature is attributed by the narrator to her "infectious ardour" (32). Mlle Julie is capable of communicating "a Promethean fire" (32) to even the dullest student—no small accolade from a self-proclaimed fan of Shelley who has earlier confessed her belief that Prometheus is greater than Christ (16). Olivia's identification with her teacher's desires thus provides the protagonist with conduits for her own, as desire is carried along the currents of a contagious passion for learning.

When then does a scene of instruction become a scene of seduction? In *Olivia* the problem of identification is directly thematized and placed at the center of a drama of desire. Framed from the very beginning of the novel in familial terms, the teacher-student relation replays and revises the structural plasticity of the family romance, a point on which both Freud and Strachey appear to agree. Freud writes in "Some Reflections on Schoolboy Psychology" that in their role as substitute figures for parents, siblings, and nurses, teachers are obliged to take over every student's "emotional heritage," further noting that without an under-standing of identification and transference, "our behaviour to our schoolmasters would be not only incomprehensible but inexcusable."[37] But whereas Freud also insists that the purpose of education is ulti-mately to divert sexual energy into cultural work, Strachey inverts Freud's theory of sublimation to demonstrate how, in the social space of the school, intellectual training forms the very structure necessary for desire to reach its object. Seduction is, after all, a question of transport—not "of moving in space but of moving the desires of a person"[38]—and bonds of identification provide the critical channels of this transport. Strachey's novel suggests that the mimetic function of the educational process is precisely what invokes, impels, or institutes desire, which is to

say that all pedagogy comes under the sign of sexuality.[39] The question is thus not, When does a scene of instruction become a scene of seduction? but rather, When is a scene of instruction *not* a scene of seduction?

The school, with its regulatory regimes and disciplinary structures, only appears to work against and to block the circulation of desire. More than a simple mechanism of repression opposed to sexual pleasure, the institution of the secondary school actually helps to produce the very desires it was instituted to manage.[40] Scenes of reading aloud provide one such instance in *Olivia* where educational discipline induces pleasure. When Mlle Julie instructs her pupils in the rigors of the French classics by reading to them daily, Olivia finds herself irresistibly transported by her schoolmistress's voice into "the presence of great emotions." The performativity of the group ritual, organized around an erotics of reading, authorizes the teacher to display a range of intense feelings and the students seated at her feet to study with impunity the face of a beloved idol whose features are "moved by passion" (27). The novel's references to Mlle Julie's "infectious ardour" point to a metaphorics of contagion at work within this scene of instruction; the mimetic structure of the educational process relays the infectious desire along the open channels of identification between teacher and student.

The "look" carries a particularly strong erotic charge in *Olivia*. The desire between teacher and student is most compellingly figured in the novel as a subtle tension created by glances held and by fascinated, searching looks exchanged. Olivia recalls the involuntary compulsion of her own "intolerable gaze": "I think the passion that devoured me at that time was the passion of curiosity. Once, as I was watching her like this, she suddenly opened her eyes and caught me. Her glance held me for a moment, and I was too fascinated to look away. Her glance was piercing, not unkind but terrifying. She was searching me. What did she see?" (39) This encounter on a train is later replicated by a scene in the school library, the climactic scene in which Olivia first dramatically proclaims her love for Mlle Julie: "At last I raised my head and saw her eyes fixed upon me. Without knowing what I was doing, without reflection, as if moved by some independent spring of whose existence I was unaware, and whose violence I was totally unable to resist, I suddenly found myself kneeling before her, kissing her hands, crying out over and over again, 'I love you!'—sobbing, 'I love you!'" (60)

In the first scene Mlle Julie catches Olivia in her covert stare, while in the second Mlle Julie is herself detected in her secret contemplation of

Olivia. The two scenes of seduction stand in mirror relation to one another, as if to suggest an imaginary relation of primary identification. But the metaphorics of hypnosis in both these passages conveys a strong suggestion of an unequal symbolic relation structuring this desire. The language of hypnotic possession is not unfamiliar; mesmerism is one of the central romantic tropes in the nineteenth and twentieth centuries for figuring lesbian desire.[41] Before discussing the nature of the hypnotic structure of the look in *Olivia*, let me return, for a moment, to Freud's repudiation of hypnosis and to the historical relation between the modern psychoanalytic talking cure and the hypnotic treatment that it seeks to replace.

It can be argued that the discarded theory of suggestion returns to psychoanalysis under cover of the idea of transference, with Lacan the first to suggest that transference is simply the inverted image of suggestion, operating much in the manner of an "upside-down hypnosis."[42] Léon Chertok, Franklin Rausky, and Mikkel Borch-Jacobsen all read psychoanalysis as the latest chapter in the history of hypnosis.[43] Borch-Jacobsen, for example, usefully identifies the phenomenon of possession as the point where the opposition between illness and remedy becomes confused and undecidable, noting that the trance that psychoanalysis seeks to eliminate is present in the very therapeutic transference that would seek to cure it; the therapy in question is modelled on the structure of the illness, and the illness, in turn, imitates the therapy. Because the transferential process works along the same channels as the illness itself, the "cure" for hysterical possession actually operates as a kind of repossession, "a *catharsis* of *mimesis* by *mimesis*" (115). But even so, the psychoanalytic approach is not identical to the practice of hypnosis. Psychoanalysis ultimately departs from hypnosis in its demystification and desymbolization of the therapeutic power of the trance, now identified as the "sleep of reason, which no longer engenders any monsters" (127). Borch-Jacobsen, whom I have been citing here, is able to conclude optimistically that "we live in a society that can no longer believe in 'possession,' no matter what form it might take" (126).

It seems all too painfully clear, however, that the symbolic fantasy of an imaginary possession does persist in certain widespread cultural figurations, chief among them the representation of "homosexuality" as a form of demonic possession. Next to the sign of contagion, possession is the chief figure in homophobic explanations of the "spread" or "transmission" of homosexuality, and indeed the two figures of hypnosis and

contagion are interrelated to the degree that each participates in a rhetoric and dread of "exposure." Nowhere is the hypnosis trope more potent and more damaging than in the homophobic campaigns directed against gay teachers in the schools, campaigns that conjure up the fearful image of innocent children "exposed" to pederasts and "inducted" into homosexuality through the power of mimetic suggestion. In these phobic portraits, homosexuality is portrayed as an *induced* state or an *involuntary* possession, which is why modern attempts to "cure" homosexuality resemble nothing so much as variations on exorcist rituals. Of course, the paranoid fear of invasion conveyed by these images acknowledges in its very articulation a nervous awareness of the heterosexual subject's own susceptibility to same-sex desire and thus to the ever present possibility of loving otherwise. Figured as either communicable disease or demonic possession, these phobic representations throw into high relief the insecurity and instability at the heart of cultural constructions of normative heterosexuality.

To return to *Olivia*, Strachey figures the lesbian desire between teacher and student in the cultural terms available to her. Mlle Julie "fixes" Olivia with her stare, moving Olivia to a trance-like declaration of her love. The adolescent girl is like one possessed, paralyzed in a hypnotic state that the narrator later describes as "a kind of coma" (62). Olivia's passion for Mlle Julie, her first love, is repeatedly described as "involuntary," a term given special prominence by the novel's epigraph from Jean de La Bruyère: "L'on n'aime bien qu'une seule fois: c'est la première./Les amours qui suivent sont moins involontaires."[44] Moreover, sexual passion is associated throughout the novel with scenes of illness. Mlle Julie visits Olivia's bedroom late at night on the pretext of monitoring her student's health, and Olivia spends a night feverishly ill in Mlle Julie's room after the mysterious death of Mlle Cara. In Freud and Breuer's *Studies on Hysteria*, the etiology of hysteria is repeatedly linked to nursing; the hysteria of both Anna O. and Elisabeth von R. can properly be said to begin in the sickroom, as each woman nurses an ailing father. One might say that Strachey, taking a cue from the hysteric, eroticizes the sickbed, thus reversing Freud's medicalization of eros. But if passion and illness are linked in this novel, their association works to represent desire between women in the overly sentimental nineteenth-century terms of physical comfort rather than in the more modern vocabulary of mental pathology.

This is not to imply that the language of moral vice is wholly absent from the novel, but only to point out that Strachey's narrative interests lie in a nostalgic recuperation of a much earlier and decidedly more benign bourgeois model of same-sex desire. It should also be noted here that Olivia's hypnotic possession produces fantasies, dreams, and intense emotions—but no hysterical symptoms. A character who has yet to figure prominently in this reading, Mlle Cara, functions as both the school's resident hysteric and its voice of capricious authority and moral rectitude. In *Olivia*, the discourse of law and the theme of hysteria actually converge in the same person, posing an entirely different set of questions for a reading of the politics of hysteria.

The Hysteria of the Law

In many ways, the psychoanalytic literature on hysterical identification is about the problem of law and letters—the letter of the law that produces the hysteric as ill and the law of letters that allows the hysteric to speak nonetheless through the language of the symptom. Lacan lyrically describes the hysterical symptom as "letters of suffering in the subject's flesh."[45] For Lacan, these corporeal letters speak mutely but eloquently to the hysteric's difficulty in entering into the order of sexual difference; they signal the subject's failure to take up "her" place in a symbolic apparatus that institutes the law of sexuality. For Irigaray, by contrast, "there is a revolutionary potential in hysteria. Even in her paralysis, the hysteric exhibits a potential for gestures and desires." In this reading, hysteria's "letters" mark not a psychical failure but a "movement of revolt and refusal,"[46] a social repudiation of both the tyranny of symbolic law and the normativity of the sexual identifications that it officially sanctions. Yet read as failure or refusal, hysteria in either case *opposes* the law, articulates itself always as a response to or a defense against the symbolic order. *Olivia* implicitly poses the question of whether there could be another, different relation of hysteria to the law. Through the figure of Mlle Cara, Strachey's novel follows the trace of a certain movement of hysteria to the other side of the symbolic divide, examining a form of hysteria not opposed to the law but intimately allied with it. It considers the possibility of a more complicated relation of mutual contamination between the "letter" of hysterical speech and the "letter" of symbolic prohibition.

Mlle Cara is a classic portrait of the hysteric. Suffering from migraines, excitability, and sudden fits of weeping, Mlle Cara is described by the narrator as "pretty and invalidish" (21), "graceful and languid" (22). Although too ill to teach lessons, she nonetheless exerts over the school "a pervading influence—the influence of an invalid" (40). It is Mlle Cara who, finding Olivia asleep in Mlle Julie's library, accosts her for her idleness, demoralization, and depravity, and it is Mlle Cara who not only accuses Olivia of turning "vicious" (73) but Mlle Julie, her own former partner, of corrupting her. Mlle Cara, in her hysteria, becomes the novel's voice of moral law and social intolerance, acting as a kind of cultural mouthpiece for the modern pathologization of sexual desire between women.

The shape of this new narrative of hysteria does not fit squarely into the theoretical geometry provided for us by either Freudian or Lacanian psychoanalysis. Understood psychoanalytically, hysteria operates not just as a confirmation of the law but as a repudiation of the law, or as a confirmation through repudiation. Ellie Ragland-Sullivan succinctly defines hysteria as "a certain subversive attitude toward norms." In her being the hysteric "reveals the incapacity of any human subject to satisfy the ideals of Symbolic identifications." Hysteria refuses the logic of the Symbolic whenever "the hysteric's question prevails over the master's answer."[47] Strachey, however, puts the master's answer into the hysteric's mouth, displacing hysteria onto the law and disorientating and confusing the difference between them. In part, the usefulness of a novel like *Olivia*, when read alongside Freud's work on hysterical identification, is that it allows us to widen the sphere of possible questions we can ask about hysteria—and, for that matter, resistance, sexuality, and the law.

What is to prevent us from reading the law itself as hysterical symptom, much as we have read the figure of the letter in Freud's narrative of group hysteria? The significance of the structure of hysteria is that it is all structure. Whatever the hysteric once knew she has forgotten: content is displaced onto form, the law onto the letter. The hysteric's secret remains a secret even to the hysteric, which is precisely why hysteria demands a reading. Can the law keep secrets from itself? Is there something within the law that resists the law? What, if anything, comes before the law whose repression might be said to institute that law?

These are some of the questions Derrida implicitly invites us to consider in his essay "Devant la Loi" ("Before the Law"), a reading of

Kafka's allegorical story by the same title. Kafka's brief story tells the tale of a man who begs the doorkeeper of the Law for admittance but, repeatedly rebuffed, dies at its portals never having attained the inner precincts of the Law. In this story, the law itself is forbidden, not merely what forbids.[48] What we might call the letter of the law, like the symptom of hysteria, has no immediate referent. In both cases, letter and symptom are set loose from any origin; "what remains concealed and invisible in each law is thus presumably the law itself" (134). If I digress on the subject of Derrida on the law in my examination of psychoanalysis, I can only point, by way of precedent, to the digression on psychoanalysis at the heart of Derrida's essay on the law. Derrida calls attention to Freud's "discovery" of the source of morality in the concept of repression by citing one of Freud's letters to Fliess in 1897:

> Before the holidays I had told you that my most important patient was myself; and then, suddenly, on returning from my holidays, my self-analysis, which at that time had given me no sign, began again. Some weeks ago I desired that repression be replaced by the essential thing that lies behind it and that is what occupies me now.... [R]epression gives the affective foundation of many intellectual processes, such as morality, decency, and so on. The whole set of these reactions occurs at the expense of (virtual) sexuality by way of extinction.[49]

Although Derrida does not mention hysteria in his reading of this passage on the law, we might recall that the "self-analysis" Freud refers to here is his self-treatment for hysteria that leads to the very discovery of repression as the basis of the law. It is true, as Derrida notes, that from the outset Freud "wanted to write a history of the law" (135); it is also the case that, from the outset, this history of the law *is* a history of hysteria. Put within the terms of Derrida's own historical reading, we might say that there is no hysteria before, outside, or beyond the law. And yet my question here, though related, takes a rather different tack: what might it mean to say that there is no law outside of hysteria? Or, more precisely, that the hysteria of the law obeys the logic of the law of hysteria?

To pose this question is to entertain the possibility that the Symbolic itself is ill. This confusion of illness and remedy becomes manifestly clear in *Olivia's* account of the origin of Mlle Cara's hysteria. Mlle Cara is driven into a neurotic state by another instructor at the school, Frau Riesner, who encourages her superior to sink into invalidism through a

"campaign of insinuation" (56). Frau Riesner is the novel's sketchily characterized villain who ascends into a position of authority after Mlle Cara's mysterious death by overdose. It is hardly accidental that it is the German instructor, suspected by the narrator of literally murdering her colleague with a medicinal overdose, who figuratively poisons her with the language of moral vice. Nor is it insignificant that it is specifically chloral, the medical remedy most commonly prescribed in the late nineteenth century to *cure* hysteria, that finally kills Mlle Cara. *Olivia* becomes a crime story at the exact moment when Mlle Cara dies and Frau Reisner gains legal title to the school. The novel's sudden and awkard shift in genre—from sentimental adolescent love story to murder-crime mystery—allegorically maps Strachey's response to a dramatic historical shift in attitudes towards bourgeois lesbian relations. From a privileged position of hindsight some half a century later, Strachey encodes through this curious breach in narrative continuity her own suspicions about the new sciences of sexuality. *Olivia* quietly condemns the cultural replacement of "the French" by "the German" which, in this novel, translates into the annihilation of emotion (and the related discourse of romantic attachment) by science (and its attendant discourse of sexual pathology). The novel, in other words, registers Strachey's nostalgia for a preFreudian, premodern world before passionate relations between women became the object of scientific inquiry and "psycho-analysis."

That *Olivia* has been all along an act of memorialization—a kind of love letter—is first hinted at by the novel's opening dedication to "the beloved memory" of Virginia Woolf, whose passionate attachments to women (before and during her marriage) became for Strachey the basis of a powerful and lasting identification.[50] The choice of title and literary pseudonym adds a second layer of mourning as Strachey pays homage to a younger sister named Olivia who died in infancy. Strachey, a former teacher of Shakespeare in a girls' boarding school, also surely had another Olivia in mind when she named her fictional alter ego: the heroine of the Shakespearean comedy *Twelfth Night*. One of Shakespeare's most memorable melancholics, Olivia mourns the death of her brother until she falls in love with a woman disguised as a man. A tangled romance of sartorial masquerade and comic impersonation, of sexual confusion and gender ambiguity, *Twelfth Night* serves as the perfect analogue for Strachey's literary exploration of the improbability of her own "unheard of" passions.

But the most direct indication of the novel's elegiac temper comes in the final pages as the adult narrator pays nostalgic tribute to her former teacher, Mlle Julie. The novel closes with the image of an ivory paper cutter engraved with the name "JULIE"—a momento bequeathed to Olivia after Mlle Julie's sudden death by pneumonia. A metaphor throughout the novel for the intellectual identification between teacher and student, the letter opener also symbolizes their unfulfilled desire and tragic separation. The very exercise of writing the novel is, for the adult narrator, a process of mourning, an attempt to sustain desire by narratively incorporating the Other who has been lost. The point of terminal identification for *Olivia* is JULIE: the Other, as always, gets the last word.

Conclusion

There is a clear suggestion in *Olivia* that the law induces what it purports to cure. Much the same charge can be levelled against the early psychoanalysts whose medical practices were almost entirely dependent for their economic survival upon the "epidemics" of hysteria amongst middle-class women. But finally, a far more interesting point can be made about the connection between psychoanalysis and hysteria, namely, that psychoanalysis is itself a hysterical theory of sexuality. To make such a claim is not to lessen our interest in psychoanalysis but to amplify it by drawing attention to what psychoanalysis does not or cannot say, to what it repeatedly forgets, to what it compulsively tries to read. It also encourages a theoretical and historical framing of psychoanalysis as not only what Foucault would perhaps too quickly dismiss as simply another repressive discourse based upon a juridical model but also, simultaneously, a refusal and a subversion of that juridical model. If psychoanalysis is a curative science that seeks to strengthen the law by tending to its ills, it is also the "plague" that Freud brings with him to America. As a hysterical theory of the law—the law of desire—psychoanalysis keeps itself open, prevents its own foreclosure in or as the law.

And yet even this reading of the law of desire, and the hysterical identification that disturbs it, is too simple, for the psychoanalyst poses the very same question as the hysteric: What does it mean to be a woman? to be a man? The letter of hysterical speech and the letter of symbolic prohibition follow an identical path of transmission, reminding us that in our present cultural symbolic the language of desire *is* the language of

prohibition. The law's production of the hysterical symptom works in the manner of a *letter opener* that permits the law to sustain itself through the introduction and management of its own breaches and resistances. Yet what finally remains unquestioned in psychoanalysis is the origin of the law itself. Symbolic oedipality is assumed in order to be interfered with, but assumed even so. The hystericisation of the law thus performs an instrumental role: the muteness or silent aporia at the heart of the law makes possible its articulation *as* the law. Lacan calculated as much—"it is the law in so far as it is not understood."[51] Hysteria may be only the most eloquent sign of this tragic misunderstanding.

NOTES

1. In a section on modesty Wollstonecraft writes: "in nurseries, and boarding-schools, I fear, girls are first spoiled; particularly in the latter. A number of girls sleep in the same room, and wash together. And, though I should be sorry to contaminate an innocent creature's mind by instilling false delicacy, or those indecent prudish notions, which early cautions respecting the other sex naturally engender, I should be very anxious to prevent their acquiring nasty, or immodest habits." See *A Vindication of the Rights of Woman*, ed. Carol H. Poston (New York and London: W. W. Norton and Company, 1988), 127. Havelock Ellis and John Addington Symonds, *Sexual Inversion* (London: Wilson and Macmillan, 1897). Reprinted by Arno Press (New York, 1975), 141.

2. Reverend J. M. Wilson, "Olim Etoniensis," *Journal of Education* 1882, 85. Cited in Ellis, 38.

3. The belief that intellectual exertion posed a serious risk to the health of young women was offerred as one of the central arguments for denying girls access to secondary school education. See Carol Dyhouse, *Girls Growing Up in Late Victorian and Edwardian England* (London: Routledge and Kegan Paul, 1981). Female adolescence was itself pathologized, largely through the medical representation of menstruation as illness or disease, as Carroll Smith-Rosenberg reminds us in her discussion of "Puberty to Menopause: The Cycle of Femininity in Nineteenth-Century America," in *Disorderly Conduct: Visions of Gender in Victorian America* (Oxford: Oxford University Press, 1985), 182–196. Martha Vicinus speaks of the morbidification of girls' same-sex crushes in her fascinating essay, "Distance and Desire: English Boarding-School Friendships," in *Signs* 9:4 (Summer 1984): 600–622. And Leila J. Rupp argues that during the early and mid-twentieth century (the period in which Dorothy Strachey writes *Olivia*), most adult middle-class women saw lesbianism as simply another of those "emotional extravagances of the adolescent." Particularly relevant to the present reading, lesbianism was colloquially attributed to an identificatory disease; a woman who desired another woman was said to be "afflicted with Jeanne d'Arc identification." See Rupp's "'Imagine My Surprise': Women's Relationships in Mid-Twentieth Century America," in *Hidden From History: Reclaiming the Gay and Lesbian Past*, eds. Martin Duberman, Martha Vicinus, and George Chauncey, Jr. (New York: Meridian, 1989), 405, 406.

4. Freud, "Contributions to a Discussion on Suicide" (1910), *Standard Edition*, 11: 231, 232. Freud subscribed to the position that homosexuality is part of "normal" adolescent development and will eventually, without undo interference, revert back into "proper" object-choice.

5. John Neubauer, *The Fin-de-Siècle Culture of Adolescence* (New Haven: Yale University Press, 1991), 6. Neubauer's introduction gives a brief but useful overview of the debates on the invention theories of adolescence. For more on the central role played by public school reform in the invention of adolescence, see John Gillis, *Youth and History: Tradition and Change in European Age Relations, 1770–Present* (New York and London: Academic Press, 1974), esp. 95 ff.

6. For an important critique of the more uncompromising dismissals of Hall's *The Well of Loneliness*, see Esther Newton's "The Mythic Mannish Lesbian: Radclyffe Hall and the New Woman," *Signs* 9:4 (Summer 1984): 557–575. Newton's discussion of both the novel and the historical context in which it was produced reminds us that Hall's own narrative is not without some strategies of resistance to the medical paradigm she allegedly adopts wholesale.

7. It is not my intent to substitute one "representative" narrative for another but rather to call into question the very idea of representativity, which works in exclusionary fashion to mask the diversity of texts that fall not only outside its generic boundaries but within them as well.

8. Jeannette H. Foster, *Sex Variant Women in Literature* (Tallahassee, FL: The Naiad Press Inc., 1985), originally published by Vantage (1956), 55. Foster's ambitious reference volume, published almost forty years ago, has yet to receive the serious critical attention it deserves. On school narratives, see also Elaine Marks, "Lesbian Intertextuality" in *Homosexualities and French Literature: Cultural Contexts/Critical Texts*, ed. George Stambolian and Elaine Marks (Ithaca and London: Cornell University Press, 1979): 353–377.

9. Adolf Belot, *Mlle Giraud, Ma Femme* (Paris: Dentu, 1870); Dubut de Laforest, *La Femme d'Affaires* (Paris: Dentu, 1890); and Charles Montfont, *Le Journal d'une Saphiste* (Paris: Offenstadt, 1902).

10. In Germany the boarding school narrative begins later, perhaps because Germany has no elite boarding schools comparable to those in France (see Neubauer, 166). Frank Wedekind, *Mine-haha* (Munich: Langen, 1905); *Pandora's Box* (New York: Boni and Liveright, 1918); and *Franziska: A Modern Mystery* (Munich: Miller, 1913).

11. Christa Winsloe, *The Child Manuela*, trans. Agnes Neil Scott (New York: Arno Press, 1975).

12. Charlotte Brontë, *Jane Eyre* (London and New York: Penguin, 1966; first published 1847); A. T. Fitzroy, *Despised and Rejected* (London: Daniel, 1918); Rosamund Lehmann, *Dusty Answer* (New York: Holt, 1927); and Wanda Fraikan Neff, *We Sing Diana* (Boston: Houghton, 1928). The motif of the book and the exercise of reading provide the structural relay for desire between women in the Lowood section of *Jane Eyre,* which is organized around the female homosocial triangle of Jane-Helen-Miss Temple. Brontë's novel is as much about the passions of women's education as it is a novel about heterosexual romance, and indeed the two plots interfere with each other in complicated and interesting ways.

13. Colette, *Claudine a l'école*, in *The Claudine Novels*, trans. Antonia White (London: Penguin Books, 1963; first published 1900).

14. Dorothy Strachey, *Olivia* (New York: Virago Press, 1987). First published by the Hogarth Press (London, 1949). Strachey is sixty-eight years old when she writes *Olivia* and eighty-three when it is finally published.

15. Along with the "idle" woman, Foucault cites the privileged "schoolboy" as one of the earliest figures to be invested by the deployment of sexuality, one of the first social subjects to be "sexualized." See Michel Foucault, *The History of Sexuality*, trans. Robert Hurley (New York: Vintage Books, 1980), 121.

16. The categorization of these thinly disguised autobiographical novels as "fiction" does little to undermine their importance as correctives to the Freudian narrative of female adolescent desire; instead I believe they tell us something important about the "fictionality" of the psychoanalytic case history and about the "truth" of narratives that attempt to tell similar stories of illicit passion in a fictional mode.

17. Freud, *Group Psychology and the Analysis of the Ego* (1921), *Standard Edition*, 18:107.

18. Freud, *The Interpretation of Dreams* (1900), *Standard Edition*, 4:149–50. This narrative is actually sandwiched in the middle of Freud's analysis of the butcher's wife's dream (see Chapter 1).

19. This temporal reversal of sympathy and identification does not, of course, adequately explain why women are more "prone" to identification if sympathy is its effect, not its cause.

20. Freud develops his theory of the flight into illness in several places, most prominently in *Fragment of an Analysis of a Case of Hysteria* (1901), *Standard Edition*, 7:3–122; "The Future Prospects of Psycho-Analytic Therapy" (1910), 11:139–51; "Introduction to Psycho-Analysis and the War Neuroses" (1919), 17:205–15; and *Inhibitions, Symptoms and Anxiety* (1926), 20:77–174.

21. See, for example, Freud's "Hysterical Phantasies and Their Relation to Bisexuality" (1908), *Standard Edition*, 9:155–66, and "Some General Remarks on Hysterical Attacks" (1909), 9:227–34.

22. Freud, "Hysterical Phantasies," 166.

23. Freud, *The Interpretation of Dreams,* 149.

24. In *The Poetics* Aristotle defines metaphor as "the transfer [*epiphora*] to a thing of a name that designates another thing." See also Paul De Man's reading of Aristotelian metaphor in chapter seven of *Allegories of Reading: Figural Language in Rousseau, Nietzsche, Rilke, and Proust* (New Haven and London: Yale University Press, 1979): 135–59.

25. Mary Jacobus, *Reading Woman: Essays in Feminist Criticism* (New York: Columbia University Press, 1986). In an especially shrewd reading of Anna O., Jacobus argues that what the analyst learns from the hysteric's misreading is precisely how to be a good reader.

26. For the complete spectrum of these views, see the essays in the collection, *In Dora's Case: Freud-Hysteria-Feminism*, ed. Charles Bernheimer and Claire Kahane (New York: Columbia University Press, 1985). See also Hélène Cixous and Catherine Clément, *The Newly Born Woman*, trans. Betsy Wing (Minneapolis: University of Minnesota Press, 1986), and Jane Gallop, *The Daughter's Seduction: Feminism and Psychoanalysis* (Ithaca: Cornell University Press, 1982).

27. Lacan, "Intervention on Transference," in *Feminine Sexuality: Jacques Lacan and the école freudienne*, eds. Juliet Mitchell and Jacqueline Rose, trans. Jacqueline Rose (New York: W. W. Norton and Company, 1982), 70.

28. Madelon Sprengnether, "Enforcing Oedipus: Freud and Dora." In *In Dora's Case*, 255. Sprengnether's reading of *Dora* emphasizes the way in which desire is carried along the currents of illness in a shifting network of nurse-invalid identifications.

29. Friedrich Nietzsche, *The Will to Power*. Vol. 15 of *The Complete Works*, trans. Anthony M. Ludovici (New York: Russell & Russell, Inc., 1964), 256. And Vol. 14 of *The Complete Works*, 34.

30. This question is far too extensive to be examined here. For a much fuller treatment of the history of hysteria in psychoanalysis, see Monique David-Ménard, *Hysteria From Freud to Lacan: Body and Language in Psycho-analysis*, trans. Catherine Porter (Ithaca: Cornell University Press, 1989). David-Ménard has also addressed the question of identification from a more explicitly clinical perspective in *Les Identifications: Confrontation de la clinique et de la théorie de Freud à Lacan* (Paris: Denoël, 1987).

31. Laplanche and Pontalis make this point directly: "for Freud the question of *who resists* remains open and vexed." *The Language of Psychoanalysis*, trans. Donald Nicholson-Smith (New York: W. W. Norton and Company, 1973), 396.

32. The *Collected Papers* was initially published in four volumes with a fifth volume published by James Strachey twenty-five years later; Freud was particularly delighted with the translations of Joan Riviere who did the bulk of the translation work for this series. Though they seem to have pleased Freud, James Strachey's own translations are by no means uncontroversial. For critical reservations on the English translations of Freud, see *Freud in Exile: Psychoanalysis and Its Vicissitudes*, ed. Edward Timms and Naomi Segal (New Haven and London: Yale University Press, 1988).

33. Sigmund Freud, *Group Psychology and the Analysis of the Ego*, trans. James Strachey (London and Vienna: International Psycho-Analytical Press, 1922).

34. And yet it is a difficult metaphorization, perhaps even another kind of colonization. While the allusion to the incredible devastation wrought by the introduction of European diseases into the colonies is intended to emphasize the violence of a young girl's emotions, figuring the "foreignness" of lesbian desire in specifically racial and national terms, it does so by appropriating the colonial other as no more than a trope for the novel's discursive construction of lesbian identity as bourgeois and Anglo-European. It is difficult to forget in this context that Dorothy Strachey was a member of one of England's most famous colonialist families. Access to the elite boarding school described in *Olivia* (a comparatively safe space, after all, in which to explore sexual desire) was made possible in the first place by the Strachey family's prolonged and intimate involvement in Britain's political and economic colonization of India. Daughter of Lady Jane Maria Strachey and General Sir Richard Strachey, Dorothy Strachey was connected on both sides of the family to the British military and its colonial administration. Her mother was the daughter of the lieutenant governor of Bengal. Her father, Secretary to the Government of the Central Provinces and later chief engineer of India's canal and rail system, helped to put down the Indian Mutiny of 1857–58. In 1868, Dorothy, at the age of three, was bridesmaid to the Viceroy's daughter. Not until Richard Strachey's retirement in 1872 did the family settle permanently in London. Even then, Dorothy's brother Oliver continued the family tradition of colonial administration, working for the Indian railway. For an inadvertently revealing account of the family's colonial history, see the history-memoir by Oliver Strachey's daughter and Dorothy's niece, Barbara Strachey, entitled *The Strachey Line: An English Family in America, in India and at Home, 1570 to 1902* (London: Victor Gollancz Ltd., 1985).

35. These lines from Baudelaire's "Invitation au voyage" are lifted, appropriately enough, from *Les fleurs du mal*, one of nineteenth-century French literature's most famous treatments of the theme of "decadent" female sexuality—a book usurped in importance only by the appearance of that other great French text of "homosexual" desire, Proust's *A la recherche du temps perdu*.

36. *Les Avons* is a combined portrait of the French finishing school *Les Ruches*, run by Lady Strachey's close friends Mlle Souvestre (*Olivia*'s Mlle Julie) and Mlle Dussaut (Mlle Cara), and its English boarding school successor Allenswood that Marie Souvestre started after her partnership with Mlle Dussaut failed. By all accounts a charismatic and gifted teacher, Souvestre counted among her more famous students Dorothy Strachey and her sister Elinor, Natalie Barney, and Eleanor Roosevelt. Strachey herself taught Roosevelt (a possible prototype for *Olivia*'s Laura) when she became a teacher of English at Allenswood. For more on Marie Souvestre and her finishing schools, see Blanche Weisen Cook's absorbing biography, *Eleanor Roosevelt, Vol. I: 1884–1933* (New York: Penguin, 1992), 102–124.

37. Freud, "Some Reflections on Schoolboy Psychology" (1914), *Standard Edition*, 13: 243, 244. This short piece was written to celebrate the 50th anniversary of *K. k. Erzherzog-Rainer Realgymnasium*, the secondary school Freud himself attended from 1865 to 1873. The public address is noteworthy for its complete *avoidance* of a direct discussion of sexuality. Faced with his own former schoolmasters, Freud tellingly censors what is most radical about psychoanalysis—its theory of sexuality.

38. I quote here from Barbara Johnson's elegant reading of none other than Baudelaire's "Invitation au voyage." See *The Critical Difference: Essays in the Contemporary Rhetoric of Reading* (Baltimore and London: The Johns Hopkins University Press, 1980), 27.

39. For an extended analysis of the predominantly sexual character of the transmission of knowledge, a discussion which is also grounded in a reading of Freud's *Group Psychology*, see Juliet Flower MacCannell's "Resistance to Sexual Theory" in *Theory/Pedagogy/Politics: Texts for Change*, ed. Donald Morton and Mas'ud Zavarzadeh (Urbana and Chicago: University of Illinois Press, 1991): 64–89. I borrow here MacCannell's concise pedagogical formula: "*all* pedagogy comes under the sign of the sexual" (66).

40. Linda Singer has recently made a similar point about "the productive relationship between discipline and pleasure, those moments when disciplines function as enabling forces for inciting and stylizing that which they also claim to regulate." *Erotic Welfare: Sexual Theory and Politics in the Age of Epidemic*, eds. Judith Butler and Maureen MacGrogan (New York and London: Routledge, 1993), 70. Singer raises the question of "whether or not there is anything like undisciplined sexuality, and what kind of politics can and should be mobilized/developed on its behalf" (80). My own reading comes down squarely on the side of Foucault, calling into question any possibility of an undisciplined (which is to say *ahistorical*) sexuality.

41. In my mind, the best narrative example of lesbian mesmerism comes from a most unlikely source: Oliver Wendell Holmes' *Elsie Venner* (Boston: Boston Ticknor and Fields, 1861).

42. Jacques Lacan, *The Four Fundamental Concepts of Psychoanalysis*, ed. Jacques-Alain Miller and trans. Alan Sheridan (New York and London: W. W. Norton, 1978), 273.

43. Léon Chertok and Raymond de Saussure, *La naissance du psychanalyste* (Paris: Payot, 1973); Franklin Rausky, *Mesmer ou la révolution thérapeutique* (Paris: Payot, 1977); and Mikkel Borch-Jacobsen, "Mimetic Efficacity: From Trance to Transference," *Stanford*

Literature Review 8: 1–2 (Spring–Fall 1991): 103–127. Borch-Jacobsen detects the operative traces of hypnosis in both Freud's idea of "a 'demonic' unconscious resistant to reason" and his notion of "the light hypnosis of free association" (123 and 126). All references from Borch-Jacobsen are hereafter cited in the text. See also Borch-Jacobsen's *The Emotional Tie: Psychoanalysis, Mimesis, and Affect* (Stanford: Stanford University Press, 1993).

44. "One only loves well one time: the first time./The loves that follow are less involuntary" (my translation).

45. Jacques Lacan, "The Function and Field of Speech and Language in Psychoanalysis," in *Écrits*, trans. Alan Sheridan (New York: W. W. Norton and Company, 1977), 92.

46. Luce Irigaray, "Women-Mothers, the Silent Substratum of the Social Order," in *The Irigaray Reader*, ed. Margaret Whitford (Oxford: Basil Blackwell, 1991), 47.

47. Ellie Ragland-Sullivan, "Hysteria," in *Feminism and Psychoanalysis: A Critical Dictionary*, ed. Elizabeth Wright (Oxford: Basil Blackwell Ltd, 1992), 164–65.

48. Jacques Derrida, "Devant la Loi," trans. Avital Ronell, in *Kafka and the Contemporary Critical Performance: Centenary Readings*, ed. Alan Udoff (Bloomington and Indianapolis: Indiana University Press, 1987): 128–149.

49. Derrida, 135; Freud, Letter to Fliess, November 14, 1897, *Standard Edition*, 1:268–69.

50. I should note here that Strachey herself, at the age of thirty-eight, married the French painter and portraitist Simon Bussy with whom she had a daughter. Strachey's marriage by no means discredits the importance of *Olivia* as an autobiographical "lesbian novel"; if anything it may lend a certain poignancy to the unmistakable (and at times unrelenting) tone of nostalgia that drives this narrative from start to finish. As with Virginia Woolf, Dorothy Strachey's sexuality defies easy, quick, or simplistic categorization.

51. Jacques Lacan, "Censorship Is Not Resistance," in *The Seminar of Jacques Lacan, Book II: The Ego in Freud's Theory and in the Technique of Psychoanalysis, 1954–1955*, ed. Jacques-Alain Miller and trans. Sylvana Tomaselli (New York and London: W. W. Norton and Company, 1988), 129.

5

INTERIOR COLONIES:
FRANTZ FANON AND
THE POLITICS OF IDENTIFICATION

I CONCLUDE THIS BOOK ON IDENTIFICATION with two claims: first, that identification has a history—a colonial history; and second, that this colonial history poses serious challenges for contemporary recuperations of a politics of identification. I do not mean to imply that identification, a concept that receives its fullest elaboration in the discourse of psychoanalysis, cannot be successfully mobilized for a radical politics. I mean only to suggest that if we are to begin to understand both its political usages and its conceptual limitations, the notion of identification must be placed squarely within its other historical geneologies, including colonial imperialism. To assist me in this reading, I turn to one of the most important twentieth-century writers working at the intersection of anti-imperial politics and psychoanalytic theory, the practicing psychiatrist and revolutionary philosopher, Frantz Fanon. Psychoanalysis's interest in the problem of identification provides Fanon with a vocabulary and an intellectual framework in which to diagnose and to treat not only the psychological disorders produced in individuals by the violence of colonial domination but also the neurotic structure of colonialism itself. At the same time, Fanon's investigation of the dynamics of psychological alterity within the historical and political frame of colonialism suggests that identification is neither a historically universal concept nor a politically innocent one. A by-

product of modernity, the psychoanalytic theory of identification takes shape within the larger cultural context of colonial expansion and imperial crisis.

Imperial Subjects

Contemporary theories of racial alterity and difference owe much to the rethinking of self-other relations that Fanon elaborates in his anticolonialist treatise, *Black Skin, White Masks* (1952). Most prominently, Edward Said's enormously influential theory of orientalism, which posits the Muslim "Orient" as a phobic projection of a distinctly Western imaginary,[1] echoes elements of Fanon's own theory of colonial psychopathology in which the black man is subjugated to the white man through a process of racial othering: "for not only must the black man be black; he must be black in relation to the white man."[2] Assigned the role of embodying racial difference within a colonialist metaphorics of representation, the black man becomes for the white man the repository of his repressed fantasies, "the mainstay of his preoccupations and his desires" (B, 170). Under colonialism, Fanon contends, "the real Other for the white man is and will continue to be the black man" (B, 161).[3] Yet significantly complicating this notion of "Black as Other" is a rather different reading of alterity in Fanon's work with potentially even greater import for an anticolonialist politics. In this second theory of white-black relations, Fanon implicitly disputes his own initial formulation of racial alterity and asks whether, in colonial regimes of representation, even otherness may be appropriated exclusively by white subjects. Fanon considers the possibility that colonialism may inflict its greatest psychical violence precisely by attempting to exclude blacks from the very self-other dynamic that makes subjectivity possible. This alternative theory of (non)alterity elaborated in *Black Skin, White Masks* does not so much call into question the first as uncover another, deeper, more insidious level of orientalism.

Fanon proposes that in the system of power-knowledge that upholds colonialism, it is the white man who lays claim to the category of the Other, the white man who monopolizes otherness to secure an illusion of unfettered access to subjectivity. Deploying the conventional psychoanalytic grammar of "the other" and "the Other" to distinguish between imaginary and symbolic difference, or between primary and secondary identification,[4] Fanon implies that the black man under colonial rule

finds himself relegated to a position other than the Other. Colonialism works in part by policing the boundaries of cultural intelligibility, legislating and regulating which identities attain full cultural signification and which do not. For the black man, the implications of his exclusion from the cultural field of symbolization are immediate and devastating. If psychoanalysis is right to claim that "I is an Other,"[5] then otherness constitutes the very entry into subjectivity; subjectivity names the detour through the Other that provides access to a fictive sense of self.

Space operates as one of the chief signifiers of racial difference here: under colonial rule, freedom of movement (psychical and social) becomes a white prerogative. Forced to occupy, in a white racial phantasm, the static ontological space of the timeless "primitive," the black man is disenfranchised of his very subjectivity. Denied entry into the alterity that underwrites subjectivity, the black man, Fanon implies, is sealed instead into a "crushing objecthood." Black may be a protean imaginary other for white, but for itself it is a stationary "object"; objecthood, substituting for true alterity, blocks the migration through the Other necessary for subjectivity to take place. Through the violence of racial interpellation—"'Dirty nigger!' Or simply, 'Look, a Negro!'"—Fanon finds himself becoming neither an "I" nor a "not-I" but simply "an object in the midst of other objects": "the movements, the attitudes, the glances of the other fixed me there, in the sense in which a chemical solution is fixed by a dye" (*B*, 109). Stricken and immobilized by a white child's phobically charged cry, "Mama, see the Negro! I'm frightened!," Fanon's very body strains, fragments, and finally bursts apart: "I took myself off from my own presence, far indeed, and made myself an object. What else could it be for me but an amputation, an excision, a hemorrhage that spattered my whole body with black blood?" (*B*, 112). "Fixed" by the violence of the racist interpellation in an imaginary relation of fractured specularity, the black man, Fanon concludes, is "forever in combat with his own image" (*B*, 194). The black man (contra Lacan) begins and ends violently fragmented.

For the white man, the considerable cultural capital amassed by the *colonization of subjectivity* amounts to nothing less than the abrogation of universality. While the "black man must be black in relation to the white man," the converse does not hold true; the white man can be white without any relation to the black man because the sign "white" exempts itself from a dialectical logic of negativity. Consider Fanon's formula for "whiteness":

White
———————————

Ego different from the Other (*B*, 215).

Claiming for itself the exalted position of transcendental signifier, "white" is never a "not-black." As a self-identical, self-reproducing term, white draws its ideological power from its proclaimed transparency, from its self-elevation over the very category of "race."[6] "White" operates as its own Other, freed from any dependency upon the sign "Black" for its symbolic constitution. In contrast, "Black" functions, within a racist discourse, always diacritically, as the negative term in a Hegelian dialectic continuously incorporated and negated. Fanon articulates the process precisely: "The Negro is comparison" (*B*, 211).

The broad outlines of Fanon's theory of otherness are borrowed from Jean-Paul Sartre, whose use of the Hegelian dialectic in *Being and Nothingness* provides Fanon with a useful paradigm for theorizing psychological alterity in specifically historical and political terms. Sartre's thesis that it is the Other who founds one's being, the Other who holds for the Self the "truth" of identity, becomes the theoretical basis for Fanon's repeated calls in *Black Skin, White Masks* for an ethics of mutual identification, "a world of reciprocal recognitions" (*B*, 218).[7] Recently, the category of the Other has achieved considerable prominence in critical discussions of identity, offerring a ready and useful shorthand for signaling the production of cultural difference. Yet often in reading this work I am struck by the inadequacy of the term to do everything we ask of it. To invoke "the Other" as an ontological or existentialist category paradoxically risks eliding the very range and play of cultural differences that the designation is intended to represent. Reliance upon the Other as a categorical imperative often works to flatten rather than to accentuate difference.[8]

Moreover, the signifier "Other," in its applications, if not always its theorizations, tends to disguise how there may be other Others—subjects who do not quite fit into the rigid boundary definitions of (dis)similitude, or who indeed may be left out of the Self/Other binary altogether. Fanon sees the Other for what it is: an ideological construct designed to uphold and to consolidate imperialist definitions of selfhood. Thus, in Fanon's estimation, Sartre's theory of alterity fails on two counts. First, it fails to register how, in colonial history, not all others are the same:

"though Sartre's speculations on the existence of The Other may be correct," Fanon argues, "their application to a black consciousness proves fallacious. That is because the white man is not only The Other but also the master" (*B*, 138). Second, Sartre's deployment of a Self/Other dialectics fails to see how *the Other who is master* is firmly located in an economy of the Same. In a colonial dialectics, based on a radical asymmetry of power, symbolic alterity operates precisely as a privilege of the Self-Same.[9]

The problem originates with the Hegelian dialectic which, as Robert Young has recently observed, is modelled upon Enlightenment history. As a form of knowledge based upon incorporation, Hegel's philosophical theory of self-other relations "simulates the project of nineteenth-century imperialism ... mimics at a conceptual level the geographical and economic absorption of the non-European world by the West."[10] Both the existentialist and the psychoanalytic notions of otherness, which Fanon inherits from Sartre and Freud respectively, operate on the Hegelian principle of negation and incorporation. The colonial-imperial register of self-other relations is particularly striking in Freud's work, where the psychoanalytic formulation of identification can be seen to locate at the very level of the unconscious the imperialist act of assimilation that drives Europe's voracious colonialist appetite. Identification, in other words, is itself an imperial process, a form of violent appropriation in which the Other is deposed and assimilated into the lordly domain of Self. Through a psychical process of colonization, the imperial subject builds an Empire of the Same and installs at its center a tyrranical dictator, "His Majesty the Ego."[11]

What happens when imperial subjects become Imperial Subjects? When Otherness, and thus subjectivity, is claimed as a prerogative of the colonizer alone? For Fanon, the answer is clear: when subjectivity becomes the exclusive property of "the master," the colonizer can claim a sovereign right to personhood by purchasing interiority over and against the representation of the colonial other as pure exteriority. This is the elusive meaning of Fanon's enigmatic phrase "the *Umwelt* of Martinique" (*B*, 37), one of many references in *Black Skin, White Masks* to Lacan's 1949 paper on the mirror stage, in which the function of the mirror is said "to establish a relation between the organism and its reality ... between the *Innenwelt* and the *Umwelt*."[12] But if Martinique is the *Umwelt* to Europe's *Innenwelt*, if the colonized is no more than a narcissistic self-reflection of the colonizer, then the latter's exclusive

claim to "humanness" is seriously compromised, put into jeopardy by the very narcissism that paradoxically constructs the nonhuman in the Imperial Subject's own image. Moreover, by imposing upon the colonial other the burden of identification (the command to become a mimic Anglo-European), the Imperial Subject inadvertently places himself in the perilous position of object—object of the Other's aggressive, hostile, and rivalrous acts of incorporation.

It therefore becomes necessary for the colonizer to subject the colonial other to a double command: be like me, don't be like me; be mimetically identical, be totally other. The colonial other is situated somewhere between difference and similitude, at the vanishing point of subjectivity. Of course, the same dialectic of difference and similitude constitutes the Imperial Subject as well. Any racial identity is organized through a play of identification and disidentification: "The Negro is not. Any more than the white man" (*B*, 231). But "white" defines itself through a powerful and illusory *fantasy* of escaping the exclusionary practices of psychical identity formation. The colonizer projects what we might call identification's "alienation effect" onto the colonized who is enjoined to identify and to disidentify simultaneously with the same object, to assimilate but not to incorporate, to approximate but not to displace. Further, in attempting to claim alterity entirely as its own, the Imperial Subject imposes upon all others, as a condition of their subjugation, an injunction *to mime* alterity. The colonized are constrained to impersonate the image the colonizer offers them of themselves; they are commanded to imitate the colonizer's version of their essential difference. What, then, is the political utility of mimesis for the colonized, when mimesis operates as one of the very terms of their cultural and political dispossession under colonial imperialism?

In recent feminist theory, mimesis is most frequently understood in opposition to the category of masquerade: "mimicry" (the deliberate and playful performance of a role) is offered as a counter and a corrective to "masquerade" (the unconscious assumption of a role).[13] The critical difference between masquerade and mimicry—between a nonironic imitation of a role and a parodic hyperbolization of that role—depends on the degree and readability of its excess. In this reading, mimicry resists and subverts dominant systems of representation by intentionally ironizing them. Postcolonial discourse theory understands mimicry in strikingly contrary terms, not as a tactic of dissent but as a condition of domination. In the words of Homi Bhabha, "mimicry emerges as one of

the most elusive and effective strategies of colonial power and knowl-
edge." Bhabha's theory of colonial mimicry, developed through a series
of important readings on Fanon's work, reminds us that it is precisely
through the figures of *"trompe l'oeil,* irony, mimicry, and repetition"
that the discourse of colonial imperialism exercises its authority.[14] In this
second reading, mimicry subtends rather than disturbs dominant sys-
tems of representation; it operates as an emphatic instrument of political
regulation, social discipline, and psychological depersonalization.

Yet despite their apparent incompatibility, these two notions of mime-
sis cross, interact, and converge in ways that make it increasingly difficult
to discriminate between a mimicry of subversion and a mimicry of subju-
gation, or at least to know with any degree of certainty their possible
political effects. Bhabha makes it clear that the ever-present possibility of
slippage—from mimicry into mockery, from performativity into parody—
immediately discredits colonialism's authorized versions of otherness and
profoundly undermines the colonizer's elusive self-image to the point
where "the great tradition of European humanism seems capable only of
ironizing itself."[15] As narcissistic authority evolves into paranoiac fear,[16]
the rents and divisions within colonialist narratives of domination
become more visible. Not even the colonial production of the divided
other—black skin, white masks—leaves the colonizer's authority com-
pletely intact: "in occupying two places at once ... the depersonalized,
dislocated colonial subject can become an incalculable object, quite liter-
ally, difficult to place. The demand of authority cannot unify its messages
nor simply identify its subjects."[17] Bhabha's point, simply put, is that the
production of mimic others can prove to be disruptive in ways colonial
discourse does not intend and cannot possibly control.

If the mimicry of subjugation can provide unexpected opportunities
for resistance and disruption, the mimicry of subversion can find itself
reinforcing conventional power relations rather than eroding them. This
is the conclusion of several recent studies on a form of racial cross-iden-
tification that Fanon does not discuss in *Black Skin, White Masks*,
namely the subject position of *white skin, black masks*, or whites in black
face.[18] In a reading of racial fetishism and the homoerotic imaginary,
Kobena Mercer asks: "what is going on when whites assimilate and
introject the degraded and devalorized signifiers of racial otherness into
the cultural construction of their own identity? If imitation implies iden-
tification, in the psychoanalytic sense of the word, then what is it about
whiteness that makes the white subject want to be black?"[19] Kaja

Silverman, in her analysis of Lawrence of Arabia, provides a possible answer with her theory of the double mimesis. While, on the one hand, T. E. Lawrence's adoption of Arab dress and custom promoted an unorthodox homoerotic identification with Arab nationals, on the other hand, the very same cultural impersonation masked a will to power, a desire to outdo the Arabs in their "Arabness," an ambition to become more truly other than the Other.[20] Gail Ching-Liang Low expresses a similar concern when she speculates on whether, for the colonial subject, "the primary attraction of the cross-cultural dress is the promise of 'transgressive' pleasure without the penalties of actual change."[21] Keeping in mind the power relations involved, there may be little if anything subversive in cross-cultural impersonations that work in the service of colonial imperialism. When we take into account multiple axes of difference that cross-cut, interfere with, and mutually constitute each other, the dream of a playful mimesis cannot be so easily or immediately recuperated for a progressive politics. Given the various and continually changing cultural coordinates that locate identity at the site of both fantasy and power, one would have to acknowledge, at the very least, that the same mimetic act can be disruptive and reversionary at once.

Folded into one another, these two notions of mimicry together suggest that context is decisive in registering the full range of political meanings one might attribute to even a single identification. The deceptively simple details of who is imitating whom, and under what conditions, stand as the most insistent, intricate, and indispensable questions for a politics of mimesis. The project of evaluating the political effects of mimesis encounters further complications when we consider the ways in which "imitation repeatedly veers over into identification."[22] Psychoanalytic theories of identification all seem to agree that "every imitation . . . is also an incorporation."[23] In the next section I would like to examine at least one instance in Fanon's work where this premise does *not* appear to hold true, one scene of mimesis that draws its power from a certain *refusal* of identification. Tentatively unfastening impersonation from identification, I propose to demonstrate how mimesis might actually be deployed to counter a prescribed identification. When situated within the context of colonial politics, the psychoanalytic *assumption* that every conscious imitation conceals an unconscious identification needs to be carefully questioned, read for the signs of its own colonizing impulses.

Impersonating Identification

The wearing of the veil throughout the period of the French occupation of Algeria provides Fanon with one of his most important examples of the role of mimesis in the psychopathology of colonial relations. In the opening essay of *A Dying Colonialism*, entitled "Algeria Unveiled," Fanon examines the mutable and contradictory cultural meanings attributed to Arab women's dress, what he suggestively denotes as "the historic dynamism of the veil" (*DC*, 63). For the European occupiers, the veil functions as an exotic signifier, invested with all the properties of a sexual fetish. Faced with a veiled Algerian woman, Fanon writes, the European is consumed with a desire to see, a desire that, in colonialism's highly sexualized economy of looking, also operates as an urge for violent possession:

> Every new Algerian woman unveiled announced to the occupier an Algerian society whose systems of defense were in the process of dislocation, open and breached. Every veil that fell, every body that became liberated from the traditional embrace of the *haïk*, every face that offered itself to the bold and impatient glance of the occupier, was a negative expression of the fact that Algeria was beginning to deny herself and was accepting the rape of the colonizer. (*DC*, 42)

The colonialist desire to unveil the Algerian woman is given special urgency by the capability of the veil to block the look of the Other while permitting the woman herself to assume the privilege of the Imperial Subject—to see without being seen (*DC*, 44). Fanon reads the French colonial political program of "unveiling" as an attempt to strip all Algerians of their national, cultural, and religious identity by reducing the Algerian woman to a sexual representation more readily assimilated to white European ideals of womanhood. In direct opposition to the signification of the veil for the French colonialists, the veil comes to function for the colonized as a visible sign of Algerian nationalist identity and a symbol of resistance to imperial penetration and colonial domination. Each attempt to Europeanize the Algerian woman is countered by a reinvestment of the veil with national import. Even more importantly for Fanon, the wearing of the veil operates as one of the most visible and dramatic indices to the historical emergence of women's political agency: "the Algerian women who had long since dropped the veil once

again donned the *haïk*, thus affirming that it was not true that woman liberated herself at the invitation of France and of General de Gaulle" (*DC*, 62).

Yet as Mervat Hatem reminds us, revolutionary calls for the reassumption of the veil may have quite other motivations during times of severe economic hardship brought on by the colonial wars: the veil, and the exclusion of women from the public sphere that it signifies, upholds a traditional sexual division of labor and preserves for men increasingly scarce jobs in the workplace.[24] Within a single discourse the veil can thus signify doubly, as a mode of defying colonialism and as a means of ensuring patriarchal privilege.[25] Conversely, the veil can carry a similar meaning across seemingly antithetical discourses: in the discourse of colonial imperialism and in the discourse of national resistance, the veiled Algerian woman stands in metonymically for the nation. In both instances, the woman's body is the contested ideological battleground, overburdened and saturated with meaning. It is the woman who circulates as a fetish—both the site of a receding, endangered national identity and the guarantor of its continued visibility. In Fanon's "Algeria Unveiled," the wearer of the veil becomes a veil, the inscrutable face of a nation struggling to maintain its cultural inviolability. A fetishistic logic of displacement operates in Fanon's own text, as the veiled Algerian woman comes to bear the burden of representing national identity in the absence of nation.

Fanon extends this logic of fetishization to include the *unveiled* Algerian woman as well. His argument rests on a paradox of unveiling: if some Algerian women during the war have begun to dress in European clothes, this act of cultural cross-dressing is testimony not to the success of the relentless European attempts at psychological conversion and deculturation but to their failure; these women, enlisted by the FLN, unveil themselves only in order to better disguise themselves. "Passing" as European, Algerian women can move freely through the European quarters of the city, carrying concealed guns, grenades, ammunition, money, papers, and even explosives. For Fanon, this kind of national passing in the service of revolutionary activity is never a question of imitation:

> It must be borne in mind that the committed Algerian woman learns both her role as "a woman alone in the street" and her revolutionary mission instinctively. The Algerian woman is not a secret agent. It is without ap-

prenticeship, without briefing, without fuss, that she goes out into the street with three grenades in her handbag or the activity report of an area in her bodice. She does not have a sensation of playing a role she has read about ever so many times in novels, or seen in motion pictures. There is not that coefficient of play, of imitation, almost always present in this form of action when we are dealing with a Western woman.

What we have here is not the bringing to light of a character known and frequented a thousand times in imagination or in stories. It is an authentic birth in a pure state, without preliminary instruction. There is no character to imitate. On the contrary, there is an intense dramatization, a continuity between the woman and the revolutionary. (*DC*, 50)

Fanon's insistence upon the *nonmimetic* character of the Algerian woman's national cross-dressing poses a number of questions for a politics of mimesis. What does it mean to say that this woman "learns" her role "instinctively," without apprenticeship and without example? Can one imitate without an object or a model to impersonate? Can there be impersonation without imitation, or role-playing without a role to play? In one sense, yes. Theories of the masquerade remind us that there is no model behind the imitation, no genuine femininity beneath the performance, no original before the copy.[26] But Fanon's insistence that the Algerian woman's European impersonation is "an authentic birth in a pure state" presumes not that femininity is itself a cultural production of the masquerade, but that masquerade is a natural function of femininity. It assumes that if the Algerian woman in her performance as "European" expertly dissimulates, she does so naturally, without "that coefficient of play, of imitation" that characterizes Western women. Fanon's retrieval of an essentialist discourse of black femininity to explain the paradox of the unveiled Algerian woman's nonmimetic imitation appears motivated by a desire to refuse any possibility of cultural contamination between the imitator and her subject, the colonized and the colonizer, the Algerian and the European. But is it possible to separate so completely the imitation from what it imitates? Is it possible for the mimicking subject to inhabit fully a performative role while still remaining largely outside it? Where, in other words, in a politics of imitation can one locate the politics?

Following the mimicry/masquerade distinction, we might be tempted to conclude that the revolutionary agent that Fanon describes, the Algerian woman "radically transformed into a European woman, poised and unconstrained, whom no one would suspect" (*DC*, 57), engages in

a form of mimicry but not masquerade. Her "transformation" involves the deliberate taking up of a cultural role for political ends rather than the unconscious "bringing to light of a character known and frequented a thousand times in imagination or in stories." However, the success of this particular mimetic act depends not upon excess but equivalency, not upon mimicry's distance from masquerade but upon its approximation to it. "Algeria Unveiled" dramatizes a form of mimesis that takes masquerade as its object; the political strategy described is more like that of *miming masquerade*. To avoid inspection by the French soldiers, the unveiled Algerian woman, by impersonating the sartorial masquerade of white European femininity, submits herself to another kind of examination: "The soldiers, the French patrols, smile to her as she passes, compliments on her looks are heard here and there, but no one suspects that her suitcases contain the automatic pistol which will presently mow down four or five members of one of the patrols" (*DC*, 58). To do its work, this form of tactical mimesis must be perceived by its colonialist target as feminine masquerade (where both "feminine" and "masquerade" signify "European"), and the masquerade, in turn, as evidence of another Algerian woman "saved," another victory of Europeanization, another piece of "the flesh of Algeria laid bare" (*DC*, 42).

It might be more accurate to say, then, that imitation is very much at issue in Fanon's example of the Algerian woman unveiled, but that not all forms of imitation are identifications. The importance of Fanon's reading of this particular scene can be registered elsewhere, in its attempt to install a wedge between identification and imitation, in its suggestion that not every imitative act harbors a secret or unconscious identification. Indeed, to read uncritically the Algerian woman's *dramatization* as an act of *identification* risks trivializing the role that political necessity plays in this performance and minimizing the trauma of the historical event that occasions it. Fanon implies that some imitations may only disguise themselves as identifications. But, it could be objected, in so doing might the act of mimesis actually produce the very identification it seeks to disavow? Identification, after all, is an unconscious operation that repeatedly resists our attempts to govern and to control it. Did the opportunity to dress in European clothes permit some Algerian women to engage in cross-national, cross-racial, cross-class, and cross-cultural identifications with white bourgeois European women? Perhaps. (Although there is no simple way of knowing anything about the fantasies, desires, and identifications of the women in the FLN

from Fanon's admittedly opaque texts: elsewhere Fanon claims to "know nothing" about the woman of color [*B*, 179-80]). But the point to be registered is that while imitation may either institute or gratify an unconscious identification, it can and does frequently exceed the logic of that identification. Put another way, identification with the Other is neither a necessary precondition nor an inevitable outcome of imitation. For Fanon it is politically imperative to insist upon an instrumental difference between imitation and identification, because it is precisely politics that emerges in the dislocated space between them.[27]

It is because the French colonialists did not understand the difference between identification and imitation that their own deployment of a politics of mimesis failed as spectacularly as the Algerians' succeeded. In *The Wretched of the Earth* Fanon discusses the colonialist practice of interning leading Algerian male intellectuals and submitting them to prolonged sessions of brainwashing, a strategy designed "to attack from the inside those elements which constitute national consciousness" (*W*, 286). The details Fanon provides of the "pathology of torture" show how this particular form of psychological abuse aspires to nothing less than the *forcible realignment of identifications* achieved through a program of strictly monitored imitations: during the psychological "conversion" process, the intellectual is ordered to "play the part" of collaborator; his waking hours are spent in continuous intellectual disputation, arguing the merits of French colonization and the evils of Algerian nationalism; he is never left alone, for solitude is considered a rebellious act; and he must do all his thinking aloud, since silence is strictly forbidden (*W*, 286–87).

Ultimately, the native intellectual's life depends upon his ability to imitate the Other perfectly, without a trace of parody; it depends, in short, upon his ability to mime without the perception of mimicry. Once again, mimicry must pass as masquerade if the subject who performs the impersonation is to survive to tell the tale. This type of torture is perhaps only the most extreme form of what Bhabha has described as the primary mode of subjectification under colonial domination: "a grotesque mimicry or 'doubling' that threatens to split the soul."[28] Yet this violent attempt to produce an identification (what psychoanalysis calls an "identification with the aggressor") fails "to split the soul," and it fails because imitation alone is not sufficient to produce an identification. Those interned subjects released after "successful completion" of the conversion program, Fanon tells us, all returned to their communities

and took up, once again, their respective roles in Algeria's struggle for national liberation.

This is not to say, however, that the male revolutionaries Fanon describes in *The Wretched of the Earth,* forced to imitate the ideology, speech, and mannerisms of their European captors, were not left un-scarred by the process. Indeed, as early as *Black Skin, White Masks,* Fanon is concerned with the profoundly debilitating psychological effects of colonial mimesis on all black men who must labor under the brutal colonial injunction to become (in Bhabha's eloquent turn of phrase) "almost the same but not white."[29] For the black man, mimesis is a by-product of the colonial encounter, a pathology created by the material conditions of imperial domination, a psychological "complex" that at all points must be refused and resisted.[30] If we compare Fanon's discussion of black men in *Black Skin, White Masks* to his later discus-sion of black women in "Algeria Unveiled," we detect a dubious gender incongruity structuring Fanon's theory of colonial mimicry: whereas colonial mimicry for black men is alienating and depersonalizing, for black women it is natural and instinctive. In Fanon's view, black women are essentially mimics and black men are essentially not. Fanon's analy-sis of colonial mimesis repeatedly runs aground on the question of sexual difference. What are the implications of Fanon's sex/gender essentialisms for his project to decolonize sexuality?

Decolonizing Sexuality

Fanon's disquieting discussions of not only femininity but homo-sexuality—inextricably linked in Fanon as they are in Freud—have received little if any attention from his critical commentators. Passages in Fanon's corpus articulating ardent disidentifications from black and white women and from white gay men (for Fanon, homosexuality is cul-turally white) are routinely passed over, dismissed as embarrassing, baf-fling, unimportant, unenlightened, or perhaps simply politically risky. In this section I turn specifically to Fanon's theory of "the sexual perver-sions" for several reasons. First, these difficult passages tell us some-thing important about Fanon's own sexual identifications as they are shaped within and against a colonial discourse of sexuality that appro-priates masculinity as the exclusive prerogative of white male colonizers while relegating black male sexuality to the culturally abjected, patholo-

gized space of femininity, degeneracy, and castration. Second, Fanon's remarks on homosexuality, while failing to challenge some of Freud's most conventional and dangerous typologies of sexuality, simultaneously question, at least implicitly, the ethnological component of psychoanalysis that has long equated "the homosexual" with "the primitive."[31] Finally, Fanon's theory of racialized sexualities under colonialism helps point us in the direction of interrogating the ethnocentrism of the very category of "sexuality." Along the way, I hope to avoid the problem of oversimplification—either hastily dismissing Fanon's notions of sexuality as theoretically suspect, or uncritically recuperating them as historically overdetermined—by employing a double reading strategy. The most appropriate methodology for reading the politics of sexual identifications may be to theorize and to historicize at once, to follow what I take, in fact, to be Fanon's own reading strategy elaborated more fully in later works like *The Wretched of the Earth*.

Fanon's theory of the sexual perversions appears within a broader discussion of the problem of Negrophobia in chapter six of *Black Skin, White Masks*. "The Negro and Psychopathology" takes as its central focus fantasies by white subjects in which black men perform the role of "phobogenic object[s]" (*B*, 151). Following closely Angelo Hesnard's definition of phobia as "a neurosis characterized by the anxious fear of an object,"[32] Fanon widens the field of the clinical disorder by explaining that the phobic object need not be present in actuality but need only exist as a possibility in the mind of the subject (*B*, 154). In a reading of the fantasy "A Negro is raping me" (the chapter's central example of Negrophobia) Fanon identifies the phobia as a disguised expression of sexual desire: "when a woman lives the fantasy of rape by a Negro, it is in some way the fulfillment of a private dream, of an inner wish. . . . [I]t is the woman who rapes herself." How can it be said that the Negrophobic woman rapes herself? Like Freud's hysteric,[33] Fanon's phobic can apparently occupy in fantasy two or more positions at once. Through a cross-gendered and cross-racial identification, the white Negrophobic woman usurps the position she herself has assigned to the black man and plays the role not only of victim but of aggressor: "I wish the Negro would rip me open as I would have ripped a woman open" (*B*, 179). For Fanon, the white woman's fantasy "A Negro is raping me" is ultimately an expression of either a violent lesbian desire or a wish for self-mutilation, with narcissism ultimately blurring the distinction between them.

Even more questionable, the desire to be a rapist is posited as the basis of the desire to be raped, a masochistic identification that Fanon unproblematically takes as one of the defining psychopathologies of white femininity. It is, however, important to recall at this juncture that Fanon constructs his reading of this particular fantasy during a period when fabricated charges of rape were used as powerful colonial instruments of fear and intimidation against black men. Fanon's deeply troubling comments on white women and rape are formulated within a historical context in which the phobically charged stereotype of the violent, lawless, and oversexed Negro put all black men at perpetual risk. What we might call Fanon's myth of white women's rape fantasies is offered as a counternarrative to "the myth of the black rapist."[34]

Ultimately, what may be most worrisome about the treatment of interracial rape in *Black Skin, White Masks* is not what Fanon says about white women and black men but what he does *not say* about black women and white men. As Mary Ann Doane notes in her reading of Fanon's analysis of rape and miscegenation,

> Fanon asks few (if any) questions about the white man's psycho-sexuality in his violent confrontation with the black woman—fewer still about how one might describe black female subjectivity in the face of such violence. In the historical scenario conjoining rape and lynching, the emotional charge attached to miscegenation, its representational intensity, are channeled onto the figure of the white woman, effectively erasing the black woman's historical role.

According to Doane, rape itself undergoes a certain displacement—"from the white man's prerogative as master/colonizer to the white woman's fears/desires in relation to the black male."[35] What disappears in Fanon's act of displacement is any analysis of the production and institutionalization of a violent imperial masculinity necessary to keep the social structure of colonial domination firmly in place. What drops out is a recognition of how sexual violence is imbricated in an entire economic and political system in which the rape of black women by white settlers (or "colons") works to establish and to maintain what is, in effect, a slave economy.[36] What is missing, finally, is any serious discussion of black women's subjectivity under colonial rule: "Those who grant our conclusions on the psychosexuality of the white woman may ask what we have to say about the woman of color. I know nothing about her" (B, 179–80).[37]

If, in Fanon's theory of Negrophobia, the white woman who fears the black man really desires him, then so apparently does the phobic white man: "the Negrophobic woman is in fact nothing but a putative sexual partner—just as the Negrophobic man is a repressed homosexual" (*B*, 156). For Fanon, the root pathogenic cause of Negrophobia is sexual perversion—a perversion of sexual object-choice for men and sexual behavior for women ("All the Negrophobic women I have known had abnormal sex lives. . . . [t]here was also an element of perversion, the persistence of infantile formations: God knows how they made love! It must be terrifying" [*B*, 158]). In both instances, perversion is represented specifically as a *white* pathology. There are no homosexuals in Martinique, Fanon speculates, because the Oedipus complex remains, in every sense, foreign to the Antilles: "Like it or not, the Oedipus complex is far from coming into being among Negroes" (*B*, 152). Fanon insists that while Martinique may have its "godmothers," male transvestites in the Antilles nonetheless lead "normal sex lives" and "can take a punch like any he-man" (*B*, 180). For white men homosexuality is a pathological condition; for black men it is "a means to a livelihood," a by-product of colonialism in which black men from the colonies are forced into homosexual prostitution in the metropole in order to survive economically.

The most serious problem with Fanon's theory of the sexual perversions is the pivotal role assigned to homosexuality in the cultural construction of racism. All of the psychical components Fanon identifies as central to the "hate complexes" are identical to those he posits as constitutive of same-sex desire: "fault, guilt, refusal of guilt, paranoia—one is back in homosexual territory" (*B*, 183). It is not entirely clear which of these two "complexes" (racism or homosexuality) Fanon believes to be the pathological trigger for the other; more certain is the sleight of hand in which "homosexuality" is inserted into a violent cultural equation where "homophobia" properly belongs. As Lee Edelman has pointed out, homosexuality and homophobia are made to change places with one another in a falsely syllogistic logic: "homophobia allows a certain figural logic to the pseudo-algebraic 'proof' that asserts: where it is 'given' that white racism equals castration and 'given' that homosexuality equals castration, then it is proper to conclude that white racism equals (or expresses through displacement) homosexuality and, by the same token, in a reversal of devastating import for lesbians and gay men of color, homosexuality equals white racism."[38] If racism is articulated

with homosexuality instead of homophobia, where are antiracist les-
bians and gay men, of all colors, to position themselves in relation to
same-sex desire? Fanon's theory of sexuality offers little to anyone com-
mitted to both an anti-imperialist and an antihomophobic politics.

Yet, like Fanon's theory of white femininity, his complicated reading
of homosexuality needs to be framed historically, placed within the
prism of the particular colonial history that shapes and legislates it.
Fanon's concern with the economics of sexual exchange between colo-
nizer and colonized is not entirely without warrant; prostitution was
indeed one of the few occupations open to black immigrants in colonial
France. The point needs to be made that colonialism's insatiable desire
for exotic black bodies, its institutionalization of a system of sexual
exploitation that focussed largely on black women, was extended to
include many black men as well. Moreover, Fanon's effort to call into
question the universality of the Oedipus complex may constitute what is
most revolutionary about his theoretical work, a political intervention
into classical psychoanalysis of enormous import for later theorists of
race and sexuality. Responding to an allusion by Lacan to the "abun-
dance" of the Oedipus complex, Fanon shows instead the limitations of
Oedipus, or rather the ideological role Oedipus plays *as a limit* in the
enculturating sweep of colonial expansionism. Prone to see Oedipus
everywhere they look, Western ethnologists are impelled to find their
own psychosexual pathologies duplicated in their objects of study (*B*,
152). Under colonialism, Oedipus is nothing if not self-reproducing.

Taking their cue in part from Fanon, two French theorists of the
metropole, Gilles Deleuze and Félix Guattari, unmask oedipality as a
form of colonization turned inside out: "Oedipus is always colonization
pursued by other means, it is the interior colony, and ... even here at
home, where we Europeans are concerned, it is our intimate colonial
relation."[39] Deleuze's and Guattari's *Anti-Oedipus*, published in the
early 1970s during the watershed period of publications on Fanon's
work,[40] is as much a polemic against the psychology of colonization as it
is a demystification of the imperial politics of oedipalization, and indeed
the great insight of this wildly ambitious book is its demonstration of
how the historical emergence of both colonization and oedipalization
participate in a double ideological operation where each serves effec-
tively to conceal the political function and purpose of the other. "Even
in the case of worthy Oedipus," pronounces *Anti-Oedipus*, "it was
already a matter of 'politics'" (98).

Fanon's insistence that there is no homosexuality in the Antilles may convey a more trenchant meaning than the one he in fact intended: if by "homosexuality" one understands the culturally specific social formations of same-sex desire as they are articulated in the West, then indeed homosexuality is foreign to the Antilles. Is it really possible to speak of "homosexuality," or for that matter "heterosexuality" or "bisexuality," as universal, global formations? Can one generalize from the particular forms sexuality takes under Western capitalism to sexuality *as such*? What kinds of colonizations do such discursive translations perform on "other" traditions of sexual differences? It is especially important, confronted by these problems, to focus attention on the ethnocentrism of the epistemological categories themselves—European identity categories that seem to me wholly inadequate to describe the many different consolidations, permutations, and transformations of what the West has come to understand, itself in myriad and contradictory fashion, under the sign "sexuality."

Fanon's disavowal and repudiation of "homosexuality" take on special meaning in light of the parallel that psychoanalysis draws between "perversion" and "primitivity." This is not by any means to say that Fanon's work is free of the specter of homophobia. When Fanon confesses, "I have never been able, without revulsion, to hear a *man* say of another man: 'He is so sensual!'" (*B*, 201), the very form of the enunciation obeys the terms of Fanon's own earlier definition of phobia as "terror mixed with sexual revulsion" (*B*, 155). However, Fanon's disidentification can be read as another kind of refusal as well, an implicit rejection of the "primitive = invert" equation that marks the confluence of evolutionary anthropology and sexology and their combined influence on early twentieth-century psychoanalysis.

Inversion, Freud comments in *Three Essays on the Theory of Sexuality*, "is remarkably widespread among many savage and primitive races ... ; and, even amongst the civilized peoples of Europe, climate and race exercise the most powerful influence on the prevalence of inversion and upon the attitude adopted towards it."[41] In these curious lines linking inversion to race and climatology, Freud has in mind the influential theory of the "Sotadic Zone" developed in the final volume of Richard Burton's *The Arabian Nights*. Burton's Sotadic Zone, a global mapping of inversion according to certain latitudes and longitudes, covers all the shores of the Mediterranean, including North Africa, and extends as far as the South Sea Islands and the New World.[42] While Burton

describes his sexual topography as "geographical and climactic, not racial," he nonetheless finds the incidence of "Le Vice" to be highest amongst the Turks ("a race of born pederasts" [232]), the Chinese ("the chosen people of debauchery" [238]), and the North American Indians ("sodomites" and "cannibals" [240]). The sexologist Havelock Ellis, following Burton, also finds a "special proclivity to homosexuality ... among certain races and in certain regions."[43] For Burton and Ellis, the category "race" encompasses more than simply skin color; for these writers "race" operates as a somewhat more elastic term folded into the category of nation ("the British race"), species ("the human race"), and even gender ("the male or female race"). Not insignificantly for the present reading of racialized sexualities, fin-de-siècle sexology routinely refers to "the third sex" as a separate race or species. In both Ellis's and Burton's discourse of Empire, Algeria is singled out as the most dangerous—because the most sexually infectious—of the Sotadic Zones. Like a kind of venereal disease threatening the moral health of an Empire, homosexuality is said to be "contracted in Algeria" by members of the French Foreign Legion, "spread" through entire military regiments, and finally transmitted to the civilian population.[44] Through what we might call an *epidemiology of sexuality*, colonial discourse represents places like North Africa as breeding grounds for immorality and vice, thereby inverting and disguising the real trauma of colonial imperialism: the introduction of highly infectious and devastatingly lethal European diseases into the colonies.

Fanon's theory of the sexual perversions can thus be more fully understood as an impassioned response to popular colonialist theories of race and sexuality. Fanon's resolutely masculine self-identifications, articulated through the abjectification of femininity and homosexuality, take shape over and against colonialism's castrating representations of black male sexuality. Unfortunately, Fanon does not think beyond the presuppositions of colonial discourse to examine how colonial domination itself works partially through the social institutionalization of misogyny and homophobia. Fanon's otherwise powerful critique of the scene of colonial representation does not fundamentally question the many sexualized determinations of that scene. In each of Fanon's works, including "Algeria Unveiled," the colonial encounter is staged within exclusively masculine parameters; the colonial other remains an undifferentiated, homogenized male, and subjectivity is ultimately claimed for men alone. When the politics of sexual difference is in ques-

tion, Fanon's theory of identification risks presenting itself as simply another "theory of the 'subject' [that] has always been appropriated by the 'masculine.'"[45]

Identification in Translation

It is important to remember, when discussing the complicated subject of Fanon's own personal identifications, that he was a practicing clinician whose theoretical and cultural work was informed and shaped by an entire institutional, professional, and political apparatus located in the space of violent colonial struggle. The complexity of Fanon's heterogeneous subject position—an Antillean-born, French-educated physician practicing psychiatry in North Africa—helps to frame one of the most startling contradictions of his clinical practice. As a psychiatrist Fanon treated all types of patients during the early years of the Algerian war: during the daytime he worked with French soldiers suffering psychological breakdowns as a result of their daily torture of suspected Algerian nationals; at night he treated the victims of these tortures, often restoring them to health only to see them returned once again to the brutality of a French police interrogation.[46]

Not surprisingly, Fanon's attitudes toward psychiatry reflected the deep ambivalences of his own changing political affiliations and personal identifications. As a member of the FLN and eventually one of its most important international spokesmen, Fanon warned against colonialist appropriations of the psychoanalytic "cure" as a convenient method of cultural socialization, a means of adjusting members of the colonial population to their political condition of social alienation. At the same time, as a doctor from the metropole, Fanon continued throughout his life to promote psychoanalysis as one of the most powerful instruments available to combat those mental pathologies that are "the direct product of oppression" (*W*, 251). Introduced into Algeria in 1932, the psychiatric hospital ironically became for Fanon a site of active resistance to the violence of the colonialist enterprise that instituted such Western-style institutions in the first place.

When Fanon was appointed in the fall of 1953 director of the Hospital at Blida-Joinville, the largest psychiatric hospital in Algeria, there were eight psychiatrists and 2,500 beds for a national population of 8.5 million Muslims and 1.5 million Europeans.[47] Disproportionate to their numbers, over half of Fanon's patients were white Europeans, the rest

black Algerians; Fanon ministered to both. However, Fanon's sessions with his European and Algerian patients were marked by a radical disparity, for the French-speaking Fanon spoke neither Arabic nor Kabyle and could not communicate with his Muslim patients without the mediation of a translator.[48]

There are two immediate points to be made on the subject of the translator in Fanon's clinical practice. The first is what is added to the analytic process: a heightened awareness of language as an embattled site of historical struggle and social contestation. Fanon's complete reliance upon translators to converse with his Muslim patients is nothing if not a powerful reminder, to both doctor and patient, of the immediate political context in which the therapeutic dialogue struggles to take place. The daily translations of Arabic and Kabyle into French could not avoid reproducing, within the space of the clinical treatment, the very structure of the colonial relation. The second is what is lost in this translation: quite simply, the analysand's own speech, the speaking unconscious. What ultimately escapes Fanon are the slips and reversals, the substitutions and mispronounciations, in short, the free associations that provide the analyst with his most important interpretive material, the traces and eruptions of the patient's unconscious into language. Strictly speaking, the speech Fanon analyzes in the sessions with his Muslim patients is the translator's, not the patient's, a situation that impossibly confuses the analytic process and urgently poses the question of whether a therapeutic model constructed in one language or culture can be so easily or uncritically *translated* into another.

Fanon's essay "The 'North African Syndrome,'" published in the February 1952 issue of *L'esprit*, gives us some indication of the formidable problems posed by the use of a translator in colonial medicine. The following scene dramatizes, with wry humor, a routine medical examination between a French doctor and a North African patient:

> [The patient] tells about *his pain.* Which becomes increasingly his own. He now talks about it volubly. He takes hold of it in space and puts it before the doctor's nose. He takes it, touches it with his ten fingers, develops it, exposes it. It grows as one watches it. He gathers it over the whole surface of his body and after fifteen minutes of gestured explanations the interpreter . . . translates for us: he says he has a belly-ache. (*T*, 5)

Fanon later faced very similar difficulties in his psychiatric practice at Blida, where the problem of language comprehension was further exac-

erbated by the tendency of analysis to base itself almost exclusively upon dialogue, upon close attention to the intonations and equivocations of language, language that indeed must be said to be completely and inescapably culturally-inflected. Fanon's own clinical writings provide us with little clue to the presence of a third party interpreter in the psychiatric sessions with his Algerian patients; all traces of this fundamental disturbance in the actual scene of analysis are entirely erased from the written case histories. Who were these translators without whom Fanon could not do his work? Fanon's translators at Blida were the hospital's male nurses, educated Algerian men who, under colonial rule, were denied the opportunity to pursue advanced medical degrees. It was this group of male nurses whom Fanon counted as his closest supporters in the battle to institute a series of controversial hospital reforms; it was the Algerian nurses and not the European staff who possessed the appropriate language skills necessary for running a multilingual hospital; and it was the nurses to whom Fanon dictated his case notes, the nurses who, in some instances, actually *wrote* the case histories that were later edited by Fanon.[49] Unlike Freud, then, who had the luxury of a private practice that selectively treated exclusively middle-class patients, Fanon's professional sessions were conducted in a large psychiatric state hospital and were dependent upon the intensive labor of a whole team of invisible workers that administered to the needs of many hundreds of patients a day. This cadre of nurse-translators may be only the most visible sign of an institution that in both purpose and design continued to bear the stamp of a colonial import.

Ultimately, the use of a translator in his clinical work may provide the most powerful testimony of all to Fanon's hypothesis that to be exiled from language is to be dispossessed of one's very subjectivity.[50] When Fanon begins his investigation of cross-racial identifications in *Black Skin, White Masks* with a chapter called "The Negro and Language," he does so to emphasize the importance of speech to the assumption of subjectivity: "to speak is to exist absolutely for the other" (B, 17). Moreover, "to speak a language is to take on a world, a culture. The Antilles Negro who wants to be white will be the whiter as he gains greater mastery of the cultural tool that language is" (B, 38). Racial difference operates in this context as a linguistic construct bounded and defined by opportunities of class and education. Fanon recognizes that his facility with the French language accords him what he calls "honorary citizenship" as a white man (B, 38). He also recognizes that this citizenship is

never more than "honorary," insofar as a racialist discourse of immutable biological difference ceaselessly works to "seal" the white man in his "whiteness" and the black man in his "blackness" (*B*, 9). To his white European patients, Fanon is ineluctably black—"the Negro doctor" (*B*, 117). To his black Algerian patients, Fanon is white: a French-educated, upper-middle-class professional who cannot speak the language. Identifying with both groups but accepted by neither, Fanon's shifting and contradictory subject positions keep identity perpetually at bay. It is precisely identity that is suspended or deferred by the work of identification, identity that remains in a state of internal exile. Put another way, Fanon's own identifications are in constant translation, caught in a system of cultural relays that make the assumption of racial identity both necessary and impossible.[51]

In light of his own ambivalent identifications, Fanon's attempt to perform a sociohistorical analysis of the process of psychical incorporation takes on singular political importance. Interestingly, the question of the politicality of Fanon's psychoanalytic theory is a contentious, even divisive issue for his biographers. Irene Gendzier's important biography of Fanon notes that although Fanon was aware of a connection between psychiatry and politics, he nonetheless "abandoned" the one in his quest for the other.[52] Gendzier expresses the view held by many readers of Fanon's life and work that it was necessary for Fanon, after the publication of his first book, *Black Skin, White Masks*, to repudiate "psychoanalysis" to access "politics." Jock McCulloch's carefully researched study of Fanon's often overlooked clinical writings makes the counterargument that "there is no epistemological or methodological break between Fanon's earlier and later works" and that indeed "all of Fanon's works form part of a single theoretical construct."[53] The critical debate over the relation between Fanon's psychiatric training and his political education—posed in the oppositional terms of dramatic break or seamless continuity—obscures the critical faultlines upon which Fanon's own work is based, for Fanon himself was interested precisely in the linkages and fissures, the contradictions and coimplications, the translations and transformations of the theory-politics relation. I have tried to explore in this essay the way in which, in Fanon's thinking, the psychical and the political are hinged together on the point of identification. I am reminded of the concluding line of Philippe Lacoue-Labarthe's study of mimesis: "why would the problem of identification not be, in general, the essential problem of the political?"[54]

Fanon's own politics takes the multifarious form of an extended investigation of the psychopathology of colonialism that not only describes imperial practices but also, where sexual differences are concerned, problematically enacts them. When addressing the politics of sexual identifications, Fanon fails to register fully the significance of the founding premise of his own theory of colonial relations, which holds that the political is located within the psychical as a powerful shaping force. I take this working premise to be one of Fanon's most important contributions to political thought—the critical notion that *the psychical operates precisely as a political formation.* Fanon's work also draws our attention to the historical and social conditions of identification. It reminds us that identification is never outside or prior to politics, that identification is always inscribed within a certain history: identification names not only the history of the subject but the subject in history. What Fanon gives us, in the end, is a politics that does not oppose the psychical but fundamentally presupposes it.

NOTES

1. Edward Said, *Orientalism* (New York: Vintage Books, 1978). See also Said's "Representing the Colonized: Anthropology's Interlocutors," *Critical Inquiry* 15:2 (Winter 1989): 205–225.

2. Frantz Fanon, *Black Skin, White Masks*, trans. Charles Lam Markmann (New York: Grove Press, 1967), 110; originally published as *Peau Noire, Masques Blancs* (Paris: Editions de Seuil, 1952). Also cited in this essay are Fanon's other three published volumes: *A Dying Colonialism*, trans. Haakon Chevalier (New York: Grove Weidenfeld, 1965); originally published as *L'An Cinq, de la Révolution Algérienne* (Paris: François Maspero, 1959). *The Wretched of the Earth*, trans. Constance Farrington (New York: Grove Press, 1963); originally published as *Les damnés de la terre* (Paris: François Maspero, 1963). *Toward the African Revolution*, trans. Haakon Chevalier (New York: Grove Press, 1967); originally published as *Pour la Revolution Africaine* (Paris: François Maspero, 1964). All page numbers will be cited in the text after the following volume abbreviations: B (*Black Skin, White Masks*), DC (*A Dying Colonialism*), W (*The Wretched of the Earth*), and T (*Toward the African Revolution*).

3. Later in this chapter I discuss more fully Fanon's problematic use of the masculine as both the point of departure and the final referent for a new theory of the subject. Suffice it to say here that Fanon's powerful anticolonial polemics remain completely caught up in the masculinist presuppositions of the discourse they seek to displace.

4. In Lacanian terms, these two concepts can be distinguished in at least three ways: first, the other (small o) denotes a specular relation to an Imaginary rival, while the Other (capital O) designates a linguistic relation to a Symbolic interlocutor; second, the other depends upon a narcissistic relation, while the Other marks the locus of intersubjectivity; and third, the other is produced as an effect of primary identification in which the subject recognizes itself in its own image, while the Other is constructed as an effect of secondary identification in which the subject shifts its point of address to another speaking subject. For a much fuller discussion of the psychoanalytic definition of alterity, see Marie-Claire Boons-Grafé's entry on "Other/other" in *Feminism and Psychoanalysis: A Critical Dictionary*, ed. Elizabeth Wright (Oxford: Blackwell Publishers, 1992), 296–99. For a

deconstruction of the psychoanalytic distinction between primary and secondary identification, and its normative applications, see Chapter 2.

5. Jacques Lacan, *Écrits*, trans. Alan Sheridan (New York: W. W. Norton and Company, 1977), 23.

6. In "Race Under Representation," David Lloyd emphasizes the explicitly *metaphoric* pretenses of a white mythology: "this Subject becomes representative in consequence of being able to take anyone's place, of occupying any place, of a pure exchangeability." *The Oxford Literary Review* 13: 1–2 (1991): 70. Deconstructing the category white therefore involves making visible its founding metaphorics and ideology of invisibility. For more on the culturally constructed category of whiteness, see Toni Morrison, *Playing in the Dark: Whiteness and the Literary Imagination* (Cambridge, MA: Harvard University Press, 1992); Richard Dyer, "White," *Screen* 29:4 (Autumn 1988): 44–64; Jane M. Gaines, "Competing Glances: Who Is Reading Robert Mapplethorpe's *Black Book*?" *New Formations* 16 (Spring 1992): 24–39; Elizabeth Abel, "Black Writing, White Reading: Race and the Politics of Feminist Interpretation," *Critical Inquiry* 19:3 (Spring 1993): 470–498; and Kobena Mercer, "Black Hair/Style Politics," *New Formations* 3 (Winter 1987): 33–54.

7. Jean-Paul Sartre, *Being and Nothingness*, trans. Hazel Barnes (London: Methuen, 1957). Originally published as *L'être et le néant* (Paris: Gallimard, 1943). Fanon takes his theory of "recognition" from the section on "Lordship and Bondage" in G. W. F. Hegel's *The Phenomenology of Mind*, trans. J. B. Baillie (New York: Humanities Press Inc., 1977). The subject of Fanon's interest in Hegel and Sartre has received extended treatment elsewhere. See, for example, Irene Gendzier, *Frantz Fanon: A Critical Study* (New York: Grove Press, Inc., 1973; rpt. 1985), and Jock McCulloch, *Black Soul, White Artifact: Fanon's Clinical Psychology and Social Theory* (Cambridge, UK: Cambridge University Press, 1983). To avoid terminological confusion, let me note that the "Other" for Sartre refers to a specular, dyadic order similar to Lacan's idea of the Imaginary. Sartre's "Other" thus corresponds roughly to Lacan's "other," the other of the mirror stage.

8. Eve Kosofsky Sedgwick has recently made a very similar point about the colloquial use of the term "Other": "the trope of the Other ... must a priori fail to do justice to the complex activity, creativity, and engagement of those whom it figures simply as relegated objects." *Tendencies* (Durham: Duke University Press, 1993), 147.

9. I should clarify here that Fanon's profound discomfort with Sartre's endorsement of negritude in *Orphée Noir* is provoked not by Sartre's use of the dialectic per se, but by the specific place that negritude is made to occupy within it. Sartre's dialectic of thesis (white racism), antithesis (negritude), and synthesis (humanism) assigns "black" to the role of negation in what is essentially, for Fanon, a dialectics of racial assimilationism. See Jean-Paul Sartre, *Orphée Noir*, preface to *Anthologie de la nouvelle poésie nègre et malgache* (Paris: Presses Universitaires de France, 1948). *Black Orpheus*, trans. S. W. Allen (Paris: Présence africaine, 1963). The works of Aimé Césaire, Léopold Senghor, and Léon Damas, featured in the negritude anthology prefaced by *Orphée noir*, provide Fanon with an alternative philosophical and political position from which to critique Sartre's controversial introduction.

10. Robert Young, *White Mythologies: Writing History and the West* (New York and London: Routledge, 1990), 3.

11. Freud, "Creative Writers and Day-Dreaming" (1908). *The Standard Edition of the Complete Psychological Works of Sigmund Freud*. Ed. and trans. James Strachey. 24 vols. (London: The Hogarth Press, 1953–74): 150.

12. Jacques Lacan, "The Mirror Stage as Formative of the Function of the I as Revealed in Psychoanalytic Experience," in *Écrits*, 4.

13. This theory of subversive mimicry finds its most extended treatment in the work of Luce Irigaray. See, for example, *This Sex Which Is Not One*, trans. Catherine Porter with Carolyn Burke (Ithaca: Cornell University Press, 1985). Carole-Anne Tyler's *Female Impersonators* (New York and London: Routledge, 1996) offers a careful and thorough critique of the problems with Irigaray's mimicry/masquerade distinction as it falters on the twin grounds of intention and reception.

14. Homi K. Bhabha, "Of Mimicry and Man: The Ambivalence of Colonial Discourse," *October* 28 (Spring 1984): 126. Bhabha, whose work centers on investigating the place of fantasy and desire in the exercise of colonial power, is one of the first cultural theorists to think through the ambivalences of identification in terms of its inscription in colonial history. The following essays by Bhabha all take Fanon as their theoretical point of departure: "The Other Question," *Screen* 24 (Nov–Dec 1983): 18–36; "Sly Civility," *October* (Winter 1985); "Signs Taken For Wonders: Questions of Ambivalence and Authority Under a Tree Outside Delhi, May 1817," in *Race, Writing, and Difference*, ed. Henry Louis Gates, Jr. (Chicago: University of Chicago Press, 1986), 163–84; "Remembering Fanon," Foreword to Frantz Fanon, *Black Skin, White Masks*, trans. Charles Lam Markmann (London and Sydney: Pluto Press, 1986); a greatly expanded version of this foreword can be found in "Interrogating Identity: The Postcolonial Prerogative," in *Anatomy of Racism*, ed. David Theo Goldberg (Minneapolis: University of Minnesota Press, 1990), 183–209; and "'Race', Time and the Revision of Modernity," *Oxford Literary Review* 13: 1–2 (1991): 193–219.

15. Bhabha, "Of Mimicry and Man," 128.

16. Bhabha, "Sly Civility," 78.

17. Bhabha, "Remembering Fanon," xxii.

18. One instance where Fanon does talk about this phenomenon is in a brief footnote where he lists a series of cultural impersonations in which white "admiration" for black culture masks a hidden identification: "white 'hot-jazz' orchestras, white blues and spiritual singers, white authors writing novels in which the Negro proclaims his grievances, whites in blackface" (*B*, 177).

19. Kobena Mercer, "Skin Head Sex Thing: Racial Difference and the Homoerotic Imaginary," *New Formations* 16 (Spring 1992): 21.

20. Kaja Silverman, "White Skin, Brown Masks: The Double Mimesis, or With Lawrence in Arabia," *differences* 1:3 (Fall 1989): 17–20.

21. Gail Ching-Liang Low, "White Skins/Black Masks: The Pleasures and Politics of Imperialism," *New Formations* 9 (Winter 1989): 93.

22. Silverman, 19.

23. Philippe Lacoue-Labarthe and Jean Luc-Nancy, "The Unconscious Is Structured like an Affect," (Part I of "The Jewish People Do Not Dream"), *Stanford Literature Review* 6 (Fall 1989): 208.

24. Mervat Hatem, "Toward the Development of Post-Islamist and Post-Nationalist Feminist Discourses in the Middle East," in *Arab Women: Old Boundaries, New Frontiers*, ed. Judith Tucker (Bloomington and Indianapolis: Indiana University Press, 1993), 31. In the same volume, in an essay entitled "Authenticity and Gender: The Presentation of Culture," Julie M. Peteet speaks of the "remarkable flexibility" of a symbol like the veil

whose use can be "both calculated and creative": "the same veil that symbolized a militant, female activism now is used to circumscribe women's presence in the workplace and confine them to the home" (52). Both Hatem and Peteet interrogate women's semiotic role as bearers of culture. Hatem notes that "while men were expected to interact with their changing environment, women were relegated to the task of being the conservators of the traditional culture" (43). Peteet points out that this is true whether women symbolize progress or tradition; either way, they are still considered repositories of "authentic culture" (60). See also Juliette Minces, "Women in Algeria," in *Women in the Muslim World*, eds. Lois Beck and Nikki Keddie (Cambridge, MA: Harvard University Press, 1978), 159–171. For more on the figure of the veil, see Fatima Mernissi, *Beyond the Veil* (Cambridge, MA: Schenkman, 1975); Malek Alloula, *The Colonial Harem*, trans. Myrna Godzich and Wlad Godzich, intro. by Barbara Harlow (Minneapolis: University of Minnesota Press, 1986); and Lama Abu Odeh, "Post-colonial Feminism and the Veil: Thinking the Difference," *Feminist Review* 43 (Spring 1993): 26–37. Odeh, discussing the veil in a contemporary context, observes that many Muslim women typically wear Western clothes under their veils, further complicating the question of sartorial impersonation and cultural resignification.

25. For a more extended treatment of this theme, see Jeffrey Louis Decker, "Terrorism (Un)veiled: Frantz Fanon and the Women of Algiers," *Cultural Critique* (Winter 1990–91): 177–195. John Mowitt investigates Fanon's fetishistic investment in the category of nation in "Algerian Nation: Fanon's Fetish," *Cultural Critique* 22 (Fall 1992): 165–86. For an interesting reading of the etymological link between fetish and masquerade, see Charles Bernheimer's "Fetishism and Decadence: Salome's Severed Heads," in *Fetishism as Cultural Discourse*, eds. Emily Apter and William Pietz (Ithaca and London: Cornell University Press, 1993), 62–83.

26. Joan Riviere, "Womanliness as a Masquerade" (1929), in *Formations of Fantasy*, eds. Victor Burgin, James Donald, and Cora Kaplan (London and New York: Methuen, 1986), 35–44; Stephen Heath, "Joan Riviere and the Masquerade," in *Formations of Fantasy*, 45–61; and Mary Ann Doane, "Film and the Masquerade: Theorising the Female Spectator" and "Masquerade Reconsidered: Further Thoughts on the Female Spectator" in *Femmes Fatales: Feminism, Film Theory, Psychoanalysis* (New York and London: Routledge, 1991), 17–43.

27. Fanon does not get away from the problem of intentionality here; indeed, Fanon's point is that politics necessarily resides in intentionality. Fanon's strategy is to reconstruct the possibility of agency that colonialism vitiates, and he does this by locating "politics" in the space where imitation exceeds identification.

28. Bhabha, "The Other Question," 27.

29. Bhabha, "Of Mimicry and Man," 130.

30. The clearest statement of Fanon's view that identification itself is a pathological condition produced by the colonial relation comes in *Black Skin, White Masks*, where Fanon suggests, again using Sartrean terms, that "as long as the black man is among his own, he will have no occasion . . . to experience his being through others" (109). For Fanon it is not the case that unconscious racial identifications create the colonial drive for assimilation, but rather that colonial dominations produce the phenomenon of racial identification. No identification without colonization.

31. A significant body of work already exists on the role nineteenth-century racial models of the Jew play in shaping Freud's work. See, for example, Jay Geller, "'A glance at the

nose': The Inscription of Jewish Difference," *American Imago* 49 (1992): 427–44; Geller, "Freud V. Freud: Freud's Reading of Daniel Paul Schreber's *Denkwurdigkeiten Eines Nervenkranten,*" in *Reading Freud's Reading*, eds. Sander Gilman, Jutta Birmele, Jay Geller, and Valerie D. Greenberg (New York: New York University Press, 1994), 180–210; Daniel Boyarin, "Freud's Baby, Fliess's Maybe: Homophobia, Antisemitism, and the Invention of Oedipus," *GLQ* 2:1 (1994); and Boyarin, "*Épater L'embourgeoisement:* Freud, Gender, and the (De)colonized Psyche," *Diacritics* 24:1 (Spring 1994): 17–41. Most recently, Sander Gilman's *Freud, Race, and Gender* (Princeton: Princeton University Press, 1993) argues for understanding Freud's theory of femininity as an anxious displacement of dominant racial representations of the male Jewish body. Something rather similar may be going on in Fanon's passages on femininity and homosexuality, where the popular colonialist caricature of the black man as castrated and sexually degenerate is seamlessly transposed onto women and gay men. In this section I briefly discuss Fanon's complicated negotiations of colonial representations of black sexuality—racial epistemologies in which Freud is inevitably implicated. For Fanon, the problem of anti-Semitism and racism are not unrelated. Fanon in fact models his investigation of Negrophobia in *Black Skin, White Masks* on Sartre's study *Anti-Semite and Jew* (New York: Grove Press, 1960), adapting Sartre's claim that "it is the anti-Semite who *makes* the Jew" into his own formulation on racism, "it is the racist who creates his inferior" (B, 93). The representational history of Jews as "the Negroes of Europe" (cited in Gilman, 20) provides the basis of a powerful and ambivalent identification for Fanon with the figure of the male Jewish intellectual. For Fanon's comparisons in *Black Skin, White Masks* of the Jew and the Negro, the anti-Semite and the Negrophobe, see especially 87–93, 115–16, 157–66, and 180–83.

32. The original citation is from Angelo Louis Marie Hesnard's *L'univers morbide de la faute* (Paris: Presses Universitaires de France, 1949), 37.

33. I refer to Freud's favorite example of hysteria: the woman who plays both parts of a seduction at once, tearing her dress off with one hand ("as a man") and pressing it to her body with the other ("as a woman"). See Freud's "Hysterical Phantasies and Their Relation to Bisexuality" (1908), *Standard Edition* 9:155–66, and "Some General Remarks on Hysterical Attacks" (1909), *Standard Edition* 9:227–34. See also Chapter 4.

34. See Angela Davis, "Rape, Racism and the Myth of the Black Rapist," in *Women, Race, and Class* (New York: Random House, 1981).

35. Mary Ann Doane, "Dark Continents: Epistemologies of Racial and Sexual Difference in Psychoanalysis and the Cinema," in *Femmes Fatales*, 222.

36. For just such a careful analysis of the racialized class field of sexuality, see, for example, M. Jacqui Alexander's "Redrafting Morality: The Postcolonial State and the Sexual Offences Bill of Trinidad and Tobago," in *Third World Women and the Politics of Feminism*, eds. Chandra Talpade Mohanty, Ann Russo, and Lourdes Torres (Bloomington and Indianapolis: Indiana University Press, 1991): 133–152. In her essay "Cartographies of Struggle: Third World Women and the Politics of Feminism," Chandra Talpade Mohanty also analyzes how "racialized sexual violence has emerged as an important paradigm or trope of colonial rule" (17).

37. Fanon immediately undermines this disclaimer by extending the myth of rape fantasy to black women, asserting in the very next line that light-skinned Antillean women also have fantasies of rape, masochistic wish fantasies in which the role of aggressor is played by black men of darker skin color than their own. While Fanon sympathizes with black men who are constrained under colonial domination to identify with white men, his comments on black women's identification with white women are comparatively harsh and

unsympathetic. See Fanon's reading of Mayotte Capécia's autobiographical book, *Je suis Martiniquaise*, in Chapter Two of *Black Skin, White Masks*. For a more extended analysis of Fanon's dismissal of Capécia's book, see Gwen Bergner's "Who Is That Masked Woman? Or, the Role of Gender in Fanon's *Black Skin, White Masks*." *PMLA* 110:1 (January 1995).

38. Lee Edelman, *Homographesis: Essays in Gay Literary and Cultural Theory* (New York and London: Routledge, 1993), 55.

39. Gilles Deleuze and Félix Guattari, *Anti-Oedipus: Capitalism and Schizophrenia*, trans. Robert Hurley, Mark Seem, and Helen R. Lane (Minneapolis: University of Minneapolis Press, 1983), 170. Originally published as *L'Anti-Oedipe* (Paris: Les Editions de Minuit, 1972). After all, "the revolutionary is the first to have the right to say: 'Oedipus?' Never heard of it" (96). Hereafter, all page numbers cited in the text.

40. In addition to Gendzier's biography, several other critical studies on Fanon appeared in the early 1970s, including Pierre Bouvier, *Fanon* (Paris: Editions universitaires, 1971); David Caute, *Fanon* (London: Collins, Fontana, 1970); Phillippe Lucas, *Sociologie de Frantz Fanon* (Alger: SNED, Societe nationale d'edition et de diffusion, 1971); Jack Woddis, *New Theories of Revolution* (New York: International Publishers, 1972); Renate Zahar, *L'Oeuvre de Frantz Fanon*, trans. R. Dangeville (Paris: François Maspero, 1970); and Peter Geismar, *Fanon* (New York: The Dial Press, 1971).

41. Freud, *Three Essays on the Theory of Sexuality* (1905), *Standard Edition* 7:139. Most of what Freud has to say on race can be found in his anthropological work, where Gustave Le Bon's use of the phrase "racial unconscious" as a synonym for "archaic" or "primitive" is revised and expanded by Freud to include his theory of repression. For Freud's most extended treatment of the subject of race, see *Totem and Taboo* (1913), *Standard Edition* 13:1–162. For the influence of Darwin on Freud's theory of race, see Edwin R. Wallace, *Freud and Anthropology* (New York: International Universities Press, Inc., 1983), and Lucille B. Ritvo, *Darwin's Influence on Freud: A Tale of Two Sciences* (New Haven: Yale University Press, 1990). Freud's *Group Psychology and the Analysis of the Ego* (1921) provides us with a psychoanalytic theory of racism that may be not without interest in the context of the present chapter: "Closely related races keep one another at arm's length; the South German cannot endure the North German, the Englishman casts every kind of aspersion upon the Scot, the Spaniard despises the Portuguese. We are no longer astonished that greater differences should lead to an almost insuperable repugnance, such as the Gallic people feel for the German, the Aryan for the Semite, and the white races for the coloured," 18:101. See also Gilman.

42. Richard F. Burton, *The Book of a Thousand Nights and a Night*, vol. 10 (London: The Burton Club, 1885). Burton writes: "There exists what I shall call a 'Sotadic Zone,' bounded westwards by the northern shores of the Mediterranean (N. Lat. 43°) and by the Southern (N. Lat. 30°). Thus the depth would be 780 to 800 miles including meridional France, the Iberian Peninsula, Italy and Greece, with the coast-regions of Africa from Marocco to Egypt" (206). See Burton's Terminal Essay for the full coordinates of the Sotadic Zone, too lengthy to be cited here.

43. Havelock Ellis and John Addington Symonds, *Sexual Inversion* (London: Wilson and MacMillan, 1897). Reprinted by Arno Press (New York, 1975), 22.

44. See Ellis and Symonds, 10; Burton, 251.

45. Luce Irigaray, "Any Theory of the 'Subject' Has Always Been Appropriated by the 'Masculine,'" in *Speculum of the Other Woman*, trans. Gillian C. Gill (Ithaca: Cornell University Press, 1985), 133–146.

46. McCulloch, 1.

47. Gendzier, 73.

48. There is considerable disagreement over the extent of Fanon's language skills and its consequences for his professional work, a dispute that in the level of its intensity underscores how very high are the stakes involved. Fanon's most sympathetic biographer, Peter Geismar, claims that by the end of 1956, several years after arriving in Algeria, Fanon could "understand most of what his patients were telling him" (86). Irene Gendzier provides a sharply differing account, describing Fanon's efforts to learn Arabic as "stillborn" and personally anguishing (77). For Albert Memmi, Fanon's refusal to learn the language of the patients he was treating constituted nothing less than a "psychiatric scandal." See Memmi's "Fanon," *New York Times Book Review*, March 14, 1971, 5.

49. Gendzier, 77; Geismar, 83.

50. Walter Benjamin's "The Task of the Translator" takes as its thesis the useful notion that any language is a place of exile, that "all translation is only a somewhat provisional way of coming to terms with the foreignness of languages," *Illuminations*, ed. Hannah Arendt, trans. Harry Zohn (New York: Schocken, 1969), 75. Benjamin's interest in translation, however, lies in the "suprahistorical kinship of languages" or "the relatedness of two languages, apart from historical considerations" (74). The theoretical move to banish history from the realm of translation operates to conceal, and ultimately to preserve, a colonizing impulse at work in translation; Benjamin's "great motif of integrating many tongues into one true language" (77) represents an imperialist dream, a fantasy of linguistic incorporation and cultural assimilation. If it is impossible to read translation outside the history of colonial imperialism, then it may also be the case that colonial imperialism operates as a particular kind of translation. In the roundtable discussion on translation included in Derrida's *The Ear of the Other*, Eugene Vance poses the question in its simplest rhetorical form: "Isn't the colonization of the New World basically a form of translation?" See Jacques Derrida, *The Ear of the Other: Otobiography, Transference, Translation*, ed. Christie V. McDonald, trans. Peggy Kamuf (New York: Schocken Books, 1985), 137. For more on the imperial history of translation, see Arnold Krupat, *Ethnocriticism: Ethnography, History, Literature* (Berkeley and Los Angeles: University of California Press, 1992), 193–200.

51. Complicating matters further is the question of Fanon as *object* of identification. In "Critical Fanonism," Henry Louis Gates, Jr. demonstrates how Fanon is inevitably a repository for his *critic's* projective identifications: "If Said made of Fanon an advocate of post-postmodern counternarratives of liberation; if [Abdul] JanMohamed made of Fanon a Manichean theorist of colonialism as absolute negation, and if Bhabha cloned, from Fanon's *theoria*, another Third World post-structuralist, [Benita] Parry's Fanon . . . turns out to confirm her own rather optimistic vision of literature and social action" (465). To this list I would have to add my own identification with Fanon the psychoanalytic theorist and university teacher. See Gates's "Critical Fanonism," *Critical Inquiry* 17:3 (Spring 1991): 457–70.

52. Gendzier, 64.

53. Jock McCulloch, *Black Soul, White Artifact: Fanon's Clinical Psychology and Social Theory* (Cambridge, UK: Cambridge University Press, 1983), 3. For another detailed study of Fanon's contributions to clinical psychiatry, see Hussein Abdilahi Bulhan's *Frantz Fanon and the Psychology of Oppression* (New York: Plenum Press, 1985).

54. Philippe Lacoue-Labarthe, *Typography: Mimesis, Philosophy, Politics*, ed. Christopher Fynsk (Cambridge, MA: Harvard University Press, 1989), 300.

INDEX

Index

Index